Faces *of the* Confederacy

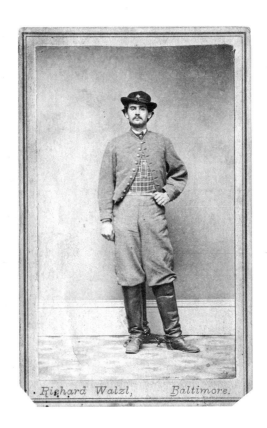

Richard Walzl, Baltimore.

This *carte de visite* of an unidentified soldier is printed at actual size. The photographs in this collection have been enlarged.

Faces *of the* Confederacy

AN ALBUM OF SOUTHERN SOLDIERS
AND THEIR STORIES

Ronald S. Coddington

WITH A FOREWORD
BY MICHAEL FELLMAN

THE JOHNS HOPKINS UNIVERSITY PRESS
BALTIMORE

2 4 6 8 9 7 5 3 1

The Johns Hopkins University Press
2715 North Charles Street
Baltimore, Maryland 21218-4363
www.press.jhu.edu

LIBRARY OF CONGRESS CATALOGING-IN-PUBLICATION DATA

Coddington, Ronald S., 1963–
Faces of the Confederacy : an album of southern soldiers and their
stories / Ronald S. Coddington.
p. cm.
Includes bibliographical references and index.
ISBN-13: 978-0-8018-9019-2 (hardcover : alk. paper)
ISBN-10: 0-8018-9019-5 (hardcover : alk. paper)
1. United States—History—Civil War, 1861–1865—Biography. 2. United
States—History—Civil War, 1861–1865—Portraits. 3. Confederate States of
America. Army—Officers—Biography. 4. Confederate States of America.
Army—Officers—Portraits. 5. Soldiers—Confederate States of America—
Biography. 6. Soldiers—Confederate States of America—Portraits. I. Title.
E467.C633 2008
973.7′820922—dc22
2008007475

A catalog record for this book is available from the British Library.

*The frontispiece photograph was taken by Richard Edmund Walzl (b. 1843)
of Baltimore, Maryland.*

*Special discounts are available for bulk purchases of this book. For more information, please
contact Special Sales at 410-516-6936 or specialsales@press.jhu.edu.*

The Johns Hopkins University Press uses environmentally friendly book materials, includ-
ing recycled text paper that is composed of at least 30 percent post-consumer waste, when-
ever possible. All of our book papers are acid-free, and our jackets and covers are printed on
paper with recycled content.

For Anne

Contents

Foreword

MICHAEL FELLMAN

AS MEN OF NORTH AND SOUTH LEFT HOME TO JOIN THE army at the outbreak of the Civil War, many of them had their picture taken. "For the few days in which the military are being enrolled," the American correspondent to an English periodical noted, "the photographic galleries are thriving: the wise soldier makes his will, and seeks the photograph as possibly the last token of affection for the dear ones at home." And so it was off into the vast, unknown conflict, to possible maiming or death, with the image of the proud and probably fearful new soldier, uniformed and posed in the photographer's studio, left behind. This magical representation, at once of the civilian he had been and the soldier he had become, remained with the home folks as they held their breath awaiting news of injury, death, or disappearance.

Into this unusual and moving volume Ron Coddington has gathered the portraits of dozens of ordinary soldiers — junior officers and enlisted men rather than the famous generals — giving us a portrait gallery of soldiers on the brink of a war that would change their lives forever, whatever their physical fate. More than that, he has tracked down the life histories of these men and tells us about their wartime and postwar experiences, their stories often ending in death by battle and disease or from postwar wounds, or continuing in more ordinary ways until death in bed, years or decades later. Although Coddington does not speculate on the psychology of these later lives, it does seem clear from their stories that for many soldiers the wounds of war were by no means all visible.

But the images were. They stemmed from a very common experience, that visit to the photographer's studio. By coincidence,

just in time for the Civil War, technological and business change made possible the ready supply of cheap graven images that matched the soldiers' great demand for some form of symbolic immortality. Democratic portraiture filled the great hunger for self-representation of a democratic and individualist soldiery.

Photography was only twenty-two years old when the war started, but it had rapidly developed from an expensive and difficult technique to one readily attuned to the mass production of inexpensive prints. In January 1839, Louis Jacques Mandé Daguerre announced the discovery that bore his name. By March, the American portrait painter and inventor, Samuel F. B. Morse, who was in Europe to secure patents for his telegraph, had met Daguerre, learned the process, purchased a camera, and brought the process back home to America, where it immediately spread as a quick method of portraiture. Daguerreotypes were unique pictures, the light being impressed directly on a plate that was the picture itself, and so the price remained relatively high—around $5 at first. By 1850 there were 938 daguerreotypists distributed among the cities and many of the towns of the United States, and the price had dropped to about $2.50—still dear, but clearly low enough to feed a rapidly growing demand.

Photography took a great leap forward in the early 1850s, when collodion technology developed, again mainly in France. The photographer now exposed his camera lens on chemically treated glass plate negatives, with the images then transferred onto ordinary, treated paper, making positive prints. This made possible the reproducibility of inexpensive photographs. And then, in 1854, Adolphe-Eugene Disdéri, the court photographer to Napoleon III, developed a movable plate holder, allowing eight to twelve poses to be imprinted on one negative plate. A single print from this negative could thus produce many images, and reproductions were made even cheaper by the fact that unskilled laborers could handle the printing processes. In 1857, according to legend and possibly in reality, the Duke of Parma gave Disdéri one of his business cards and asked that his pho-

tograph be glued onto the reverse side. As such cards were of a uniform four by two and one-half inches throughout Europe and America, this small portrait, known as the *carte de visite,* became the standard form of cheap photographic portraits.

Technological and artistic transfer from imperial France to the democratic United States (sometimes via Britain) continued its swift pace. Such trade long had been true of many products, notably Parisian women's clothing fashions. Then as now, Paris was the hub. Not only did wealthy Americans buy directly at Parisian salons, artists from *Godey's Lady's Book,* the leading American fashion magazine, attended the French showings, and within months French haute couture knock-offs appeared on the streets of Cedar Rapids, Iowa. Now the collodion process and the *carte de visite* photographic reproduction form also spread like lightning, to England, and then across the Atlantic. First advertised in January 1860 by a Broadway photographer as "The London Style, Your Photograph on a Card," *carte de visite* pictures cost only $1.00 for 25, and competition soon increased the quantity the customer's dollar would buy. What was, even at the time, called "cardomania" spread like the flu in the spring of 1860, by which time 3,154 Americans earned their living as photographers, eighty-three in New York alone, and at least one in nearly every city and town.

Within a year the newspapers were advertising another new product—photograph albums; between 1860 and 1865, fifteen styles were patented. Most versions featured recessed pockets with slots for inserting the pictures. Some albums were ornate, costing up to $40, some priced as low as $1.50. Photographers mass-produced landscapes and pictures of famous people in the *carte de visite* format, which fit in nicely amid pictures of family and friends. (Indeed celebrities soon charged for sitting; the celebrated actress Lily Langtry, for example, charged $5,000, but her photographer made a small fortune by selling copies at $5.) Photo albums frequently became the second adornment of log cabins as well as front parlors, set on a table next to the family Bible. Many of the same families also bought

stereographic prints and viewers, which created the illusion of three dimensions, but the *carte de visite* craze was even greater, especially in the North. Some Union regiments had their own photographers, and whenever armies went to winter encampments, artistic sutlers soon set up shop nearby; approximately 300 served the Army of the Potomac alone. These enterprising photographers also recorded the scenes of battlefields, after the event, their cameras being too slow for action shots during battle (when, in any event, smoke covered the field). Put on public exhibition, these scenes of vast numbers of the mangled dead soon brought the war home to civilians in a visceral way, undoubtedly contributing to the unpopularity of the war by 1864.

Mathew Brady, the most noted battlefield photographer, made his bread and butter at $1 per sitting during the war, along with scores of other picture takers, including the three brothers Bergstresser from Pennsylvania, who traveled to the front and took up to 160 portraits per day during lulls in battle. As one Boston photographer observed in May 1863, "the card photograph has for the past two years . . . been in universal demand, almost to the complete exclusion of every other style of photographic portraiture, and has in fact produced a revolution in the photographic business."

Democratic, cheap, and popular, the *carte de visite* had aesthetic limits — most soldiers were shot full figure in a very small frame—and so a larger product, the four by six and one-half inch "cabinet card," came into fashion after 1866. Cabinet cards could pay more attention to detail and to the character of the sitter. Soon, photo albums accommodating this format became all the rage and *cartes de visite* lost fashion. The cabinet card held sway until the late 1880s, when celluloid reel-to-reel film, hand-held cameras, and the photo-finishing business once more transformed and further democratized photography, in the form that lasted until the current digital craze.

Throughout the war, the home folks could gaze on the likenesses of their endangered soldier boys, and the unlucky ones possessed at least a representational reminder of the promis-

ing men who had marched off to war only to offer the ultimate sacrifice. Not without reason did Oliver Wendell Holmes call *cartes de visite* "the social currency, the sentimental 'greenbacks' of civilization." Often the soldiers carried pictures of their loved ones in their packs as well, as their end of a ritualized exchange of prewar memories on paper. Stiff though the picture poses might be, set not in nature but in airless studios beside photographers' props, the *cartes de visite* were nevertheless powerful reminders of love for men plunged into hateful circumstances.

The full meanings of soldiers' lives could never be indicated by these still and solitary photographic compositions, however much they meant to the soldiers and their families as *aides-mémoire*. Military experience meant not just the unspeakable terrors of combat but a nearly total transformation of everyday life. Confederate soldiers came from all over the South, included mountain men and French-speaking Cajuns, and ranged from poor white squatters to lordly plantation owners. Many were terribly poor and uneducated; these common folks were far less likely to have their photos taken than were the physicians, ministers, and other officers of social station who are disproportionately represented in these pages. The much higher Confederate toll—20 percent of those who joined the army—is underscored in these stories, many of which end in wartime death. Beyond those, many were wounded permanently in psychological as well as physical ways while far from home, living and dying in a manner far beyond the comprehension of the home folks or of the peaceful citizen selves they once had been. For many, perhaps most, war brought more enduring pain than glory. In that sense, these stylized pictures of composed and confident young men deny the inner experiences of the war.

By placing these still images within the context of brief, turmoil-filled biographies, Ron Coddington has given us an original memoir of the impact of the Civil War on ordinary American young men and their families. They ventured forth at great risk, often becoming sacrifices to political ends that to

them and their families were abstractions. Pride and potential loss are reflected in their pictures and their stories, as is the sheer poignancy of the impact of war. With continuing immediacy these portraits stare out at us. Coddington's stories drive home the image of the resilience and fragility of all soldiers everywhere, and during the American Civil War in particular.

Bibliographical Note

For discussions of the *carte de visite* craze set within the context of the history of nineteenth-century American photography see the following four books, noted in chronological order: Robert Taft, *Photography and the American Scene, A Social History, 1839–1889* (1938; reprinted, Mineola, N.Y.: Dover Books, 1964); Beaumont Newhall, *The History of Photography: From 1839 to the Present Day*, rev. ed. (New York: Museum of Modern Art, 1964); Alan Trachtenberg, *Reading American Photographs: Images as History, Mathew Brady to Walker Evans* (New York: Hill & Wang, 1989); Martha A. Sandweiss, ed., *Photography in Nineteenth-Century America* (New York: Henry N. Abrams, with the Amon Carter Museum, Fort Worth, Tex., 1991).

Preface

THE HISTORY OF THE CIVIL WAR IS THE STORIES OF ITS soldiers.[1] Personal accounts of Northern men comprise my 2004 book *Faces of the Civil War: An Album of Union Soldiers and Their Stories*. This companion volume profiles volunteers from the Southern states and soldiers sympathetic to the Confederate cause who hailed from Union states along the federal border and in the District of Columbia.

War is a great and terrible unifier of men. The sons of the South joined the gray armies en masse, driven by commonality of purpose and motivated by esprit de corps. Individual identities were lost as they battled with saber, musket, and cannon for four years to resolve issues that had not been settled with the pen over decades. More than 600,000 men took up arms— about half the military-aged population and one-fifth of all white males living in the South. They battled well-equipped armies four times their number. In those forty-eight months, about 134,000 perished, an average of about ninety soldiers per day: Some were killed in battle, some died later of battle wounds, or succumbed to disease, or suffered death while prisoners of war. On average, twenty-two of every one hundred males who went to war did not return home.[2] A large number of survivors endured permanent disabilities.

Many of the soldiers in this volume fought on faraway fronts while Northern forces invaded and occupied their home states, even their family homes. During and after the fighting, they and their families faced economic destabilization, physical displacement, and the breakdown of civic institutions and social order. After the end of hostilities, the vast majority of Southern veterans returned to their families and remained in the South.

By comparison, most former Union soldiers returned to homes untouched by the ravages of war; and a large number, perhaps with wanderlust from their travels in uniform, struck out for the West and other parts of the country.

Those Confederate soldiers profiled here who wrote about their reasons for joining the army considered themselves patriots possessed of love of country. Initially opposed to secession and to taking up arms against the Union, they felt compelled to fight what they thought of as a Second American Revolution after the election of Abraham Lincoln, which signaled to them a takeover of the government by forces hostile to the interests of the Southern states. Once this perspective took root in their psyche, they viewed themselves as defenders of their homeland—not aggressors who declared independence from the United States, seized federal arsenals and forts, fired on Fort Sumter, and fought four years of bloody war.

Most soldiers regained their U.S. citizenship by signing an oath of allegiance, made available by several presidential proclamations between 1863 and 1867. On July 4, 1868, President Andrew Johnson removed the oath requirement after he granted amnesty to almost all remaining Confederate combatants.

Many of the men profiled here owned slaves or hailed from slaveholding families. Woven into the fabric of their culture and economy, slavery, with its moral and social implications, its contradiction to the spirit of the Declaration of Independence and conflict with the tenets of the Constitution, is barely mentioned by these soldiers in the writing that survives. Yet, they must have discussed this topic and related issues in camp and elsewhere.

The men featured in this book did write about their military experience and were mentioned in accounts penned by their comrades. Much of the original source material quoted on these pages is taken from postwar reminiscences of aging veterans who looked back upon their Confederate army service with reverence, romance, and pride for having fought for the "Lost Cause." This theme, popular with veterans' groups during the late nineteenth and early twentieth centuries, is echoed

throughout their writings. It is inevitable that, in quoting from these sources, this theme should be reflected here. Few of these men commented on slavery, the status of freedmen, or the post-war period of Reconstruction in writings that survive.

The purpose of this volume remains unchanged from its Union companion: to offer a unique perspective on the Civil War and contribute to a better understanding of the role of the common soldier by chronicling the stories of a select group of individuals, each illustrated with an original *carte de visite* portrait photograph. The accompanying profiles put the Confederate war experience in the context of the lives of these soldiers and a generation of Americans. In this, the book differs from other works on the Civil War soldier's experience, which place it in the context of a campaign, battle, or history of a military unit.

About This Volume

Anne handed the telephone to me. "It's Suzy. She wants to talk to you." I placed the receiver to my ear and greeted Suzanna Johnson Rainsford. She and Anne grew up together in Charlotte, North Carolina, and are close friends. Suzy said her grandmother wanted to see me. "She has a book to show you." We traveled to Charlotte a few weeks later and stopped at the home of Suzy's parents to visit her grandmother. While Anne chatted with the family, Suzy's mother led me to a bedroom where ninety-one-year-old Mildred Irene Decker, affectionately known as "Mamaw," lay gravely ill, drifting in and out of consciousness. I sat down in a chair next to her bed and took one of her hands as Suzy's mother gently placed a thin, sepia-toned volume in the other.

Mrs. Decker became lucid, and we talked. She knew about my book plans and wanted to share the collected wartime letters of her grandfather, who fought for the Confederacy. She handed me the volume and said I could borrow it. I scanned its yellowed pages, and we talked until she began to tire. I promised to read the book, said goodbye, and kissed her cheek. She passed away about a month later.

Back at home in Virginia, I read *Yours Till Death*, the writings of John Weaver Cotton. He left his wife and children on the family farm to fight with a company that became part of the Nineteenth Alabama Cavalry Battalion. His letters reveal a man who wrote, as the book's editor noted, with "an honesty and uprightness that is refreshing; and . . . a pathetic homesickness and longing for 'this unholy mess' to be over so that he may enjoy peace at home again."[3] He barely survived the war, dying in 1866 at age thirty-five. The family attributed his death to disease contracted in the army. His poignant letters deepened my determination to tell the stories of Southern soldiers.

I started this volume a couple months before meeting Mrs. Decker. On a rainy Saturday morning in September 2004, in the wake of Hurricane Ivan, I drove to Maryland for Baltimore's annual book festival. The rain had slowed to a sprinkle by the time I arrived, but the wind had picked up, and it whipped around the tents erected for the outdoor event. I located the Johns Hopkins University Press tent, filled with tables of books, and met acquisitions editor Bob Brugger—our first meeting in person. He had taken an active interest in my Union *Faces* proposal in the summer of 2001, and since that time we had corresponded by e-mail and telephone. During our conversation, he asked about future projects and suggested a companion volume on Confederates. I readily agreed, and left later that day eager to begin.

The hunt for photographs became my first priority. I possessed none of named soldiers, an important difference from the first book, which featured photographs solely from my collection. I contacted individuals and organizations, and I solicited submissions through an ad, the book's Web site, and "Faces of War," my column in the *Civil War News*. I evaluated each photograph on the same criteria I had established for the Union portraits: identified soldiers below the rank of colonel photographed during the war or soon after in the *carte de visite* format. Condition and aesthetics were also important considerations. The quest lasted a year and a half and at times resembled the proverbial search for a needle in a haystack. My research in

the collection of the Museum of the Confederacy in Richmond, Virginia, illustrates the challenge. Heather W. Milne, curator of photographic collections, estimated that the museum's holdings include about 2,500 *cartes de visite,* roughly half showing civilians and half military or political figures. After subtracting the civilians, politicians, colonels and generals, and unidentified soldiers, eighty-eight images remained. Of this number, twenty-one met my criteria for condition and aesthetics. Preliminary research eliminated about half for various reasons. Ten were ultimately included—about one-half of one percent of the total.[4]

One of my contacts, Dave Neville, editor of *Military Images* magazine, led me to David Wynn Vaughan, who possesses one of the finest collections of Confederate images in the country, and of Georgia soldiers in particular. I traveled to Atlanta in April 2005 to examine his collection, equipped with a laptop computer and a scanner. We spent an enjoyable evening poring over his spectacular portraits. We had much to discuss: in addition to our common interest in photography and the Civil War, we discovered that we had attended the University of Georgia at about the same time, although we'd never met there. I left Atlanta with a new friend—and scans of the first *cartes* for this book.

I selected one of the soldiers at random, John Ells, and began to research his story. An officer in the Third Georgia Infantry, he sustained a wound in a fight soon after the Battle of Gettysburg. Before the war, he resided and married in New York.

Ells' residence in both the north and the south reminded me of my own experience. Born and raised in New Jersey, I left in 1978 with my family after a corporation bought the company for which my father worked and relocated it to Statesboro, Georgia. I arrived as a high school sophomore with a cigar box of old photographs and a passion for the Civil War. I learned about the history of the town, which lay in the path of Maj. Gen. William T. Sherman's "March to the Sea." The Confederate monument in downtown Statesboro caught my attention. I later wrote an ar-

ticle about it for my high school newspaper, *The Statesboro Hi-Owl*. My favorite Civil War destinations were Fort Pulaski, on the Savannah coast, and the site of Camp Lawton, a prisoner of war facility near Millen in today's Magnolia Springs State Park. Going off to college in Athens further exposed me to the history of the war. I especially liked to walk by the stately buildings on the University of Georgia's old campus, which escaped destruction by Sherman's forces.

During my senior year, I met my future wife, Anne Curtis Parkerson, at the student center. I later learned from her mother, Ruth, about their forefathers who served in the Confederate army: David D. Davis (1843–1885), a private in the Twenty-eighth North Carolina Infantry who suffered a wound at Gettysburg that resulted in the amputation of a leg and his capture, and Thomas Jefferson Crowell (1822–1906), who enlisted at age forty as a private in the First North Carolina Artillery. No wartime images of these men have yet surfaced. There are no veterans in my direct line: Great-great-great Grandfather Benjamin Millard Coddington (1823–1884) of New Jersey may have considered himself too old to enlist at thirty-seven. His eldest son, Millard Filmore Coddington (1849–1916), was eleven years old at the start of the war, and his youngest son, my great-great grandfather Lewis Coddington (1865–1946), came into the world six months after the end of hostilities.

The absence of a Coddington Civil War veteran, being intrigued with the history of the war, and my fascination with vernacular photography are factors that led me down the path that led to the publication of Union *Faces*. The journey continues here.

David Vaughan introduced me to Bill Turner, who generously shared his extraordinary soldier images, in particular his portraits of Virginians. About half of the *cartes* that grace these pages come from his holdings. Bill's interest in Civil War artifacts dates to the centennial celebrations. Few guidebooks and other sources of information were available to collectors then, and Bill blazed many trails as a collector and dealer. He shared

with me his knowledge and experience with the same spirit as he did his images. I spent many happy hours in his company studying his collection and on the telephone swapping stories, opinions, and information. Bill is a diligent student of the Civil War, and his knowledge is ever expanding. I admire his enthusiasm and dedication. His guidance and friendship have increased my understanding of historic photography, Southern soldiers, and the Civil War collectibles business.

Meeting Bill, David, and other enthusiasts was one of the most rewarding aspects of this project. *Cartes de visite* contributed by them comprise the bulk of this book. Two of the photographs belong to my collection; they were added after the start of this research. Also included are images from public institutions, another significant source of photographs. (These persons and institutions are named in the Acknowledgments, which may be found at the back of this volume.)

In many cases, the subject of an image is identified on the back of the *carte de visite* mount, usually with a signature. Some are unsigned. The identities of these subjects were established using several methods: by comparison to signed copies of the same *carte* or another portrait of the subject, by evaluation of the uniform and weapons shown, and by consultation with collectors, curators, families, genealogists, historians, and others.

Most of the portraits were taken before the Union naval blockade and invading armies destabilized the economy and disrupted the flow of photographic materials entering the Confederacy, or by Northern photographers operating near prisoner of war facilities, or by Southern photographers flush with supplies after the end of the war. Some of the images are copies of photographs originally created in another format.

I was unable to make a proportional representation of states based upon the number of military men the state contributed. Hence, the proportion of images is not balanced. This may disappoint those interested in a specific state. However, photographic surveys in book form exist for many states. This volume is focused on the soldier's experience. The pictures are presented

chronologically by the date of the event described at the outset of each profile.

In the Union *Faces*, I relied heavily upon detailed military service and federal pension records. Not so for the Confederate soldiers. Their military service records are fragmentary, particularly those for the final months of the war. The U.S. government did not award pensions to Confederate veterans, so the government's extensive military pension records were seldom of assistance. Individual states provided pensions, but in every case those files contained only a fraction of the information found in the federal files.

The typical research cycle averaged two months per soldier, although some required up to one year. The collectors kindly supplied me with the information in their possession. My search began on the World Wide Web: Ancestry.com, the Library of Congress, the Official Records at Cornell University, state archive pension files, and miscellaneous databases, catalogs, finding aids, books, newspapers, and other documents on the Internet. Queries posted on The Civil War Message Board Portal and GenForum.com were productive. Information obtained from these sources required follow-up e-mails, letters, telephone calls, formal requests, and research trips. I visited the National Archives and the Library of Congress in Washington, D.C., to access military service records, the *Southern Historical Society Papers*, unit history books, newspapers, and other texts. I also visited the Arlington (Virginia) Public Library to view *Confederate Veteran Magazine*, and to consult Sifakis's *Compendium of the Confederate Armies*. I tapped into the interlibrary loan system for additional materials.

These and other sources are referenced in the endnotes, which number considerably more than in Union *Faces*. To accommodate them, I omitted biographical footnotes of colonels and generals, which were included in the other volume.

The profiles produced from these sources are informal biographies, not chronological or genealogical histories. Specific dates, names of superior officers, family members, and other

particulars may have been omitted to focus on salient points of each story. Unit history details, particularly name changes during the progression from local militia to state and Confederate army service, are included in text and endnotes when relevant. I adhered to designations used by the National Archives, although these names may be different from those used by the soldiers or in common use by others. Officers commissioned by the government are listed as members of the Confederate States Army, rather than the formal Provisional Army of the Confederate States, or P.A.C.S. Descriptions of campaigns, battles, skirmishes, and other movements are included when necessary to understand circumstances encountered by the soldier. Slavery and other major political and military issues referenced in the profiles are not discussed in detail.

The caption below the photograph notes the subject's final assignment and rank. Consequently, the final rank does not always correspond with the uniform worn by the soldier in his *carte de visite*. The names and home cities of the photographers are included when available. This information typically appears on the back of the photograph's mount. Life dates have been added from the database of the George Eastman House in Rochester, New York.

In May 2005, I launched a weblog to document this project. It is linked from facesofwar.com.

A select group of experts and friends received and reviewed a copy of the manuscript before it was submitted to the publisher. All feedback received serious consideration, and revisions were made accordingly. One of the recipients, Jess Zielinski, responded with a comment that captures an essential goal of this work: "That all these men . . . get a chance to be alive again on the pages. . . . The details of what they cared about, the details of their personality and character, the facts of their service and their lives following their service—all this makes them men again."[5]

Faces *of the* Confederacy

CARTES DE VISITE

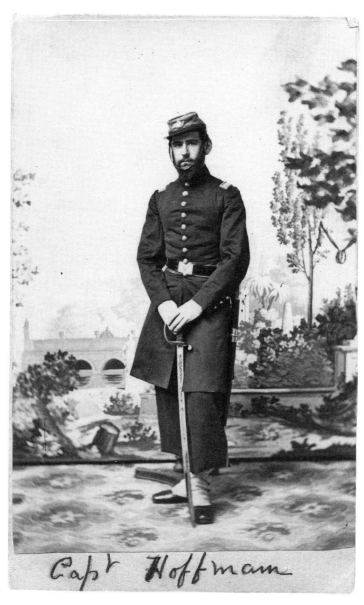

Capt Hoffman

Capt. Richard Curzon Hoffman, Company E, Thirtieth Battalion Virginia Sharpshooters

Carte de visite published by Selby & McCauley of Baltimore, Maryland, from a negative by Stephen Israel (life dates unknown) & Co. of Baltimore, about 1865. Collection of The Museum of the Confederacy, Richmond, Virginia.

Three Cheers from the Baltimoreans

SOON AFTER THE START OF THE WAR, NEWLY ORGANIZED volunteers converged on Camp Lee, near Richmond, Virginia, to muster into the army as the Twenty-first Virginia Infantry. On June 21, 1861, the two companies that would form the heart and soul of the regiment met for the first time: Company B, a select group of Baltimore's cultural and financial elite, welcomed Company F, an old militia organization composed of the crème de la crème of Richmond society. The Baltimoreans gave the Richmonders three hearty cheers.[6]

Company B's officer corps included 1st Lt. Richard Hoffman, the son of a prosperous merchant of German ancestry. His mother gave birth to him in the family's Baltimore mansion, and he attended private schools in the city and became a successful stockbroker.[7] He joined a company in the Maryland Guard Battalion, a militia unit formed in Baltimore in 1859. In the wake of the bombardment of Fort Sumter, fifty-six of the sixty-eight members resigned and left for Virginia with Hoffman in command, and Company B was dissolved. The men took part of the company name with them, re-forming as the Maryland Guard Company in May 1861. They became the only Maryland-based company in the otherwise all-Virginia Twenty-first Infantry. Their unique uniforms, influenced by the fancy Zouave style, reinforced their out-of-state distinction.[8]

The Marylanders signed up for a one-year enlistment in the Twenty-first. They spent most of their time in the Shenandoah Valley, where they saw little action, and left the regiment after their term expired. Many of the men were recruited for an all-sharpshooters unit; Hoffman signed on as captain and head of Company E of the Thirtieth Battalion Virginia Sharpshooters.

Capt. Hoffman spent significant amounts of time away from his new command. Military authorities detached him for a variety of duties, including recruiting, hunting for deserters, and serving on a board of courts martial. He tendered his resignation in February 1865. Gen. Robert E. Lee refused to accept it, and he remained in the army for two more months.[9]

After the war, Hoffman returned to Baltimore and entered the coal business, opening his own firm in 1875. Among his other business interests was the Seaboard Air Line Railroad, and in 1877, a stop along a new rail line in Western Maryland was named for him. It attracted a small population, and the following year the fledgling community established a post office. Hoffman, Maryland, later became an incorporated town. In 1893, he assumed the presidency of the railroad company. During his two-year tenure in that post, he successfully fought a hostile takeover attempted by J. P. Morgan and a group of New York businessmen.

In 1880, at age forty-one, Hoffman married and started a family that grew to include six children. He belonged to several social clubs and Confederate veterans' groups. He lived until the age of eighty-six, dying in 1926.[10]

He Defended His Hometown

SECOND LIEUTENANT PETER McENERY JR. WAS AN ANOMaly in the Twelfth Virginia Infantry. He was a factory manager in Petersburg before the war, and men of his occupation rarely became officers. The class-conscious men in the regiment frowned upon the workers he supervised in civilian life as belonging to "a distinct and definitely lower social class," according to a regimental historian.[11]

McEnery, the eldest of four children raised by Peter Sr., an immigrant from Limerick, Ireland, and his Virginia-born wife, Dorothy, grew up in Petersburg.[12] The elder McEnery prospered as a slaveholding tobacco merchant with clients in the North and Great Britain. He conducted his business from a large factory, and Peter Jr. ran its daily operations. The young man also served as a first sergeant in the Petersburg City Guard, a militia company noted for being part of the security detail present at the hanging of John Brown in 1859.[13]

Soon after the start of the war, McEnery's militia company elected him second lieutenant and merged into the Confederate army as part of the Twelfth Virginia Infantry. One year later, in May 1862, the company's term of enlistment expired. It reorganized and held elections for officers. Two documents in his military service file record the result: One notes that the rank and file failed to reelect him, and another states that he was "thrown out" of the regiment. The reason why is unknown.

McEnery reentered the military in 1864 as a private in Capt. Edward Graham's Virginia Horse Artillery. Its best-known action occurred in defense of Petersburg on June 9, 1864: Graham's gunners, part of a hastily organized force of about 2,500 men, drove back a superior force of Yankee invaders. In a con-

gratulatory order, the general in charge, the acerbic Henry Wise, stated, "With such troops as all have proven themselves, commanders may well give assurance with confidence to the people of Petersburg."[14] The city held out against the enemy until April 1865.

McEnery's whereabouts after the war are sketchy. The 1880 census lists him as a Petersburg policeman, unmarried, and living in a boarding house. He was in his early forties.[15]

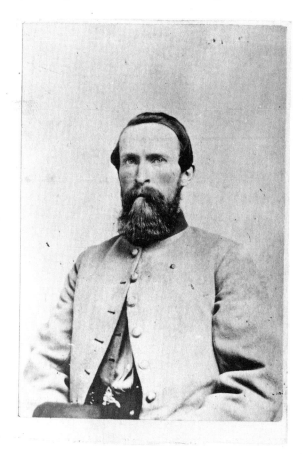

Pvt. Peter A. McEnery Jr., Capt. Edward Graham's Company, Virginia Horse Artillery

Carte de visite by Stanton (life dates unknown) & Butler (life dates unknown) of Baltimore, Maryland, about 1865. William A. Turner collection.

Custer's Roommate

EARLY IN THE MORNING OF JULY 20, 1861, BREVET 2ND Lt. Jim Parker of the Fourth U.S. Infantry lay asleep in bed when his West Point pal and former roommate George Armstrong Custer showed up unannounced at his rented room in the Ebbitt House in Washington, D.C.[16] Custer recalled years later that he anxiously asked Parker for the latest news from Virginia, where two opposing armies were converging on nearby Manassas Junction and all expected an engagement at any hour (the First Battle of Manassas occurred the following day). Custer then inquired about Kentucky-born Parker's plans, though he might have already guessed the answer. Parker pointed to a document lying upon a table near his bed and Custer read it, an official order from the U.S. War Department dismissing Parker from the army "for having tendered his resignation in the face of the enemy."[17]

After spending the next hour discussing the war, Custer remembered, "I bade a fond farewell to my former friend and classmate, with whom I had lived on terms of closer intimacy and companionship than with any other being. We had eaten day by day at the same table, had struggled together in the effort to master the same problems of study; we had marched by each other's side year after year, elbow to elbow, when engaged in the duties of drill, parade, etc., and had shared our blankets with each other when learning the requirements of camp life. Henceforth this was all to be thrust from our memory as far as possible, and our paths and aims in life were to run counter to each other in the future."[18]

Their friendship might have seemed unlikely: One historian describes Parker as "a stout, slow-moving, rugged young man, al-

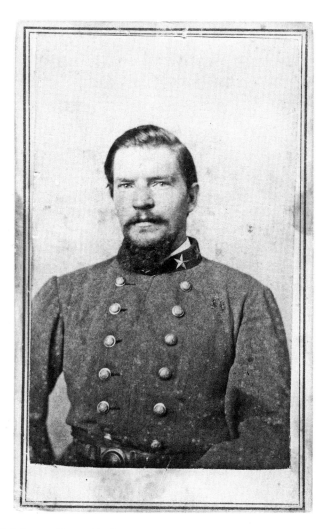

Lt. Col. James Porter Parker, First Mississippi Light Artillery
Carte de visite by unidentified photographer, about 1865. John Sickles collection.

most the physical opposite of Custer."[19] However, the two young men had hit it off when they met at West Point in 1857. Both belonged to Company D, a generally rowdy group mostly from the South and West. According to one cadet, the pair "fooled away many an hour that should have been devoted to study."[20]

They ranked at the bottom of their class in grades and racked up demerits by the score. School officials dismissed Parker in June 1861 for exceeding the limit of demerits, and he did not graduate with Custer and the rest of his class.[21] Despite his deficiency in conduct, the Union army offered him a commission as a brevet second lieutenant. He accepted it, and reported to Washington for orders. But he could not bring himself to fight against his home state, and he had resigned shortly before Custer's surprise visit.

Custer, the dashing and flamboyant cavalryman, fought his way to major general. The solid and slow-moving Parker received a lieutenant colonel's commission in the Confederate army and joined the First Mississippi Light Artillery. Dispatched to Vicksburg in May 1862, Parker and his cannoneers defended that key Confederate bastion against advancing Union ironclad warships and gunboats. By July, the Union vessels had backed off. Local commanders commended Parker for his assistance. Later that year, he moved to Port Hudson, Louisiana, took charge of several batteries, and assisted in the defense of the town during the forty-eight-day siege that ended with the surrender of the garrison on July 8, 1863, four days after the fall of Vicksburg.[22] Parker spent the next two years in Northern prisons. He gained his release after signing the oath of allegiance in July 1865.

After the war, he made his way to the silver-mining boomtown of Kingston in the New Mexico Territory.[23] He remained there after the great ore deposits were played out and worked as a surveyor. He died in 1918 at about age seventy-nine, outliving Custer by more than forty years. He never married.

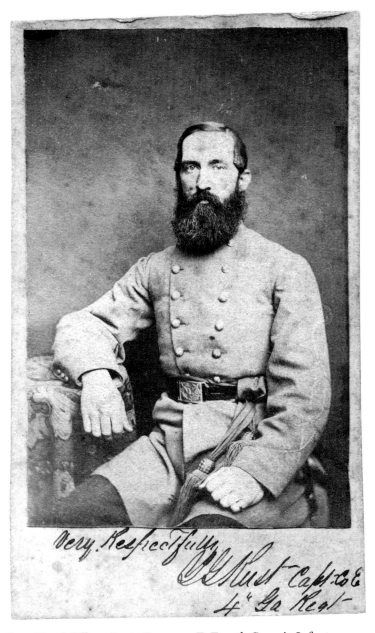

Capt. Youel Gilbert Rust, Company E, Fourth Georgia Infantry

Carte de visite by unidentified photographer, 1861–1862. David Wynn Vaughan collection.

From Former Mayor to Infantry Officer

ON THURSDAY, NOVEMBER 7, 1861, AT CAMP JACKSON IN the Confederate capital, Company E of the Fourth Georgia Infantry assembled for another day of drilling. Capt. Youel Rust announced to his men that much needed supplies had been received from their home county's Ladies' Relief Society. The list included hickory shirts, mattresses, underwear, leggings, socks, blankets, and other comforts. His soldiers must have been delighted. They had departed for Virginia six months earlier, having "left hastily for the scenes of war, carrying with them only such clothing as the necessity of the moment required."[24]

The arrival of the Fourth in Virginia was a homecoming of sorts for Richmond-born Rust. His Scottish first name and English surname honor his heritage. About 1844, in his early twenties, he had left for Georgia and settled in Albany. He married the following year and became active in local government. After the town received its charter in 1853, he became its first mayor and later served as an alderman. By 1861 he had established a reputation as an efficient public servant and a refined gentleman of marked intelligence.[25]

Rust's leadership abilities made him an obvious choice as an officer in the county militia, the Albany Guards. It formed in 1857, soon after the organization of Dougherty County, a rich agricultural area with a large slave population in the southwestern region of the state. It became Company E of the Fourth Infantry after the war began and was among the first Georgia units dispatched to Virginia.

His tenure as company commander lasted one year. Rust resigned after the regiment's enlistment expired in 1862. The Fourth reorganized and went on to fight with the Army of North-

ern Virginia from the Seven Days Battles to Appomattox Court House. According to one historian, Rust's early leadership "did much to bring the regiment to that state of discipline for which it was always celebrated."[26]

After leaving the army, Rust returned to Albany and was welcomed home by his wife, two sons, and two daughters. He worked for many years as a bank cashier and later rose to president of a savings and loan association. He served two stints as town postmaster and played an active role in other local institutions. At his death in 1901 at age seventy-eight, he ranked as the oldest male resident of Albany. Townfolk remembered him as a gallant Confederate soldier who led a long, useful life.[27]

"One of the Most Dangerous Men in Arkansas"

A CONTINGENT OF TEXAS HORSE SOLDIERS, GRIMY, DUST covered, and heavily armed, arrived at Des Arc, Arkansas, in early 1862. "Riding far in advance on a magnificent chestnut sorrel, known to his proud owner as *Limber Jim*, and leaning forward in an huge saddle that almost obscured its occupant, sat an innocent looking man of barely twenty-one years," noted one writer. "His long tawny hair, which hung far below his shoulders, was crowned with a sombrero of unusual proportions, the brim, adorned with small bells that jingled with each motion of the horse's gait. Securely fastened about the crown [of his bridle], as though with a garland of withered ivy, glistened the scales of a Texas rattler."[28]

The young man was Howell Rayburn. Friends knew him by a nickname attributed to a childhood disease: "Yellow Doc," or simply "Doc."[29] His enemies called him "Banditti" or "Bandit." A biographer pronounced him "one of the most dangerous men in Arkansas."[30] One physical feature conveyed his deadly nature perhaps better than any other: "His blue eyes seemed at times to have lost every vestige of tenderness, compassion and mercy, especially for those who differed with his views." It may have been this dark side of his character that contributed to one historian's statement that "he was often accused of committing depredations on friends as well as foes."[31]

Doc grew up in a farming family of nomadic habits. He lived in four states during his first ten years: from his birthplace in Tennessee, the Rayburns moved to Georgia, then Alabama before settling in Texas about 1849. He appears to have been orphaned before 1860.[32] The following year, he and his younger brother Milton enlisted as privates in a company that joined the

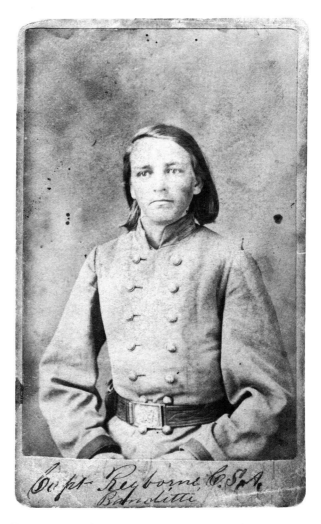

Howell A. Rayburn, Independent Guerrilla Command

Carte de visite by unidentified photographer, about 1864–1866. Lawrence T. Jones III collection.

Twelfth Texas Cavalry. Milton later deserted.[33] Doc also left the regiment—but not by choice.

After arriving at Des Arc, he fell ill with tuberculosis. A local woman nursed him back to health. His recovery took almost a year. During that time, while the Twelfth campaigned in that

part of Arkansas, between the White and Mississippi rivers, Union forces moved into the area, trapping him behind enemy lines.[34] Doc determined to fight on, and he raised a cavalry company. His activities attracted the attention of Confederate colonel Thomas H. McCray, who took an interest in the young man and used his influence to help. Union intelligence reported that the company became McCray's bodyguard.[35] Doc's recruits were adventurous boys whom he had befriended in Des Arc. He inspired about fifty to enlist, and he became their captain. Together, they rode on a string of lightning-quick raids against Yankee wagon trains in central Arkansas. His command became known as the "Phantom Unit" for its ability to appear out of nowhere and pounce on unsuspecting federals. On occasion, Doc took advantage of his long hair and girlish looks to dress as a woman so he could enter and spy on enemy camps.[36] Union high command tried to capture Doc Rayburn and his guerrillas, but their efforts failed.[37] At some point he sat for his *carte de visite* portrait (his name is misspelled "Reyborne" on the *carte*).

Doc survived the war but did not live long afterwards. Accounts of his death vary. One source notes that "after peace had been declared one of the Confederate soldiers, who hated Rayburn, slipped back and shot him one evening just at sun down. He lived about twenty minutes after he was shot." According to another source, U.S. authorities imprisoned him for wartime guerrilla activities, and his tuberculosis returned. Friends obtained his release on the basis that he would not live long. He died in 1865 and received a burial in the vicinity of Des Arc. The exact location of his gravesite is unknown. A simple headboard that soon decayed may have marked his final resting place. His wife, Martha Ann, whom he married in the summer of 1865, survived him. His horse, Limber Jim, was sold at a government auction and died of disease soon after.[38]

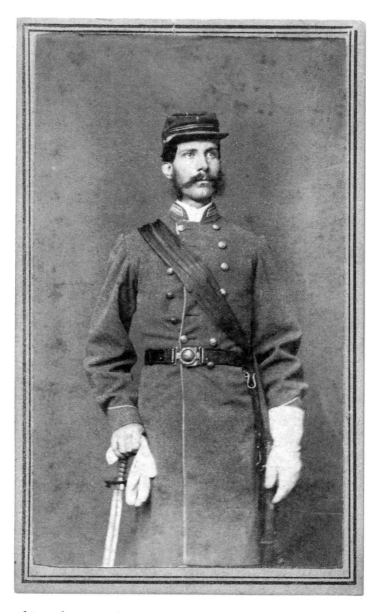

2nd Lt. John McKinley Gibson, Company A, Thirteenth Louisiana Infantry

Carte de visite by W. J. Carpenter (life dates unknown) & James Mullen (life dates unknown) of Lexington, Kentucky, about 1864–1865. David Wynn Vaughan collection.

Running the Blockade

"I HAVE GOOD CAUSE TO BE THANKFUL TO GOD," WROTE prosperous plantation owner Tobias Gibson to a friend in April 1862, "for the safety of my youngest son McKinley who after an absence of ten years, in his eagerness to serve his native land ran the blockade on his return from Europe and arrived at a Southern Port a few days ago."[39] After landing in America, the young man visited his family and prepared for war.

McKinley was born in 1840, the hundredth anniversary of the birth of his great-grandfather and namesake, a Revolutionary War captain killed by Indians in 1782.[40] Affectionately called "Kin" or "Kinny," he grew up in a family possessed of tremendous wealth accumulated by his father, an energetic businessman who worked his way from merchant to owner of a sugar and cotton empire in Louisiana's Mississippi Valley.[41] The crown jewel of the elder Gibson's domain, a sprawling estate called Live Oak, took its name from a venerable tree that dominated the landscape in front of the main house.[42] Seventy-five slaves tended the crops there.[43]

Kinny spent a decade away from home gaining an education and life experiences. His parents sent him to Massachusetts to attend boarding school.[44] His brother Claude, then a student at Yale, feared a character flaw might doom Kinny's academic career. "He is not himself aspiring in nature—he has not that time standard of bold & decisive character which will enable him to swim above the 'waves of commonality.'"[45] However, Kinny managed to make it through school and attended the University of Jena in Saxony.[46] In August 1861, he mused in his journal[47] about growing old, noting that half of his life was gone. He could not have known the truth of his fatalistic comment.

After his return to America, he joined the Thirteenth Louisiana Infantry and served in Company A as a junior second lieutenant. Plagued by chronic consumption, he took several sick leaves. His military career took off in 1864. In January, he received an appointment as acting aide-de-camp of Gibson's Brigade, a force commanded by his eldest brother, Brig. Gen. Randall Gibson. In April, the men of Company A elected him second lieutenant. In June, his brigadier brother commended him for "zealous gallantry" during the Atlanta Campaign battles of Resaca and New Hope Church.[48] With others from the brigade, Kinny surrendered at Meridian, Mississippi, in May 1865.[49]

After the war, McKinley Gibson struggled with the rest of his family to make ends meet. For a time in the 1870s, he joined his brother Randall as a partner in the law firm of Gibson & Gibson in New Orleans. He moved to Lexington, Kentucky, about 1879. He died there of consumption the following year at age thirty-nine, proving his 1861 journal entry to be eerily accurate.[50]

Fidelity, Intelligence, Promptness, and Energy

AT SHILOH, TENNESSEE, ON APRIL 6, 1862, BULLETS buzzed about the men of the Thirteenth Louisiana Infantry as they struggled through an almost impenetrable oak thicket that came to be known as the "Hornet's Nest." The Louisianans advanced toward enemy defenses scratched out of the tangled woods. "Four times the position was charged and four times the assault proved unavailing," wrote the regiment's commander, Col. Randall Gibson. "We were repulsed. Our men, however, bore their repulse with steadiness."[51] Casualties were many and included Capt. Walter Crouch, who suffered a slight wound to his forehead.

A native of Richmond, Virginia, Crouch had moved to Louisiana before the war and worked as a clerk in New Orleans. He entered the army as a member of the "Gladden Rifles," and the volunteers of the company elected him second lieutenant in August 1861. The outfit became part of the Thirteenth Infantry when the regiment formed later that summer. Crouch earned a promotion to captain by the end of the year and also served as assistant commissary of subsistence on the staff of Col. Gibson. The Thirteenth's assault on the Hornet's Nest at Shiloh was its first major engagement. A larger force of Confederate infantry and artillery later drove the Yankee defenders away.

Crouch spent the rest of the war as commissary and trusted staff officer to Gibson, who advanced to brigadier and command of a brigade that bore his name. Crouch's good work earned him a promotion to major and words of praise in four of Gibson's official reports. The brigadier complimented the major for his fidelity, intelligence, promptness, and energy during campaigns in Georgia, Tennessee, and Alabama.[52] The war ended for Crouch

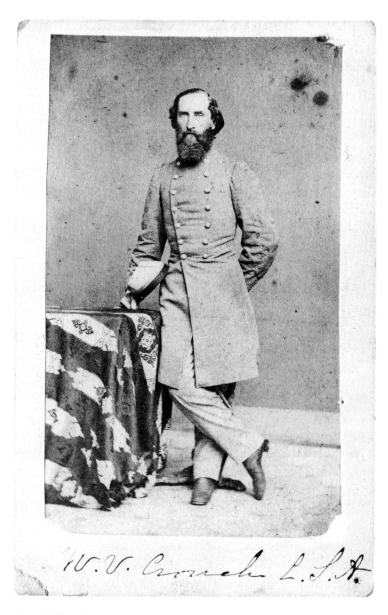

Maj. Walter Virginius Crouch, Confederate States Army

Carte de visite by unidentified photographer, about 1865. William A. Turner collection.

in May 1865, after Lt. Gen. Richard Taylor surrendered all Confederate forces in his military department.

Crouch returned to New Orleans, where he resided for the rest of his life. He spent the majority of his working days employed by the New Orleans and Carrollton Railroad as a clerk, and later became secretary and treasurer. He outlived two wives: Annie Green, the mother of his first daughter, died in 1874. Three years later, at age fifty-five, he married Mary Haughton. Twenty-four years his junior, she bore him a son and two more daughters. Mary died in 1899. Crouch arranged for her to be buried in the same plot that held the remains of his first wife, located in Lafayette Cemetery in New Orleans. He joined his wives three years later, dying in 1902 at age eighty.

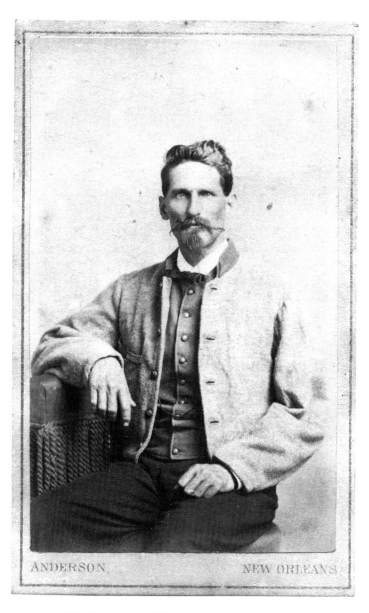

Corp. John Winfield Scott, Fifth Company, Washington Artillery (Louisiana)

Carte de visite by Samuel Anderson (b. 1825) & Augustus Austin Turner (1831–1866) of New Orleans, Louisiana, about 1864–1866. William A. Turner collection.

Gallant Behavior at Shiloh

Pvt. J. Winfield Scott and his comrades in the Fifth Company of the Washington Artillery Battalion of Louisiana formed their battery along the main avenue of a Union camp as battle raged in the fields and woods surrounding Shiloh Church, Tennessee, on Sunday, April 6, 1862. The artillerymen opened fire from a distance of about fifty yards, with four canister-charged guns, into the tents of enemy soldiers belonging to the command of Brig. Gen. William T. Sherman. Scott's captain noted, "It was at this point I suffered most. The skirmishers of the enemy, lying in their tents only a stone's throw from us, cut holes through their tents near the ground, and . . . played a deadly fire in among my cannoneers." The gray gunners continued firing and watched as the Yankees crawled from their tents and headed for nearby woods. About this time Confederate infantry arrived and charged "the whole of them in ambush and put them to flight."[53]

Shiloh was the first major engagement in which Scott fought. He had joined the Fifth Company exactly one month earlier in New Orleans, where he worked as a merchant.[54] Within days of his enlistment, the company received orders to leave for duty at Corinth, Mississippi, his birth state. Less than a week after the artillerymen arrived, the great battle at nearby Shiloh began and the Louisianans were ordered in. Scott's company fired 723 rounds from their cannons in two days of fighting. Many were fired on the first day, during which the gunners blasted away at three of five enemy camps as the Confederate attackers rode roughshod over their surprised Union foes. The company captain wrote in his official report: "The badly-torn wheels and carriages of my battery from Minie balls will convince any one

of the close proximity to the enemy in which we were." He also complimented Scott, who emerged from the battle unharmed, and other men from the rank and file for their gallant behavior.[55]

The Washington Artillery went on to further distinguish itself in numerous battles and campaigns with the Army of Tennessee over the next three years, and Scott participated in many of them. In 1864, the year he earned a promotion to corporal, he suffered two battle wounds: On June 22 at Kolb's Farm during the Atlanta Campaign, and on December 7 at Overall Creek in Tennessee. He recovered from both injuries—the nature of each went unrecorded—in good time and promptly rejoined his company. He left the army with a parole on May 10, 1865, after the Washington Artillery and all other units in its military department were surrendered.[56]

Scott moved to Mississippi after the war. In 1899, at about age seventy-two, his name last appeared on record, as a resident of Grand Lake, Arkansas.[57]

He Remained Loyal to the Confederacy

A SQUAD OF YANKEES MANNING A SINGLE CANNON FIRED on the Confederate steamer *Daniel E. Miller* as it chugged away from a landing on the St. Francis River along the border of Arkansas and Missouri in May 1862. One ball tore into the boat just below the waterline and a second crashed into the wheelhouse, bringing it to a stop. One officer onboard died in the action. The federal troops captured thirty men, including a former general's son, 2nd Lt. Washington Watkins.[58]

Days later, an old Watkins family friend who remained loyal to the U.S. government fired off a letter to the Unionist governor of Missouri seeking the young man's release. The friend explained that Watkins might not have intended to join the Confederates. "He was young, his father a Brigadier General taking the field, neither, at the time, intending rebellion against the government; and both would have probably surrendered before this, had they understood the terms upon which they might have been released."[59]

The old friend's letter spoke accurately of the general. Watkins's father, Nathaniel, a half brother of the late Kentucky senator Henry Clay and a prominent lawyer, state legislator, and slave owner, became a brigadier in the Missouri State Guard in May 1861; he resigned two months later, disillusioned with the guard's pro-Southern role in state affairs.[60] His four military-aged sons made their own decisions about the war: One left the state guard soon after his father, another did not fight, and two others, including young Watkins, cast their lot with the Confederacy.[61]

Washington Watkins, like his father, began his service in the state guard. He started as a second lieutenant in a cavalry

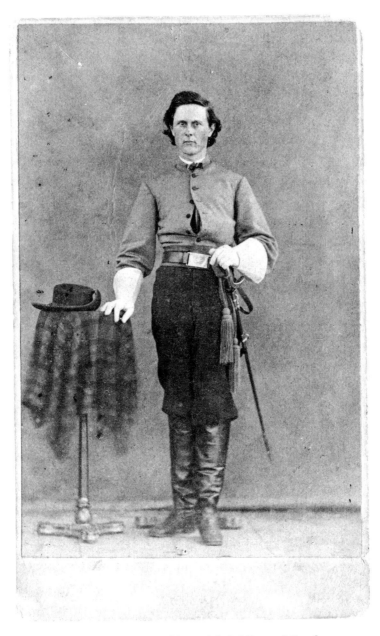

1st Lt. Washington Lewis Watkins, Eighth Missouri Cavalry

Carte de visite by unidentified photographer, about 1861–1865. William A. Turner collection.

regiment, then left in January 1862 for the Confederate army. The old family friend who intervened after his capture believed Watkins would abandon the South and pledge his loyalty to the stars and stripes if the governor granted the young officer clemency. He was wrong. Watkins remained steadfast. He spent the next five months in prison in Alton, Illinois. After his release, he joined the Eighth Missouri Cavalry as first lieutenant and acting adjutant.

In 1863, he became a prisoner of war again. On November 22, a Union officer nabbed him as he left a Missouri farmhouse where he had gone some time earlier to recuperate from an illness.[62] He spent the next four months in prison in St. Louis and Camp Chase, Ohio. In March 1864, his captors transferred him to Fort Delaware, where he remained until May 1865. He gained his release after signing the oath of allegiance to the United States.

He returned to Missouri and settled in the village of Morley, located near the family's estate, Beechwood, and died in 1879 at about age forty. He barely survived his father and the old family friend who had lobbied for his release from prison. Watkins never married.

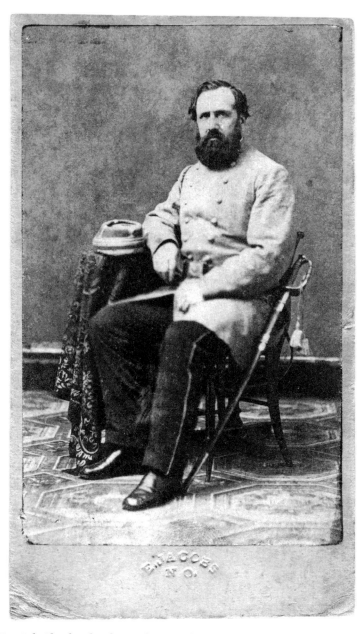

Lt. Col. Charles de Choiseul, Seventh Louisiana Infantry

Carte de visite by Edward Jacobs (1813–1892) of New Orleans, Louisiana, about 1861–1862. William A. Turner collection.

Struck Down on Virginia's "Sacré" Soil

NEAR THE VILLAGE OF PORT REPUBLIC IN VIRGINIA'S Shenandoah Valley, at a place where the gentle waters of the south fork of the Shenandoah River flow alongside a broad plain planted with wheat, Union troops advanced toward a thin line of Confederate infantrymen on the morning of June 9, 1862. Col. Harry Hays, who was commanding his Seventh Louisiana Infantry and two Virginia regiments from the highly respected Stonewall Brigade, realized that his men were in a no-win situation. He ordered a surprise charge in an attempt to throw the enemy off balance. With a yell, his men dashed across the wheat field. All hell broke loose as the opposing battle lines collided and men rallied around their flags amidst a raging fire of muskets and cannon.[63] One bullet struck Hays and took him out of action. Another ball ripped into the chest of his lieutenant colonel, Charles de Choiseul, who "was shot through the lungs, and after again and again endeavoring to hold his place on the field, was borne off almost insensible," according to one account.[64]

The French-born scion of an aristocratic family, de Choiseul grew up in Charleston, South Carolina, where his father, the Count de Choiseul, served his native land as consul for many years before the war.[65] In the 1830s, the count built a home in the western North Carolina hamlet of Flat Rock, which became known as "Little Charleston" after an influx of society families established residences there to avoid the summer heat of the South Carolina coast. In 1840, at about age twenty, young Charles became a naturalized citizen of the United States. The following year he received an appointment as surveyor for Henderson County, which includes Flat Rock.[66]

By 1850 Charles had relocated to New Orleans, where he be-

came an attorney and joined the state militia. In 1857 he was a colonel and commanded a regiment. January 1861 began perhaps the pinnacle year of his militia career: Early that month, he issued ammunition to volunteers, who proceeded to capture the U.S. arsenal in Baton Rouge.[67] At the end of the month, when the state seceded from the Union, he climbed to the top of the New Orleans city hall and raised Louisiana's pelican flag. Wild cheers and a twenty-gun salute followed this act.[68]

His banner year continuing, in May de Choiseul became lieutenant colonel of the Seventh Infantry and traveled to Virginia with his regiment. In July, Brig. Gen. P. G. T. Beauregard commended him for his actions in the victory at Blackburn's Ford during the First Manassas Campaign.[69] In October, he briefly commanded "Wheat's Battalion," better known as "Wheat's Tigers," after its major suffered a wound.[70]

"I have made up my mind to leave my bones on the 'sacré' soil of Virginia," he wrote with patriotic sentiment to a lady friend in January 1862, including a word in his native French.[71] Five months later came the fateful battle at Port Republic. Though Union troops forced his regiment back with great loss, the rest of the brigade went on to turn the tide of battle in their favor. Col. Hays survived his wounds, but the gun blast that tore through de Choiseul's lungs proved fatal. He succumbed to his wound ten days later at about age forty-two. His bones were not left in Virginia, but were sent to his two sisters in Flat Rock for burial in the cemetery of St. John in the Wilderness Episcopal Church.[72]

"A Tried and True Soldier of the South"

DAVID BOGGS WAS ONE OF TWELVE CHILDREN BORN TO a mother who hailed from North Carolina and a father born in Virginia. In the second spring of the war, he left the farm in Fayette, Missouri, which the family worked with the help of twenty-some slaves, to join the army.[73] He traveled with his horse to Des Arc, Arkansas, and enlisted in the "Western Rangers," which became Company C of the Second Missouri Cavalry, a regiment commanded by the McCullough cousins, "Black Bob" and "Red Bob." When the twenty-eight-year-old Boggs donned the uniform of a Confederate cavalryman, he likely expected rough riding and hard fighting, and he got plenty of both. He also served stints as part of an escort detail and bodyguard to three generals, a duty he probably did not anticipate.

Over the next three years, Boggs earned a reputation as "a tried and true soldier of the South" while participating in campaigns and engagements in Arkansas, Alabama, Mississippi, and Tennessee.[74] During much of the war, he and his regiment were part of Lt. Gen. Nathan Bedford Forrest's cavalry.[75]

Boggs's company on three separate occasions was detailed to protect West Point–educated generals. It acted as the bodyguard for Mexican War veteran Earl Van Dorn in 1862. The following year it served as escort to former Missouri State Guardsman John Bowen and peacetime West Point infantry tactics instructor John Forney.[76] Two of the generals did not live to see the end of 1863, but neither was killed by the enemy: a jealous husband shot Van Dorn in the back, and Bowen succumbed to disease contracted during the Siege of Vicksburg.

Boggs survived the war and returned to his family farm in Missouri. He never married. At some point he became blind,

and in 1897 he entered the Confederate Home of Missouri in Higginsville, where he resided for twenty-five years. He died in 1922 at age eighty-seven and is buried in the cemetery at the home. "May his sleep be the slumber of a faithful soldier is the wish of his old comrades," wrote a friend and fellow veteran in his obituary.[77]

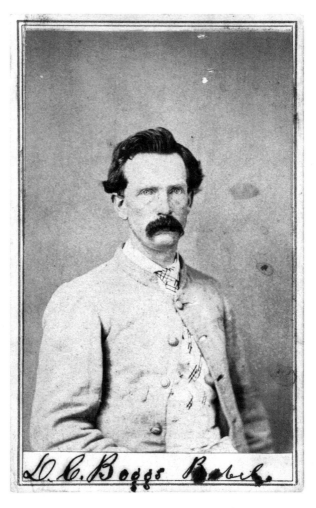

Pvt. David Crockett Boggs, Company C, Second Missouri Cavalry

Carte de visite by Bingham's (life dates unknown) Gallery of Memphis, Tennessee, May 1865. John Sickles collection.

A "Southron" at Savage's Station

Pvt. Abram Beach Reading and his company, the "Volunteer Southrons," formed for battle with the rest of the Twenty-first Mississippi Infantry and another regiment of foot soldiers, the Seventeenth Mississippi, near Savage's Station, Virginia, on June 29, 1862. About sundown the men "advanced gallantly and promptly when the order was given," recalled Col. William Barksdale, the Twenty-first's brigade commander, and moved forward "under a severe fire across an open field to the support of a battery and engaged the enemy, then strongly posted in the woods beyond the field, and poured several destructive volleys into his ranks."[78] A Mississippi private recalled: "In this fight, which lasted but comparatively a short while, . . . the 'Southrons' lost two of their best men, Beach Reading and Frank Hume,[79] and the first casualties they had suffered since entering the service. I saw them just before they were put into the ambulance to go to Richmond, and by a strange coincidence, each was wounded in the same way, in the bowels, Frank on the right, and Beach on the left side."[80]

The loss of nineteen-year-old Reading deprived the regiment of a fine soldier—and one of its best educated. In 1859, he had moved to New Jersey and started college at Princeton. He joined the American Whig Society, one of two rival fraternal organizations on campus. He would have graduated in 1863, but the war interrupted his sophomore year.[81] When he returned to his hometown, Vicksburg, he joined the "Southrons."

Other members of his family also joined the war effort. His uncle and namesake, a wealthy plantation owner and businessman, converted his iron foundry from gauge, saw, pipe and boiler production to the manufacture of bronze cannon. Beach's father was a partner in the company.[82]

33

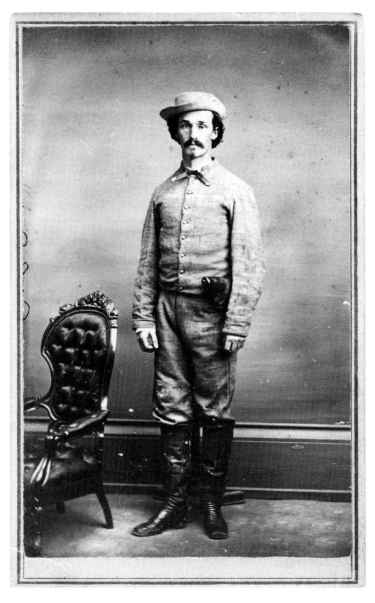

Pvt. Abram Beach Reading, Company A, Twenty-first Mississippi
Infantry

Carte de visite by Henry J. Herrick (life dates unknown) & A. J. Dirr (life dates
unknown) of Vicksburg, Mississippi, about 1861–1862. David Wynn Vaughan
collection.

By the time big guns began rolling out of the family foundry in late 1861, Beach and the Twenty-first had been stationed in Virginia for months. In the spring of 1862, the regiment mobilized with other Confederate forces to halt the Union army's Peninsular Campaign, a full-scale invasion planned to capture Richmond. The engagement at Savage's Station was his first and last fight. The bowel wound he suffered proved mortal; he succumbed to his injury on the Fourth of July, five days after the battle.[83] The soldier with whom he shared the ambulance ride to Richmond, Pvt. Frank Hume, died eight days later.[84]

Beach's name appears on a plaque in stately Nassau Hall at Princeton; it commemorates students who lost their lives during the war, regardless of the side for which they fought.

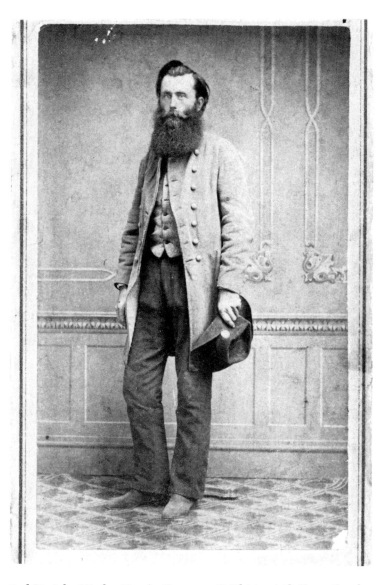

2nd Lt. John Wesley Harris, Company B, Thirty-sixth Texas Cavalry
Carte de visite by unidentified photographer, December 1866. Martin Callahan
collection.

Fighting for Texas

ON JULY 4, 1862, THE TEXAS CAVALRYMEN BELONGING TO Capt. Nat Benton's Company voted for a new lieutenant; they elected the captain's nephew, J. Wes Harris, a Tennessee-born farmer who had enlisted as sergeant.[85] Harris and his uncle had fought together before; in 1855, they had joined in an invasion into Mexico known as Callahan's Expedition. James Callahan, a Texas freedom fighter with vehement anti-Mexican sentiments, organized a force of about 130 men to punish Indian raiders. Callahan, however, had a hidden agenda: an invasion of northern Mexico to retaliate against authorities who refused offers to negotiate the return of runaway slaves. The commander attempted to keep his plan secret from his recruits, including twenty-one-year-old Harris.[86]

Harris may have enlisted simply to seek adventure. His father, who had fought along the Texas frontier in the 1830s, may have inspired him;[87] or he may have fallen under the influence of Callahan, a military and civic leader in Harris's home county of Guadalupe. Whatever the reason, he joined a company led by his Uncle Nat and crossed the border. On October 3, 1855, in the expedition's key action, the Texans skirmished with Mexican troops. Uncle Nat suffered a wound, and his son—Harris's cousin Eustis Benton—fell from his horse into a ravine after a shot struck him in the head and knocked him off his mount. Harris and two others volunteered to go back and rescue Eustis. "It was a perilous undertaking," noted one writer, "for the bullets were flying thick and the wounded boy lay in open ground. The three men made the run for the ravine on foot, and seizing young Benton bore him quickly back while the bullets kicked up the dust all around them."[88] Callahan and his men retreated and withdrew from Mexico.

Harris had participated in an invasion of a sovereign nation in the name of Texas, and he fought again for his adopted state during the Civil War. The cavalry outfit organized by his Uncle Nat became Company B of the Thirty-second Texas Cavalry regiment. Later redesignated the Thirty-sixth, the regiment patrolled ports and trade routes, kept Union sympathizers in check, and guarded against enemy invasion for about two years. In 1864, it left for Louisiana to join the Red River Campaign and fought a series of running skirmishes and battles against retreating federals. It then returned to Texas for the rest of the war.

Harris signed the oath of allegiance to the U.S. government in August 1865 and resumed his livelihood as a farmer and stock raiser. His prominent beard appeared to be a source of good-natured ribbing in the community. "Tradition says he once had it clipped, but it is doubtful that he did," quipped a local newspaper.[89] His life as a husband and father began tragically: "I have raised two families. All of the first one are now sleeping in the shade of their Mother Earth," he noted, referring to four daughters who died in childhood and the wife he divorced in 1879. He later wed a widow and mother of five girls. In 1917 he wrote: "I have lived to see them all grown and married, and all are living except one. My second marriage was blessed with a son. Now, in the evening of my life, I am enjoying the smiles of my only grandson."[90]

Harris lived five more years, dying at age eighty-eight of "general debility" in 1922.[91] His obituary noted that he was "held in high esteem by all who knew him."[92]

"Eager for the Fray"

BEFORE DAWN ON JULY 13, 1862, ABOUT 1,400 REBEL horsemen led by Brig. Gen. Nathan Bedford Forrest raided Murfreesboro, Tennessee, and launched a surprise attack on its unsuspecting 934-man federal garrison. At one point during the ensuing fight, Forrest rode up to one of his subordinates, Maj. Baxter Smith, and asked him if his Tennesseans could capture part of a hastily formed Union line held by the Third Minnesota Infantry, who were supported by four cannon. The major turned to his troopers. He looked upon the face of his nineteen-year-old aide, 1st Lt. James Trimble "Trim" Brown, and saw a young man "eager for the fray." His expression, and those of the other men, inspired the major to answer in the affirmative. The Tennessee cavalrymen promptly charged and took the position.[93] Forrest's force later captured the entire garrison and a vast quantity of supplies. Maj. Smith said of Trim, "No one on that memorable day bore himself more gallantly or acted his part better."[94]

Those who knew Trim would have expected nothing less, for he hailed from a family of leaders. Neill Brown, his father, served as governor of Tennessee during the Mexican War. His uncle, John C. Brown, became a Confederate general. Trim grew up the eldest of eight brothers and sisters in Pulaski. After being "carefully educated" by his parents, he taught in a Nashville public school. He joined the army when the war began and served in the infantry, artillery, and cavalry.[95]

Trim started as an artillery lieutenant.[96] In 1862, he learned that Forrest had received permission to organize a cavalry brigade to operate in middle Tennessee, which included Brown's home in Union-occupied Nashville. He sought out Maj. Baxter Smith and asked to join his staff. Smith agreed, he later said,

"because of my knowledge and admiration for his father and the family."[97] In September 1862, about two months after the great raid on Murfreesboro, Trim's Uncle John, an infantry brigadier in the Army of Tennessee, nominated him as one of his aides-de-camp. Trim joined his uncle and served with distinction in the 1863 battles of Chickamauga, Lookout Mountain, and Missionary Ridge.[98] The following year he left the staff as a captain, a promotion never confirmed by the government, and returned to the cavalry as an assistant adjutant general in the Army of

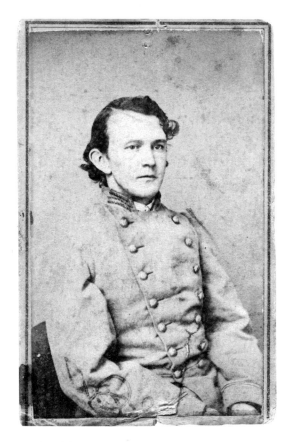

1st Lt. James Trimble Brown, Confederate States Army

Carte de visite by Frederick Newton Hughes (life dates unknown) & Thomas F. Saltsman (life dates unknown) of Nashville, Tennessee, about 1865–1866. Author's collection.

Tennessee, where he remained until the surrender of the army in North Carolina in April 1865.

Brown returned to Nashville, married, and started a family, which grew to include two sons and a daughter. He became an attorney and, driven by a burning ambition tempered by a modest, affable nature, established a reputation as one of the most promising young members of the city's bar. He became a candidate for district attorney general in 1878. On May 31, during the campaign, he participated in Decoration Day ceremonies honoring Union war dead. He became overheated during the festivities and afterwards stopped at a restaurant for a cup of tea, complaining of feeling poorly. His condition worsened, and someone on the scene sent for Trim's brother-in-law, a physician. Concerned citizens carried the ailing young man to the doctor's residence. By this time he had lapsed into unconsciousness, and he remained in that state until his death at 12:30 a.m. the next morning. He was thirty-six.

Some blamed his death on the stress he suffered in having to honor his former foes. Grief-stricken lawyers met and spoke of his untimely passing and praised a life cut tragically short. One attorney compared Brown to former Nashville-area resident and U.S. president Andrew Jackson: "In war he exhibited the heroism of a soldier. He possessed as high an order of courage as ever characterized the Hero of the Hermitage, and was as knightly and heroic in his bearing." A formal statement issued by the bar declared, "His life was brief, beautiful and brilliant."[99]

"Few funerals that were as largely reported have ever occurred in Nashville," recounted the local newspaper. A lengthy procession included the local militia to which Trim had belonged, with two large guns, suitably draped for the sad occasion, and a hearse trimmed with black plumes and drawn by four white horses. Trim's riderless horse followed, "in trappings of mourning, the helmet formerly worn by Lieut. Brown resting upon the horn of the saddle." After the memorial service, the procession moved to Mt. Olivet Cemetery for the interment of his remains. Artillerymen fired a six-gun salute after the burial.[100]

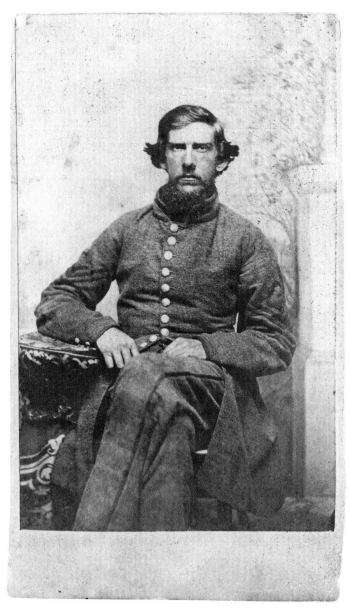

Pvt. John Robert Ellis, Company F, First South Carolina Infantry
(Hagood's)

Carte de visite by unidentified photographer, about 1861–1862. William A.
Turner collection.

"Shattered Constitution"

"I HAVE BEEN AFFLICTED WITH CHRONIC DISEASE OF THE Stomach and Bowels for the last two months and during that time I have done but one days Service," wrote 1st Lt. John Ellis of the Nineteenth South Carolina Infantry in a resignation letter to his colonel in the summer of 1862. "I feel verry feeble at present and think that my Shattered Constitution will not admit of me remaining longer in the Service."[101] An assistant surgeon recommended the resignation be accepted. It was, and the ill soldier left the army.

Ellis had joined the regiment in 1861. The only son and youngest of nine children born to a second-generation Irish-American and his wife, young Ellis married in 1856, and before the war began he and his wife had two daughters. The four of them lived on the family farm in Due West, a small community near Abbeville, South Carolina. John managed the land and thirty-two slaves.[102] In late 1861, after the death of his younger daughter, twenty-two-month-old Ann Eliza, Ellis joined the Nineteenth as first sergeant in Company I. He had advanced to lieutenant by the time he fell ill. His service with the Nineteenth ended after eight months, but the Confederacy's pressing need for fighting men brought him back into the war. In July 1863, authorities drafted Ellis as a private and assigned him to the veteran First South Carolina Infantry, also known by the name of its original colonel, Johnson Hagood.

The following spring, the First fought in the dense woodlands of The Wilderness in Virginia. On May 5, 1864, it went into battle 235 muskets strong. The next day, the South Carolinians drove enemy troops from their first line of entrenchments, but they were forced back after the regiment covering their left

flank gave way. About forty percent of the men became casualties, including Ellis. The medical records do not reveal the nature of his injury. He later rejoined his regiment and was with them when they surrendered at Appomattox Court House in April 1865.

Ellis returned to Due West, and there he died in 1873 at age thirty-four. His death was attributed to disease contracted during the war.

Wounded at South Mountain

"MY MEN WERE FIGHTING LIKE TIGERS. EVERY MAN WAS a hero," wrote Col. Cullen Battle of his Alabamians, who faced overwhelming numbers of Yankee troops on Maryland's South Mountain on September 14, 1862. Battle's regiment, the Third Alabama Infantry, "changed position no less than seven times on that mountain, and always in perfect order. Now and then it was almost a hand to hand fight," the colonel recalled.[103] Casualties were heavy, including Corp. Robert Jones. A musket ball ripped into his foot and took him out of action.

The young corporal fell into enemy hands. He received a parole and a transfer to Baltimore's Fort McHenry, where he awaited a formal prisoner exchange.[104] During this time, presumably because of infection, surgeons amputated his foot and part of his leg. He gained his release in November 1862, after eight weeks in captivity. Before leaving Maryland for the Confederacy, Jones stood with the aid of crutches for his portrait in a local photographer's studio. Jones traveled to Richmond, Virginia, where he received a furlough to visit his family in Alabama. He went home to Cross Keys, a small town located between Montgomery and Tuskegee.

Back in 1861, he had entered the army as a private in the Tuskegee Light Infantry, which became Company C of the Third. Dispatched to Virginia, the regiment reported for duty at Norfolk. It remained in the port city until Northern invaders forced all Confederate military units to evacuate the area in May 1862. The Third fell back to defend Richmond, where Union forces engaged in the Peninsular Campaign were threatening the safety of the capital. Jones and his comrades distinguished themselves in the key battles of Seven Pines and Malvern Hill.

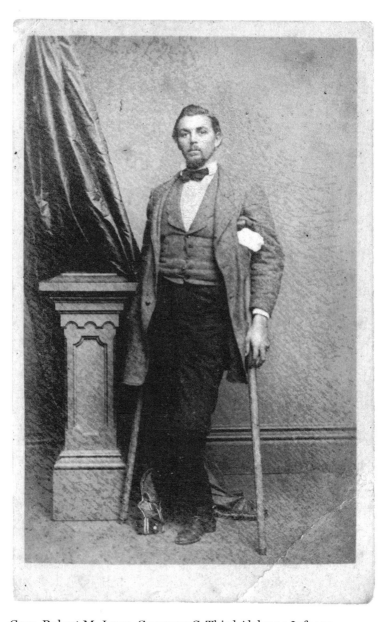

Corp. Robert M. Jones, Company C, Third Alabama Infantry

Carte de visite by Daniel Bendann (1835–1914) and David Bendann (1841–1915) of Baltimore, Maryland, about 1862. William A. Turner collection.

Four months later at South Mountain, they again fought well, and earned high praise for their actions.[105]

The Alabamians went on to further their reputation in the Army of Northern Virginia. Though the amputation had ended his career as a combat soldier, Jones found another way to serve the South: as a shoemaker, tailor, and clerk in the C.S. Clothing Bureau in Richmond. He also became an officer in the Quartermaster Battalion,[106] a unit formed to aid in the defense of the capital city.

Jones returned to Alabama after the end of the war. His name last appears on a list of residents of the Confederate Soldier's Home in Mountain Creek, which from 1903 to 1934 housed indigent veterans of various wars.[107]

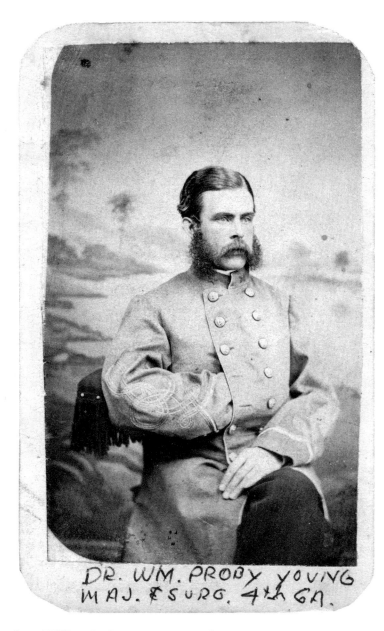

DR. WM. PROBY YOUNG
MAJ. & SURG. 4ᵗʰ GA.

Surg. William Proby Young Jr., Fourth Georgia Infantry

Carte de visite by unidentified photographer, about 1865. William A. Turner collection.

"Truly a Brave Man"

CASUALTIES FROM THE FOURTH GEORGIA INFANTRY PILED up as men fought their way through the fields and woods during the Battle of Antietam, Maryland, on September 17, 1862. The list of the wounded included the Fourth's new assistant surgeon, William Young, who remained with the men and tended to the injured while shot and shell fell around him. "He was truly a brave man, and never hesitated to go into the hottest fire on the field of battle in the discharge of duty," noted an historian. He fell into enemy hands with his patients and became a prisoner of war.[108]

Young was no stranger to his captors' culture. The Portsmouth, Virginia, native had graduated from Jefferson Medical College in Philadelphia in the late fifties, stayed in the city, and become an assistant physician in a government hospital for the mentally ill.[109]

In 1860, he had embarked on a voyage to Liberia sponsored by the American Colonization Society, although he disagreed with the organization's goal of establishing an African colony populated by free blacks transported from the United States. He served as ship's doctor, responsible for the health of the crew and hundreds of former slaves. On July 4, 1860, off the coast of Key West, Florida, Dr. Young wrote in his journal, "And this is the glorious Fourth, the day in which every American rejoices in his nativity, and expends his patriotism in the discharge of fireworks and spread-eagle speeches. Nothing about our ship gives evidence of the occasion. The Captain hasn't even hoisted the Star Spangled Banner. Says he 'don't think any more of the Fourth of July than of any other day at sea.' I'd run up my banner if it was full of holes and didn't show but one star. This

idea of letting the Fourth pass without the least notice is really painful."[110]

The outbreak of hostilities caused him to abandon the flag he loved and side with his home state. In the summer of 1862, he traveled to Richmond, where he received an assistant surgeon's commission and an assignment to the Fourth Georgia.[111] About two months later he participated in his first major battle, at Antietam. Young's wounding and courageous actions were cited in division commander Maj. Gen. Daniel H. Hill's official report. Authorities did not specify the exact nature of his injury, but it did not prevent him from continuing to attend to his fallen comrades. Young spent about two months as a prisoner before being exchanged. He returned to the Fourth, advanced to surgeon, and served in every engagement the unit undertook until the surrender of the Army of Northern Virginia at Appomattox Court House in April 1865.[112]

He then settled in Washington, D.C., where he practiced medicine and also worked as a real estate broker and secretary of a fire insurance company. He married about 1872 and had four children, all girls.[113] An army comrade described him as "an intelligent and refined gentleman, fond of his friends as well as of a good joke. He has a sunny and pleasant disposition and seems to be always in a good humor with himself and the rest of mankind."[114] He lived until about age seventy-eight, dying in 1912.

Two Times a Prisoner

CAPTAIN WILLIAM HELM FELL INTO ENEMY HANDS IN
Kentucky in October 1862. His record does not state the day of
his capture. Two reports list different towns, about forty miles
apart, Danville and Bardstown, as the place where he became a
prisoner. These scant details are all that is known about his cap-
ture. Of the fighting that was going on in that part of Kentucky
at that time, however, we have a clearer picture: Confederate
forces launched an unsuccessful campaign to wrest the border
state from Union control that autumn, and its key battle, a loss
for the gray troops, occurred on October 8 between Danville and
Bardstown, near Perryville.

Helm may have been intercepted by a federal patrol in the
days leading up to the fight at Perryville, or he might have been
nabbed in the confusion of the withdrawal of Confederate forces
afterwards. Whatever the circumstances, he remained a pris-
oner until early December, when his captors sent him by steam-
ship to a location along the Mississippi River near the strong-
hold of Vicksburg, to be exchanged.

His movements after his release are unrecorded until May 6,
1863, when federals captured him again off the coast of Alabama
on board the sleek side-wheel steamer *Eugenie*, a blockade-run-
ner bound from Havana, Cuba, to the port of Mobile.[115] A family
tie may have been responsible for his presence on the vessel. His
older brother, Charles, served as U.S. consul general at Havana
before the war and joined the Confederate government as a spe-
cial agent for the West Indies. He made his headquarters in the
Cuban capital—a port of call for blockade runners, including
the *Eugenie*.

Helm shared a common ancestor with the man who orga-

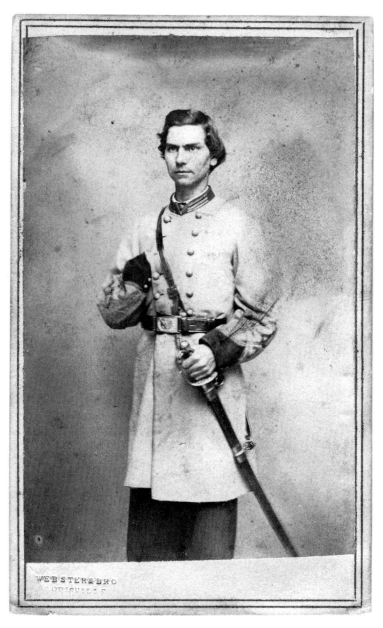

Capt. William W. Helm, First Kentucky Cavalry

Carte de visite by E. L. Webster (life dates unknown) & Israel B. Webster (b. 1826) of Louisville, Kentucky, about 1861–1862. John Sickles collection.

nized his regiment, the First Kentucky Cavalry: Brig. Gen. Ben Hardin Helm. The general, as it happens, had married a half sister of Mary Todd Lincoln and had befriended Abraham Lincoln before the war.

Helm's captors imprisoned him at Fort Lafayette in New York Harbor, and then at Fort Warren in Boston Harbor.[116] On March 15, 1865, federal authorities transferred him to Point Lookout, Maryland, where he arrived three days later as part of a group of about one thousand parolees. He soon gained his release, returned to the Confederacy, and received orders to report for duty to Lt. Gen. Richard Taylor, the commander of the Military Department of Alabama, Mississippi and East Louisiana. There is no record of whether or not he made it there before Taylor surrendered his forces on May 4, 1865. About two weeks later, Helm signed the oath of allegiance to the U.S. government in Nashville, Tennessee.[117]

He returned to his Kentucky home and married. In 1880 he was living with his wife, two sons, and a daughter in Louisville, where he practiced law. His name last appeared in print in an 1890 Louisville city directory, when he would have been in his late forties.[118]

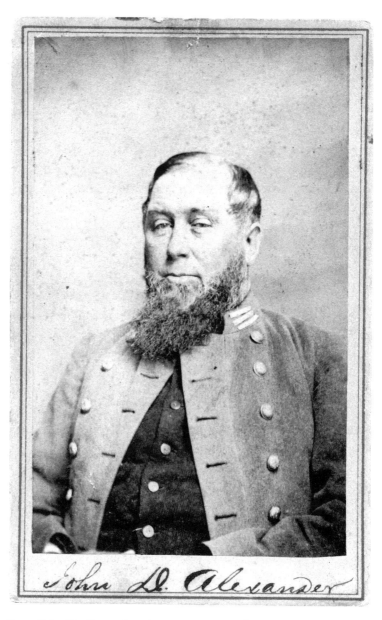

Capt. John D. Alexander, Company I, Second Virginia Cavalry

Carte de visite by Tanner (life dates unknown) & John I. VanNess (life dates unknown) of Lynchburg, Virginia, about 1861–1863. William A. Turner collection.

An Unfortunate Accusation

"GUILTY," PRONOUNCED THE MEMBERS OF THE COURT martial on the charge of "conduct subversive of good order and military discipline" leveled against Capt. John Alexander of the Second Virginia Cavalry in the fall of 1862. The finding tarnished the record of the forty-two-year-old officer, who had made a good mark for himself in battle.[119]

The previous spring, the first of the war, Alexander had left his job as Campbell County clerk and organized the "Campbell Rangers," a cavalry company composed of local volunteers, including his son, Samuel, who had served him as deputy county clerk in peacetime.[120] The men elected Alexander captain and commander. The Rangers became Company I of the Second Virginia Cavalry.

Capt. Alexander and his horse soldiers participated in their first big fight on July 21, 1861, at the Battle of First Manassas. Top commanders initially held the company in reserve. Late in the action, after Union forces began to retreat, the Rangers received an order to charge the fleeing bluecoats. They rode in with the rest of their battalion and came face to face with a Union artillery battery, which had been posted in the middle of the Warrenton Pike to cover Union infantry as it approached the suspension bridge spanning Cub Run. The Rangers successfully attacked. Alexander noted the actions of his men with pride: "They remained firm and unshaken, exhibiting an anxiety only to meet the enemy, and awaiting patiently an opportunity to strike an effective blow." Only one Ranger suffered an injury during the day—Alexander. "I received a slight wound in my leg, which did not disable me," he mentioned in his battle report.[121]

He could not have known that First Manassas would be the

highlight of his military career. The following year, he appeared before a court martial on two charges related to receiving men from another company without proper authority: subversive conduct and aiding and abetting desertion. The court declared him not guilty on the desertion charge but guilty of subversive conduct. Authorities sentenced him "to be reprimanded in orders to be read before each Regiment of his Brigade."[122]

However, a majority of the tribunal agreed that Alexander "erred inadvertently and through ignorance, not from design," and this tempered the impact of the guilty verdict.[123] But the damage was done. Within weeks, he resigned, on November 1, 1862, and returned to Campbell County, where he served as its chief clerk until 1865. He died ten years later at about age fifty-six.[124]

Evil Star

AT NOON ON NOVEMBER 26, 1862, CAPT. JIM POLK AND
a detachment of his cavalrymen reached Florence, Alabama,
where he planned to lead them across the Tennessee River and
rejoin his command. He learned that it would be impossible to
cross until the next day, and the delay disappointed him. To add
to his frustration, space for stabling the horses was tight, and
he had to split the horses between two locations. Overnight,
Skedaddle, his prized mare, and other horses and mules were
allowed to wander off. It took another day to collect them. The
incident sorely tested his patience. "You have no idea how much
this thing has troubled me, but I am living under an evil star," he
wrote to his father.[125]

Polk grew up enjoying a life of privilege at Rattle and Snap,
a stunningly handsome plantation home south of Nashville
in Maury County, Tennessee. His uncle, West Point–educated
Bishop Leonidas Polk, became a Confederate general. James K.
Polk, his second cousin once removed, had served as the eleventh
president of the United States. Young Polk left home in 1858 to
attend the University of North Carolina, where he may have first
perceived his evil star. Plagued by self-doubt, he struggled with
his studies and considered a transfer to West Point. His father
objected, arguing, "not but a small minority of those graduating
there ever make useful business men and my great desire is that
you shall not only make a good scholar, a gentleman, but a first
rate business man."[126]

If his father could have foreseen his son's military service, he
might have reconsidered his position. After the war began, Polk
became a first lieutenant in a battalion that joined the Sixth Ten-
nessee Cavalry;[127] he advanced to captain of Company E. The

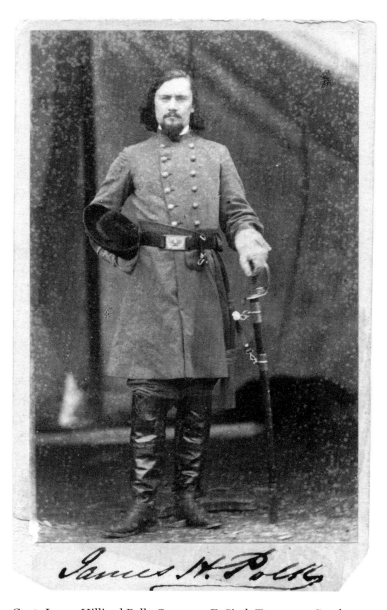

Capt. James Hilliard Polk, Company E, Sixth Tennessee Cavalry

Carte de visite by John Lawrence Gihon (1839–1878) of Philadelphia, Pennsylvania, April 1864. Collection of the Museum of the Confederacy, Richmond, Virginia.

regiment campaigned in Tennessee and Mississippi, then Alabama, where Skedaddle and the other animals went astray. On January 3, 1864, Skedaddle went lame during a raid in federal-occupied territory not far from Rattle and Snap. Rather than leave his beloved horse behind, he decided to rest her and replace the shoe on the faulty leg. About this time a Yankee patrol surprised him.

The fate of Skedaddle is not known,[128] but federal troops captured Polk and sent him to Fort Delaware, which is where he posed for this *carte de visite*. According to Polk, "Of all the mad looking Rebs the picture man said I was the madest."[129] Meanwhile, in Charleston, South Carolina, opposing commanders engaged in a heartless game in which prisoners of war from both sides were used as pawns. In June 1864, Confederate Maj. Gen. Samuel Jones exposed fifty federal officers to fire from their own long-range guns. The Yankee commander, Maj. Gen. John Foster, retaliated by placing fifty-five Confederate officers in a similar position. The face-off ended after the two sides negotiated an exchange. But Jones then put a much larger group of Yankee officers—six hundred from overcrowded Andersonville prison—in harm's way. Foster countered by bringing up a like number of officers from Fort Delaware, including Polk. On September 7, 1864, he and the other prisoners landed at Morris Island at the mouth of Charleston Harbor, and were confined in a crudely constructed stockade in front of the Union batteries. For forty-five days the officers lived in constant fear. None were injured by gunfire, but three died of starvation. The prisoners have been memorialized as members of "The Immortal Six Hundred."[130]

On October 21, Polk and the other survivors were removed to Savannah, Georgia, and imprisoned at Fort Pulaski. Overcrowded conditions caused the removal of 197 men, including Polk, to nearby Hilton Head Island. Shortly before Christmas, prison authorities declared Polk near death from starvation, and released him.[131]

He managed to recover, rejoined the Sixth, and served until the end of the war. Like many other Confederate soldiers, he

walked home after his regiment disbanded, following Maj. Gen. William T. Sherman's trail of devastation through Georgia. He passed the ruins of numerous plantation homes and feared that Rattle and Snap had suffered a similar fate. He had been out of touch with his family for months. Rumors filled in the gap: he was told that his father had been killed, and his parents had heard that he had died from a wound.[132]

Polk found Rattle and Snap miraculously intact, although badly damaged: broken windows and bullet marks scarred the exterior, much of the furniture was gone, and most of their one hundred former slaves had left or been taken away. His mother "came running into the room, brushing her hair out of her face. Tears streamed down her cheeks as she embraced James, and her hands cautiously checked his face, shoulders and back for the wounds she feared."[133] His father, although slowed by arthritis, had not been killed.

The family sold Rattle and Snap in 1867 so they could pay owed taxes and buy food. Polk moved to Mississippi, where he failed as a cotton grower. Next, he and a brother relocated to Fort Worth, Texas, and became traders in horses and cattle. Several of Jim's actions became family legend. He shot and killed the sheriff of Laredo, allegedly in self-defense. He made horse deals with the legendary outlaws Jesse and Frank James and other men of questionable character. In a contract with the British for its army fighting in the Boer War, he promised to provide horses that had been ridden at least; but to save money, he sent wild mustangs and feral animals instead. In an odd twist of fate, the horses arrived in South Africa "as tame as saddle mares," possibly due to a rough ocean voyage.[134] In 1885 he married and he and his wife subsequently had two sons. Polk lived until age eighty-four, dying in 1923.

From Diplomat to Cavalry Raider

A PACK OF JADED SCOUTS TRAVELED ON HORSEBACK IN advance of a column of Confederate cavalry. The men savored their place in the vanguard, which allowed them to be the first to enter any village and take possession of lodging, food, and supplies. They were quick to resent others who got ahead of them. Such was the case as the gritty group entered Glasgow, Kentucky, on Christmas Eve 1862. An eyewitness recalled that Charlton Morgan, a captain and aide-de-camp dressed "in brilliant staff uniform, escorted by a squadron, dashed up behind us at a gallop, evidently bent on reaching town first" to secure lodgings for himself and his fellow staffers. "As they rode through us one of our company shouted at the top of his voice, 'No danger ahead, boys; Charlton Morgan's going to the front.'" The scouts broke out in loud laughter.[135]

He "was not popular, at least so it seemed" with these men, observed the eyewitness. Any disrespect intended by the sarcastic scout was unwarranted, for Charlton had proved himself eight months earlier at the Battle of Shiloh, Tennessee, where he suffered a wound while serving as an aide to a brigade commander.[136] Authorities did not record the exact nature of his injury but did note that he received orders to report to Huntsville, Alabama, to recuperate. Days after his arrival in Huntsville, he fell into enemy hands after Union forces commanded by Brig. Gen. O. M. Mitchel occupied the city. Confederates captured the Yankee general's son, Lt. Edward Mitchel, about a month later, and exchanged him for Charlton.[137] The man responsible for the capture of Lt. Mitchel was Charlton's eldest brother, John Hunt Morgan.

Charlton, nicknamed Charly, and his five brothers all joined

the Confederacy from the border state of Kentucky.[138] He attended Lexington's Transylvania University, graduated in 1859, and accepted an appointment as U.S. Consul to Messina, Italy. There he became involved in the country's struggle to overcome Austrian rule. According to one report, he was the first diplomat to recognize the new government of freedom fighter Giuseppe Garibaldi. He then served as an aide-de-camp to Garibaldi, suf-

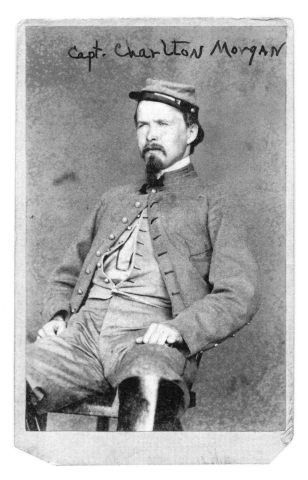

Capt. Charlton Hunt Morgan, Confederate States Army

Carte de visite by John Lawrence Gihon (1839–1878) of Philadelphia, Pennsylvania, about 1864. Collection of the Museum of the Confederacy, Richmond, Virginia.

fering a wound in the fight for independence, while maintaining his official status as consul.[139]

In February 1861, Charlton resigned his post in protest of the election of Abraham Lincoln. He became secretary to a member of a commission sent to Europe to seek official recognition for the Confederate States of America,[140] then returned home in time to participate in the Battle of First Manassas in July 1861. The following year, after his exchange for Lt. Mitchel, he joined the staff of his brother John, a brigadier general.

Charlton participated in his brother's noted Christmas Raid, where he encountered the wisecracking scouts, and later that winter fell into enemy hands again near Lexington, Kentucky. Federal authorities exchanged him in the spring of 1863, and he returned to his brother's staff.

In July 1863, he rode on the disastrous Ohio Raid with his brother's forces, and the Yankees captured him for a third time. He spent the next nineteen months in captivity. While in prison he learned of John's death when enemy troops surprised and killed him at Greeneville, Tennessee, on September 4, 1864. Charlton wrote in a letter to his mother, "On the death of Johnnie, I've not only lost a devoted brother, but one who was to me a Father. He is gone! but his memory will ever live in the hearts of his countrymen."[141] After his release from prison in February 1865, he rejoined his comrades in Virginia and served with them for the rest of the war.

Back in civilian life, Charlton moved from job to job, "generally unsuccessful in business and forever seeking political appointments."[142] In the late nineties, he secured a position with the Internal Revenue Service. He also served as a steward of the East Kentucky Lunatic Asylum.[143] He lived until age seventy-three, dying in 1912. Three family members survived him: his wife, Nellie, a niece of Francis Scott Key and one of the first presidents of the United Daughters of the Confederacy; his daughter, Ellen; and his son, Thomas Hunt, who received the Nobel Prize in 1933 for proving that chromosomes are the carriers of genes.

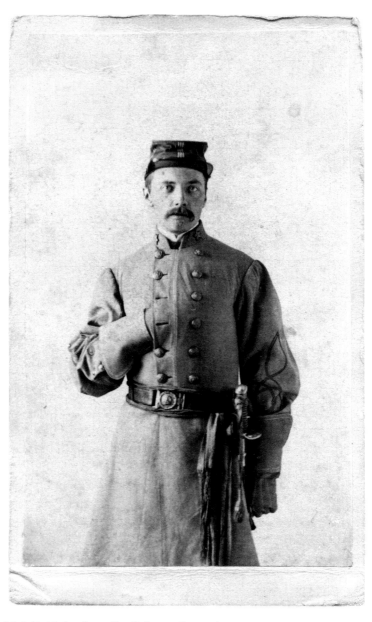

Maj. Reid Sanders, Confederate States Army

Carte de visite by James Wallace Black (1825–1896) of Boston, Massachusetts, about 1863–1864. Collection of the Museum of the Confederacy, Richmond, Virginia.

The Tin Box

Major Reid Sanders acted quickly as two Yankee warships converged and fired on his blockade runner, *Mercury*, in the dead of night on January 4, 1863, on the open sea off Charleston, South Carolina. He and the ship's mate made sure that a mailbag containing, among other items, a tin box full of sensitive government dispatches and letters bound for Europe, would not fall into enemy hands. The mate lowered the bag, weighted with iron, into the ocean and watched it sink out of sight. The federals boarded the *Mercury* and captured the men and remaining cargo.[144]

Any relief that Maj. Sanders felt after sinking the important dispatches in his care was replaced by amazement and shock when he learned that he had been betrayed by the *Mercury's* captain, Arnold Harris, a Union sailor turned special agent. Harris had slipped the tin box out of the mailbag the night before and then maneuvered the *Mercury* into sight of the enemy vessels. He turned the box over to the captain of one of the warships, and its contents were soon revealed.

The story made headlines in newspapers North and South. The *New York Times* excerpted dispatches related to the purchase of six ironclad gunboats for the Confederate navy, and other documents.[145] A *Times* profile described Sanders as "eminently distinguished for his self-esteem, 'brass' and general impudence," and, "one who always wished to rule and to force himself into notice, in doing which he often rendered himself supremely ridiculous."[146] These caustic comments were prompted in part by the fact that New York City tax dollars had paid for Sanders's education. An 1859 graduate of The Free Academy,[147] he lived in the city before the war, with his mother, an Empire

State native, and father, Kentucky-born George N. Sanders. A controversial figure, the elder Sanders rose to prominence in the early fifties as spokesman for Young America, a nationalistic political movement that sought to spread democracy worldwide by any means, including force.

The Sanders family moved to the South before the bombardment of Fort Sumter.[148] Reid received an appointment as major in the Confederate army in May 1861 and an assignment to a brigade commissary department in Mississippi. Two months later, authorities summoned him to Richmond. There he met his father, who had joined the Confederate government as a special agent charged with contracting for ironclad warships from Britain. He set up a courier service to transport dispatches to Europe and assigned his son to supervise it.

The inaugural run failed. On November 4, 1862, father and son were aboard a schooner anchored in Dividing Creek, a tributary of the Chesapeake Bay, when the U.S. Revenue cutter *Hercules* appeared at the schooner's moment of departure. The father escaped; young Sanders fell into enemy hands. The federals exchanged him about a month later. He went straight to Richmond and organized another run. This time he traveled to Charleston, purchased the single-mast sloop *Mercury,* and hired two English sailors—and special agent Arnold Harris to captain the ship.[149]

On the night of January 3, 1863, traveling under the alias "George Sharrer,"[150] Sanders and his crew set sail. The blockade ships *Quaker City* and *Memphis* intercepted the *Mercury* about six to eight miles out. Sanders became a prisoner for the second time in two months. Union authorities delivered Sanders to New York and detained him at Fort Lafayette as a political prisoner. His concerned mother wrote to "my brave and honorable & kind boy" with emotion: "I feel greatly distressed at the suffering your mind & health may have sustained by the horrible surprise. . . . I know your high spirit & keen sensibility, and I shall feel anxious until I hear how your health has borne this ordeal and your subsequent imprisonment."[151]

Reid Sanders languished at Fort Lafayette. In July 1863, his captors transferred him to Fort Warren in Boston Harbor. All attempts to gain his release failed. He petitioned President Abraham Lincoln and Secretary of the Navy Gideon Welles without success. Sanders did not help his case by masterminding an escape. One night in August 1863, he and three other Confederate prisoners slipped through a seven-inch wide musket loophole along an outer wall of Fort Warren. Sanders and another man, both poor swimmers, went into hiding. The other two men swam to a nearby island, stole a fishing boat, and went back to the fort to fetch their comrades. But daylight broke before the men could complete the task, and they left without Sanders and the other escapee. Prison guards recaptured the stranded men and placed them in close confinement. The two other men were later also caught.[152]

About a year later, still imprisoned, Sanders fell ill with dysentery. He succumbed to the infection at 1:10 a.m. on September 4, 1864. His last word was "Mother."[153]

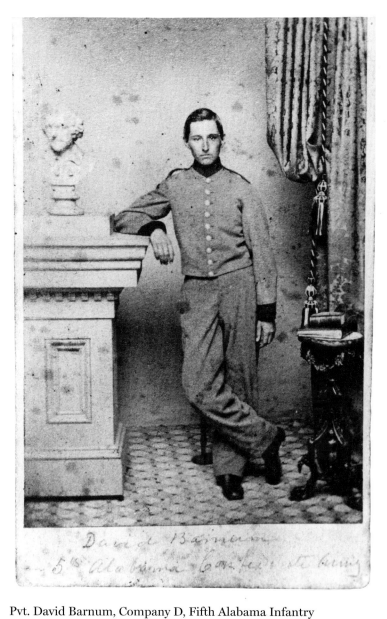

Pvt. David Barnum, Company D, Fifth Alabama Infantry

Carte de visite by unidentified photographer, about 1862–1864. Collection of the late Richard K. Tibbals, U.S. Army Military History Institute.

A Great Fondness for the Sea

ON A FRIGID FEBRUARY NIGHT DURING THE SECOND winter of the war, in the Virginia encampment of the Fifth Alabama Infantry, the cold prevented Pvt. Davy Barnum and a friend from falling asleep. They sat by the campfire until late, reading a novel together by the flickering light. A few weeks later, the two were having a long conversation about books and other subjects after supper when the talk turned to personal matters, and Davy, an undersized, scrappy kid who wanted out of the army, expressed his anxiety about the application he had made to join the navy. He had a great fondness for the sea, and, if accepted, he imagined himself realizing his dream to travel the world by ship.[154]

If the war had not happened, young Barnum would have been a senior at the U.S. Naval Academy in Annapolis, Maryland, wearing Union blue instead of Confederate gray. He had been appointed to the Academy in 1858, five months shy of his fifteenth birthday. He was ill prepared for the school's structured environment. His difficulties may have been due, in part, to the absence of a father in his boyhood.

In 1852, young Davy and his family moved to Selma, Alabama, from their home in nearby Greene County. The following year, a plague of yellow fever swept the city. His father, a physician serving as one of two health officers in town, fell victim to the disease.[155] His mother, younger brother, and he were spared. They left Alabama for St. Paul, Minnesota, from where he received his appointment to the Academy. Davy ranked near the bottom of his class in grades, and he racked up more than three hundred demerits in his first two years. He resigned under pressure in 1860, but the sympathetic secretary of the navy,

Isaac Toucey, reinstated him with the caveat that he "diligently pursue" his studies. He did not, despite the efforts of a kindly professor who volunteered to tutor him. Academy authorities held him back a year and threatened him with expulsion.[156]

The outbreak of hostilities ended his slide into academic oblivion. In the summer of 1861 Barnum left to fight for his native state. He did not record his emotions during this time, but he must have been conflicted over leaving his mother, now remarried, and brother in the North. He traveled to Union Mills, Virginia, and found the camp of the "Greensboro Guards," the Greene County militia company to which his father had once belonged.[157] It became part of the Fifth Alabama Infantry after the war started. He enlisted and took his place in the ranks.

Barnum got into his share of trouble. One comrade noted episodes of drinking and brawling. A few days before the regiment's first big battle, at Seven Pines, Virginia, Barnum reportedly pulled a knife on its bandmaster, Charles von Badenhausen, a former lieutenant in the Austrian army.[158] The pair went into battle nursing a feud. Early in the action, von Badenhausen patted Barnum on the shoulder and admonished him to "be quiet: keep cool, oderwise I draws my knife on you."[159]

The Austrian came out of the battle unscathed. Barnum did not. As the men lay upon the ground and readied to fire, a musket ball entered Barnum's left shoulder, ripped diagonally across his back, exited just before reaching the spine, and embedded itself in his right hip. Surgeons could not find the ball, and the wound healed up. Months later, on a march into Maryland in September 1862, Barnum had a poor night's sleep and blamed it on a rock under his bedding or in his pocket. Upon further examination, he discovered that it was not a rock that had kept him awake but the bullet, which had been working its way out of his body.[160]

Less than two weeks later, shortly before the Battle of Antietam, Barnum and about a dozen of his comrades were captured near Turner's Gap, Maryland, where they and two other companies from the Fifth Alabama had been ordered to cover a

Confederate withdrawal after heavy fighting. He received a parole five weeks later and returned to the Fifth in late 1862. He filed for a transfer to the navy around this time. Any hopes he may have had for a quick acceptance faded as winter turned to spring and the 1863 campaign got under way.

A noted forager, Barnum brought his skills into full play as the Fifth marched into Pennsylvania. At Gettysburg on July 2, after the regiment had participated in the rout of Union troops during the first day of the battle, he showed up with a haversack full of candy, lemons, and other niceties gathered from town and distributed the treats to his comrades.[161]

Barnum's transfer came through in August, about the time he would have graduated in the U.S. Naval Academy's Class of 1863. He reported for duty with the rank of master at the Charleston Naval Station. His stint lasted less than a year. In mid-1864, the army, needing men more desperately than the navy did, drafted him. Authorities assigned him to his old regiment, where he remained until the end of the war. According to the records, he did not surrender with his comrades at Appomattox Court House. It is likely that he deserted, with thousands of other troops from all across the Confederacy who served in the Army of Northern Virginia during its final days.

He made his way south and fell into the hands of federal authorities in Tennessee. At Chattanooga in June 1865, he signed the oath of allegiance to the U.S. government. His captain remembered him as "a gallant little soldier." Barnum died soon after the war, in St. Louis.[162] His dream of sailing the seas was never fulfilled.

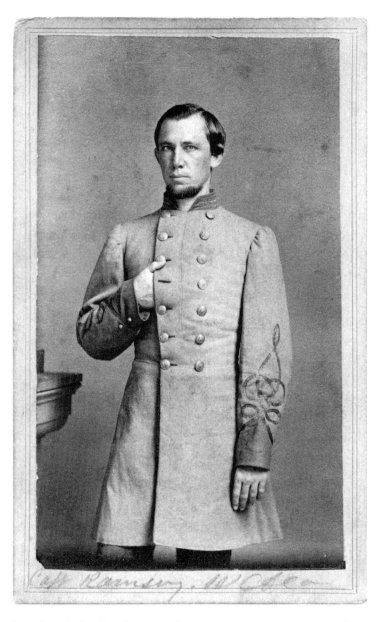

Capt. David Wardlaw Ramsey, Company B, First Alabama Artillery

Carte de visite by Samuel Anderson (b. 1825) & Samuel (or Solomon) T. Blessing (1832–1897) of New Orleans, Louisiana, about July–October 1863. David Wynn Vaughan collection.

Firing on the Mississippi

LATE IN THE NIGHT OF MARCH 14, 1863, AT A RIGHT angle bend along the Mississippi River, in the batteries defending Port Hudson, Louisiana, gray gunners brought their cannon to bear on an enemy flotilla—including three steam sloops of war, each escorted by a gunboat, and the outmoded side-wheeler *Mississippi*[163] racing towards their position.[164] All hell broke loose as artillery fire ripped into the fleet. The *Mississippi* ran aground on a sand bar near Battery No. 5, and Capt. David Ramsey and his artillerists from the First Alabama turned their cannon on the distressed vessel.

A Confederate private described the scene: The *Mississippi* "got so close under the guns at one place that Captain Ramsey could not depress his artillery to hit her, and then Captain Ramsey ordered the men of his battery to take muskets and go outside and shoot the men on deck." As Ramsey's troops marched out, another battery opened up on the grounded sidewheeler and blasted its rudder off, causing the ship to slide off the sand bar and float helplessly downstream, according to the private. He noted: "The prettiest sight I ever saw was the red hot balls screaming through the air at night seeking to locate her."[165] The *Mississippi*'s captain ordered the crew, sixty-four of whom would be killed in the battle, to burn the vessel. The blazing boat drifted down the river for several hours before the flames reached the magazine, which exploded and destroyed the ship. People miles away felt the blast, which reportedly shattered windows in Port Hudson.[166]

Ramsey and his Alabamians had been serving the Confederacy for more than two years before that night. They had joined a company called the "Wilcox County True Blues" on February

9, 1861, the very next day after the new Confederate States of America adopted a provisional constitution in Montgomery. The men elected Ramsey, a medical student who had graduated from Kentucky Military Institute in 1859, as their first lieutenant, and a physician under whom he had been studying, Dr. Isaiah Steedman, as captain. The "True Blues" received orders to garrison Fort Barrancas in Pensacola Harbor, Florida. There they became Company B of the First Alabama Infantry. The regiment earned high marks for manning the fortification's heavy guns, and decided to reform as an artillery unit in early 1862. Steedman advanced to colonel, and Ramsey became captain and company commander. Dispatched to Memphis, the First became trapped in the siege of Island No. 10. Most of the regiment surrendered, including Ramsey and his younger brother, Rob, a private. The officers and enlisted men were separated and sent to different prisons. "It was certainly a sore trial to be so separated," wrote Ramsey to his father.[167] He never again saw his brother, who died of disease while in captivity. Ramsey wound up at Johnson's Island, Ohio, where he and his fellow officers spent five months as prisoners of war. They were exchanged in September 1862.

After a short leave, Ramsey reported for duty at Port Hudson. The well-defended stronghold enabled the Confederates to control a 240-mile stretch of the Mississippi River between Vicksburg and Port Hudson. The attempt by the enemy vessels to run the batteries at Port Hudson in early 1863 was the first of many hostile actions in the area. The flagship, which carried fleet commander Adm. David Farragut, and its consort made it safely past the defenses. The other vessels turned back before the burning of the *Mississippi*. One of the *Mississippi*'s survivors, executive officer George Dewey, became the "Hero of Manila Bay" as an admiral during the Spanish-American War.

Over the next two months, the defenders of Port Hudson repelled two more major assaults and endured siege conditions. They were forced to capitulate after the fall of Vicksburg made their position untenable. Ramsey became a prisoner for the sec-

ond time. After a few months in confinement at New Orleans, he spent the duration of the war at Johnson's Island—his second stint there. Evidence suggests that he worked alongside Col. Steedman in the prison hospital.[168]

Ramsey spent almost two years in captivity. When military authorities released him in June 1865, he returned to his home in Wilcox County, married in 1866, and started a family that eventually included five daughters and three sons. In 1870, he graduated from the University of Louisiana[169] with a medical degree and opened a practice in Pineapple, the hometown of his wife, Emma. She persuaded him to leave Methodism and become a Baptist, and in 1883 he was ordained a minister. His journey from physician to minister may have been influenced by his father, a Methodist minister and one-time circuit rider. In 1893, Ramsey's wife, one of their daughters, and a son-in-law died in a typhoid epidemic. He remarried the following year and lived another twenty-three years, dying in 1916.

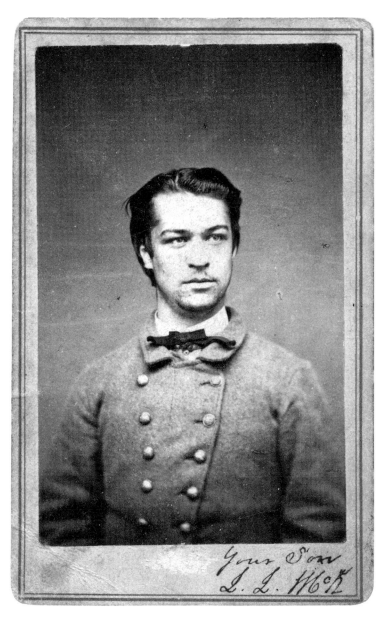

Pvt. James J. McKinley, Company H, Fourth Georgia Infantry

Carte de visite by unidentified photographer, about 1863–1864. David Wynn Vaughan collection.

A Private with Potential

"He entered at an early day, the struggle in which we are now engaged and has done good service for his Country," wrote Georgia's Sen. Herschel Johnson to C.S. Secretary of War James Seddon from the Confederate capital in the spring of 1863. These words were written on behalf of James McKinley, a private with potential. The senator hoped to secure a higher rank for the young man.

McKinley had joined Company H of the Fourth Georgia Infantry in June 1862 at about age seventeen.[170] By that time, the regiment had already seen its first action, a brisk skirmish on June 25 at King's School House on the outskirts of Richmond. McKinley did not join his company in Virginia but remained in Calhoun, the north Georgia town from which he enlisted. He went to work in the state's quartermaster department. Less than a year later, in the spring of 1863, Sen. Johnson nominated him for a cadetship—a position as a junior officer—noting, "He is of excellent family connections, is educated and upright in deportment."[171] There is no record that the War Department in Richmond acted upon his request, but he may have unofficially held the rank.[172]

McKinley's military record ends in the summer of 1864, as Maj. Gen. William T. Sherman's invading army made inroads into Georgia. He fell victim to a plague of yellow fever in Savannah in 1875 and was buried in a cemetery there. He was about thirty years old.

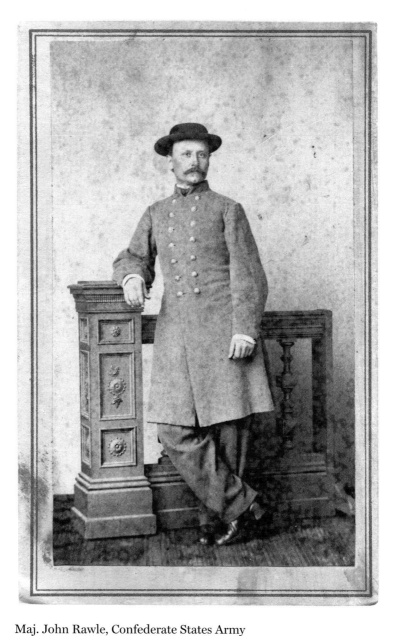

Maj. John Rawle, Confederate States Army

Carte de visite by the New Orleans Photographic Company of New Orleans, Louisiana, about 1865–1866. William A. Turner collection.

Forrest's Artillery Chief

IN JUNE 1863, BRIG. GEN. NATHAN BEDFORD FORREST selected Lt. John Rawle as his artillery chief and promoted him to major. Pleased with his choice, the general declared: "I know of no one I would prefer to Lt. Rawle in the position to which he had been appointed."[173] Rawle's leadership qualities were confirmed a month later in the Battle of Chickamauga. Forrest noted in his official report, "The conduct of Maj. Rawle, chief of artillery, and the officers and men of this battery on this occasion deserves special mention. They kept up a constant and destructive fire upon the enemy until they were within 50 yards of the guns, getting off the field with all their pieces, notwithstanding the loss of horses."[174]

Unbeknownst to Rawle and Forrest, Chickamauga marked the high point of their military relationship. Soon after the fight, a simmering feud between Forrest and his boss, Gen. Braxton Bragg, came to a boiling point. In late October 1863, Forrest received a transfer to northeast Mississippi and left with only a small cadre of his former command. Rawle's services were no longer needed, and military authorities sent him to the Department of Alabama, Mississippi and East Louisiana.[175] This move put him a little closer to his home state of Louisiana, where he had entered military service.

Rawle had served with state troops before the war started. In the summer of 1861 he received a second lieutenant's commission, a rank befitting a young man of his family connections. His father worked as a judge in New Orleans. His late grandfather, attorney William Rawle, had authored *A View of the Constitution*, an influential book that supported the argument that states had the right to leave the union.[176]

Rawle joined the staff of Maj. Gen. Leonidas Polk, as an artillery and ordnance specialist, in early 1862. He participated in several battles, including Shiloh and Stone's River, and impressed Polk as "a highly meritorious officer."[177] He left in mid-May 1863 for Forrest's command, where he further distinguished himself, until the fallout from the feuding generals resulted in his reassignment. He spent the majority of his remaining service in Alabama and signed the oath of allegiance in May 1865.

After the war, he made Natchez, Mississippi, his home. In 1867, he wed Elizabeth Stanton, the daughter of a plantation owner who had fallen on hard times. The family managed to hold on to their residence, Stanton Hall, where the couple married and three of their eight children were born.[178] Rawle sold insurance and real estate and served as an Episcopal Church vestryman.

In 1909, he wrote to *Confederate Veteran* magazine: "As the time is approaching when I may expect to turn up my toes to the daisies, I should like to hear from some of my old comrades of the Confederate war."[179] It is unknown if anyone contacted him before his death seven years later after suffering a stroke at age seventy-nine.

Artilleryman Turned Surgeon

ON APRIL 29, 1863, SEVEN UNION IRONCLAD GUNBOATS steamed down the Mississippi River and opened fire on the fortifications of Grand Gulf, as transports and barges filled with Yankee infantrymen waited for an opportunity to disembark and take the offensive.[180] Just a score of miles north, in Vicksburg, on the same day, a medical board pronounced twenty-seven-year-old John Beauchamp of Kentucky as qualified to be an army doctor.[181]

Beauchamp had earned a medical degree from the University of Nashville in March 1861. He was following in the footsteps of his father, one of the first physicians in Edmonton, Kentucky.[182] The war began about six weeks after young Beauchamp graduated, and he enlisted in the army five months later—not as a doctor, but as a private in a company that later became part of the First Tennessee Heavy Artillery. He remained in the rank and file with the regiment until he passed the medical board exam in the spring of 1863.[183]

He received an appointment as assistant surgeon and transferred out of Vicksburg before the Mississippi River stronghold fell to Union forces on July 4, 1863. The majority of his remaining military service was spent with Martin's Battalion of the Confederate Reserve Artillery.[184] He is credited with tending the wounded in the battles of Chickamauga and Missionary Ridge in Tennessee and numerous engagements during the 1864 Atlanta Campaign, including the Battle of Resaca.[185] With the battalion, he surrendered at Macon, Georgia, in April 1865.

After the war, he returned to Nashville. In 1870 he went to work at the Central Hospital for the Insane, where he spent the remainder of his career, first as an assistant physician and later

as superintendent. In 1877, at age forty-one, he wed a woman twenty years his junior. No children were born as the result of their union. Beauchamp lived until 1910, dying at age seventy-four.[186]

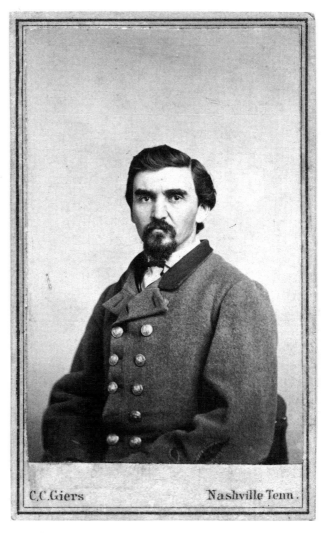

Asst. Surg. John Alfred Beauchamp, Martin's Battalion, Confederate Reserve Artillery

Carte de visite by Carl Casper Giers (1828–1877) of Nashville, Tennessee, about 1865. William A. Turner collection.

"A Very Titan War God"

ALL HELL BROKE LOOSE AFTER LT. COL. WILL DELONY and his trusted "Georgia Troopers," with swords and pistols drawn, charged a line of federal cavalry atop Fleetwood Heights near Brandy Station, Virginia, on June 9, 1863. The fiery assault crumbled the bluecoats. The scene disintegrated into a jumbled mass of men, horses, and slashing cold steel. An unruly mare carried away one gray horseman, who never forgot what happened next: "As I got control of my steed and faced her about I saw Delony, my former captain, smiting Yankees right and left as he charged along the advance. He sat on his charger grandly, his fine physique and full mahogany beard flowing, he looked a very Titan War god, flushed with the exuberance and exhilaration of victory."[187]

Delony could always be found in the thick of the action. "He was a game fighter and dared to attempt anything, even though it seemed impossible to others," noted the same soldier.[188] Delony's aggressive battlefield conduct may have been rooted in his peacetime career as a lawyer. He graduated in 1846 with honors from the University of Georgia in Athens and went on to practice his profession there. After the war started he raised a cavalry company known as the "Georgia Troopers." The men elected him captain. In August 1861, he bid his wife and two small children farewell and departed for Virginia with his horsemen as Company C of Cobb's Legion Cavalry Battalion.

Delony cared for his command. "How his men loved him, and how he stood by them," stated one soldier, "contending always for their rights and looking after their comforts."[189] However, he displayed a weakness for alcohol. Several concerned officers told the legion's colonel, T. R. R. Cobb, that Delony "was drink-

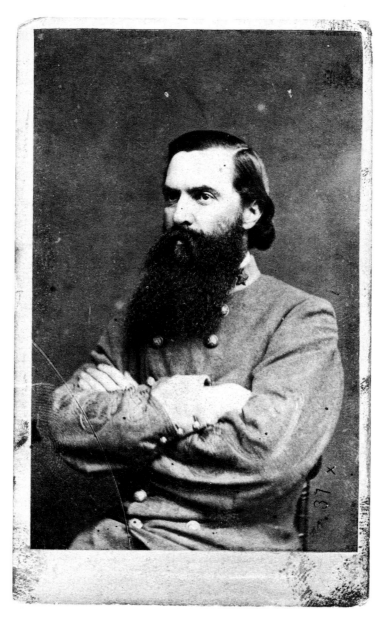

Lt. Col. William Gaston Delony, Cobb's Legion Cavalry (Georgia Troopers)

Carte de visite by Charles R. Rees (life dates unknown) of Richmond, Virginia, about 1862. David Wynn Vaughan collection.

ing a great deal." Cobb later confided his feelings in a letter to his wife, writing, "It has disturbed me very much," and "I don't know what to do about it."[190]

Delony's drinking may have saved him from a mortal wound. At Gaines' Cross Roads, Virginia, on November 8, 1862, a week after he joined the battalion staff as lieutenant colonel, he "was fighting like a mad boar with a whole pack of curs about him, having his bridle hand dreadfully hacked, his head gashed and side thrust." The next day in camp, wrapped in bandages and seated on a log, he removed a small metallic flask from his coat pocket and showed a comrade where an enemy swordsman had pierced it with an inch-wide gash.[191]

Seven months later at Brandy Station, he emerged from the fight unharmed. At the Battle of Gettysburg several weeks later, on July 2, during a cavalry fight near Hunterstown, he led a charge that blunted an onslaught commanded by newly minted brigadier George Armstrong Custer. A bullet hit Delony's horse during the action, and it toppled onto him. He managed to get out from under his mount only to be assaulted by three federals. He raised himself on one knee and fought off his attackers with his sword and the help of two comrades. Delony suffered a severe saber cut on his forehead above his right eye. A few days later, the company was being pursued by the enemy as it marched to Virginia. In typical Delony fashion, he left his ambulance, organized a force of sick and wounded, and rallied the men, who attacked the attackers and checked their progress.[192]

During the Battle of Jack's Shop on September 22, 1863, a Yankee minie bullet ripped into Delony's left thigh. Enemy troopers also shot his mount, and, in a repeat of the Gettysburg event, his horse fell upon him. Only this time he could not extricate himself, and federal soldiers captured him. They carried him to Washington, D.C., where he was admitted to a hospital. His wound became gangrenous. Surgeons ruled out an amputation due to his weakness from loss of blood. Delony asked eighteen-year-old Union private John Wright,[193] who had been hospitalized months earlier after his wounding at Chancellorsville,

to read to him from the Bible. "The 14th Chapter of John was selected, and the reader began: 'Let not your heart be troubled. . . .'" Wright looked up at Delony, who had broken down in tears. "'Oh, I could die in peace, I could die in peace,' he sobbed, 'if only I were home with my wife and children. But it is so hard to die far from home and among strangers.'"[194] He passed away on October 2, 1863, at age thirty-eight. Union authorities buried his body in a numbered grave in a hospital cemetery. His remains were later disinterred and reburied in Athens.

Testaments to his chivalrous character appeared after his death, and veterans praised his knightly deeds long after the war. An unknown author wrote perhaps the most heartfelt of his eulogies on the back of his *carte de visite*: "A true & devoted friend—a pure patriot and a Christian. Lamented by all."

Border State Brothers Cross Paths

AT DAYBREAK ON JUNE 15, 1863, MAJ. WILLIAM GOLDS-
borough and skirmishers from the Second Maryland Infantry,
which belonged to an all Maryland Confederate force known as
"The Maryland Line," proceeded cautiously through the streets
of Winchester, Virginia. Spirited fighting only hours before
had led to a rout of the federals who had occupied the town,
and Goldsborough's troops moved to the distant sound of bat-
tle between their comrades and retreating enemy forces. They
soon came upon Star Fort, taking possession of it and about
two hundred enemy troops held captive there.[195] According to
one account, William made a prisoner of his younger brother,
Charles, who served the other side as assistant surgeon of the
Union Fifth Maryland Infantry.[196] Confederate authorities sent
Charles to Libby Prison in Richmond. William and his men next
marched into Pennsylvania.

A couple of weeks later, on July 2 at Gettysburg, Goldsbor-
ough took charge of his regiment after its commander suffered
a wound in desperate fighting on Culp's Hill. The Marylanders
and other units received orders to attack the position again the
next morning. Goldsborough told one of his captains, "It was
nothing less than murder to send men into that slaughter-pen."
Despite his opinion, he carried out the order. He and his men
charged headlong over a stone wall and into an open field—
exposed to heavy artillery and musket fire all the way. Enemy
troops checked the advance and forced them back. The attack
devastated the regiment.[197] More than two-thirds of the men
became casualties, including Goldsborough.[198] A bullet ripped
into the left side of his chest. It entered at his third rib, passed
through his lung, and exited his back.[199] He was carried to a

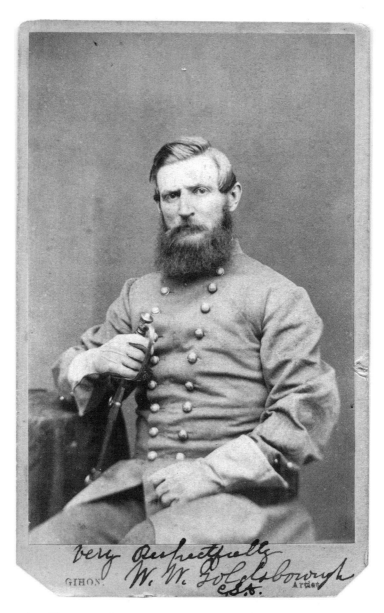

Maj. William Worthington Goldsborough, Second Maryland Infantry

Carte de visite by John Lawrence Gihon (1839–1878) of Philadelphia, Pennsylvania, about 1864. Collection of the Museum of the Confederacy, Richmond, Virginia.

nearby house, along with three other grievously wounded officers, and there they fell into enemy hands.[200] Goldsborough spent the next nine months at Union hospitals in Gettysburg and in Baltimore, where he had worked as a printer before the war.

While William recuperated, brother Charles received a parole and left Libby Prison. He returned to the North, reported for duty in Baltimore, and happened upon his brother William.[201] This time their roles were reversed. The reunion was brief and details of their meeting went unrecorded. In early 1864, Charles returned to the Union army in Virginia. William was discharged from the hospital, imprisoned in Fort McHenry, then transferred to Fort Delaware.

Between August and October 1864, William became one of six hundred officers confined in the Morris Island stockade in the line of Confederate artillery fire at Charleston, South Carolina. The men endured severe hardships and later were remembered as "The Immortal Six Hundred." After the ordeal ended, federal authorities sent William back to Fort Delaware, where he remained for the rest of the war.

Upon his release, he reunited with his wife, whom he had married about ten years before the war, and moved to Winchester, Virginia, where he established the *Winchester Times.* His account of the war, *The Maryland Line in the Confederate Army,* was published in 1869. About then, he sold the newspaper, settled in Philadelphia, and became a printer for the *Philadelphia Record.* In 1890, he moved west and worked for two newspapers in Washington State. About 1894, he returned to the East and the *Record* as shop foreman. He retired two years later after a bicycle ran over him, leaving him dependent on the aid of crutches for the rest of his life. He died on Christmas Day 1901 at age seventy. On his deathbed he told his wife, "Don't bury me among the damn Yankees here." She honored his wish and arranged to have his body interred alongside hundreds of veterans on "Confederate Hill" in Baltimore's Loudon Park Cemetery.[202]

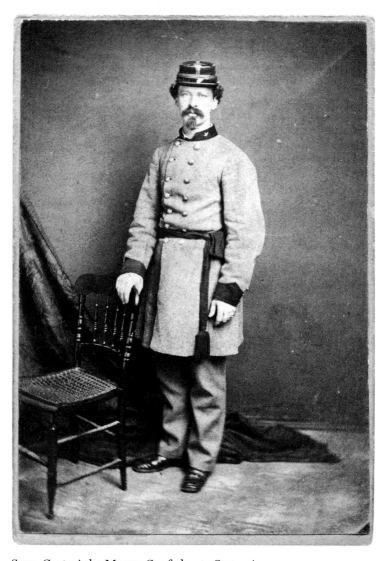

Surg. Gratz Ashe Moses, Confederate States Army

Carte de visite by unidentified photographer, about 1862–1865. William A. Turner collection.

The Idol of a Spy's Heart

IN THE SUMMER OF 1863, BELLE EDMONDSON DEDICATED a prayer in her diary to her fiancé, army doctor Gratz Moses: "Oh! My Savior, in thy mercy shield him, guide him from all temptation, protect him from disease and harm. And oh! my Father hasten the day which will make us twain. . . . I can but tremble even now, with fear, for my deep and holy love. Oh! Gratz, Idol of my heart."[203]

The two young lovers were swept up in a whirlwind romance in the midst of a war in which both actively served the South. Belle spied for the Confederate army: From her home on the outskirts of Memphis, Tennessee, the Mississippi native smuggled letters, supplies, and other goods in her clothing through occupied territory to Southern soldiers.

Gratz, the oldest of four children, was born in New Jersey, where his parents moved after his father graduated from medical school in his native Pennsylvania. When he was about two, Gratz and his family relocated to Missouri, his mother's home state, and settled in St. Louis.[204] He also became a physician. In early 1862 he received a commission as a Confederate army surgeon. His brother John also donned the gray uniform. Pro-Union St. Louis authorities jailed their father, who had openly expressed support for the South. They expelled him from federal territory, so he practiced elsewhere in the South.[205]

Gratz Moses began his military service as an artillery brigade surgeon and rose to command a medical department.[206] One of his army comrades introduced him to Belle. They fell in love and became engaged two months later. But the fire of passion that burned in his heart died, and with it went any hopes she had for marriage. In November, a distraught Belle recorded in her

diary, "Oh! God what can be wrong." Her December 31, 1863, entry noted the end of the relationship: "This day will close my happiest year. Yes my happiest and yet my sadest. May God in his majestic wisdom and mercy bless every desire of his heart—crown his future with happiness. I forgive him, oh! my Savior and bless him—teach him to think kindly of me—oh! God have mercy. My heart will break yet bless him."[207] Why Gratz jilted her is unclear. Belle's biographers suggest that the risks she took as a spy may have lowered her in his esteem, or his change of feeling may have been related to his discovery of an earlier affair she had had with a divorced man.[208]

The breakup devastated Belle. Although she continued to spy for the South, her activity level dropped off. She never wed, and she died under mysterious circumstances in 1873.[209] Gratz married, had children, and became a prominent gynecologist in partnership with his father in St. Louis. A serious fall in about 1884 left him paralyzed for the last seventeen years of his life. He died in 1901 at age sixty-one.[210]

Port Hudson Prisoner

In Ward C of the St. James U.S.A. General Hospital
in occupied New Orleans, Mike (Micajah) Wilson[211] was recu-
perating from a contusion to his right thigh caused by a gunshot
suffered during the recent siege of Port Hudson, Louisiana.[212]
As he lay in bed in July 1863, the Arkansas officer may have re-
flected on the events that led to his prisoner of war status.

He had joined the army two summers earlier. In July 1861,
the Georgia-born, widowed father of two and farmer in Union
Township[213] helped raise recruits in Ashley County. They be-
came Company K of the Ninth Arkansas Infantry and elected
him first lieutenant. He did not remain with his command
long.[214] By early 1862 he returned to his home county to orga-
nize the Ashley Light Infantry, which became Company F of the
Eighth Arkansas Infantry Battalion.[215] This time he was elected
captain. He soon rose to major, winning praise for "daring and
gallantry" in the Mississippi battles of Iuka and Corinth.[216]

On November 1, 1862, Wilson and the Eighth arrived at Port
Hudson. He and his men endured tough times over the next
eight months as they guarded against Union efforts to capture
the Confederate stronghold. Perhaps the Eighth's finest moment
occurred on the afternoon of May 27, 1863, when it participated
in a bloody repulse of an enemy assault against the Port Hudson
perimeter.[217] Five weeks later the Port Hudson garrison surren-
dered, after the fall of Vicksburg rendered its position unten-
able. The federals sent Wilson to New Orleans and admitted
him to the St. James Hospital for treatment of his thigh injury.
He returned to the general prison population within weeks and
spent the next year in various Northern prisons. In June 1864 he
was transferred to Fort Delaware.

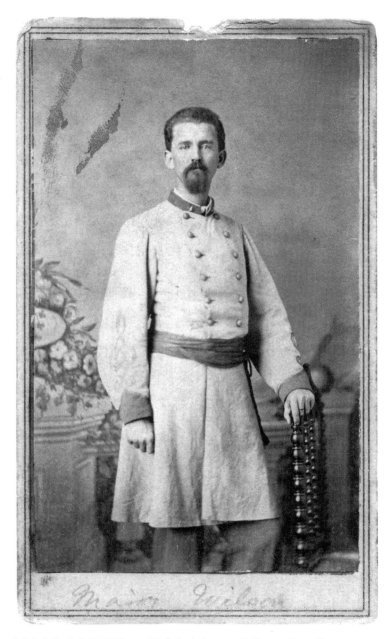

Maj. Micajah R. Wilson, Eighth Arkansas Infantry Battalion

Carte de visite by Samuel Wolfgang Moses (1798–1885) & Son of New Orleans, Louisiana, about 1861. William A. Turner collection.

Two months later, Union officials ordered six hundred officers, including Wilson, sent to Charleston, South Carolina, and confined on Morris Island in the line of Confederate fire, where they stayed for forty-five days. Afterwards, Union officials removed the officers to Georgia and confined them in Fort Pulaski. Wilson survived the ordeal. He was later returned to Fort Delaware, from where he gained his release after signing the oath of allegiance in June 1865.[218] The Confederate prisoners are remembered as "The Immortal Six Hundred."

Wilson settled in Louisiana after the war, returned to farming, and married twice more. His second wife bore him five sons, the youngest of whom was named Robert Lee Wilson.[219] Widowed a second time, he wed his third wife in 1899 at age fifty-six. They remained together until he died of pneumonia in 1904.[220]

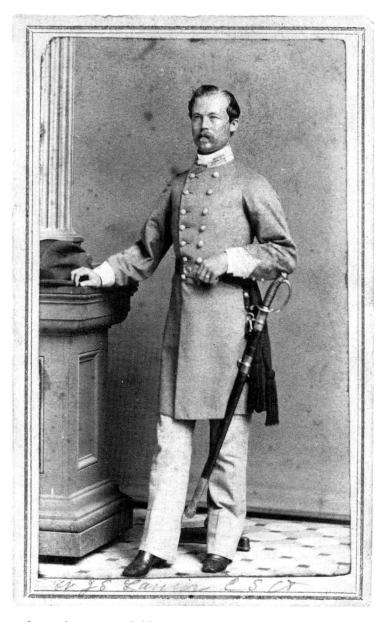

2nd Lt. John Summerfield Lanier, Confederate States Army

Carte de visite by Samuel Anderson (b. 1825) of New Orleans, Louisiana, about 1865. William A. Turner collection.

Surrender at Port Hudson

"HAVING THOROUGHLY DEFENDED THIS POSITION AS long as I deemed it necessary, I now surrender to you my sword, and with it this post and its garrison,"[221] stated Maj. Gen. Frank Gardner. With these words, spoken to his Union counterpart on the morning of July 9, 1863, the forty-eight-day siege of the Mississippi River stronghold of Port Hudson, Louisiana, was officially over. Thousands of Confederates became prisoners, including one of Gardner's capable staff officers, 2nd Lt. John Lanier.

The capture of Lanier deprived the army of a military-educated soldier. He had studied at the Georgia Military Institute,[222] earning degrees in civil engineering and the arts. After graduating, in 1858, he had returned to his home in Columbus, Mississippi, to which his family had moved from Huntsville, Alabama, during his boyhood. He applied his skills to agriculture and established himself as a planter.[223]

In May 1861 Lanier enlisted as a private in a company called the "Columbus Riflemen,"[224] but he left his comrades less than two weeks later to accept an appointment as a second lieutenant in the Confederate army. He reported to Memphis, Tennessee, for duty as a staff officer with Maj. Gen. Leonidas Polk. In April 1862, the general commended Lanier for his service during the Battle of Shiloh—the same fight that took the life of his older brother, James, a Confederate surgeon.

Authorities later assigned Lanier to the staff of Gen. Gardner, who led a brigade under Polk and took command of Port Hudson's defenses in early 1863. After the surrender of the Confederate bastion, Lanier spent the rest of the war in prison, confined for the majority of his two-year captivity at Johnson's

Island, Ohio, on Lake Erie. Federal authorities released him in June 1865 after he signed the oath of allegiance.[225]

He headed straight for New Orleans, where he married Annie Chambers about a month after gaining his freedom. In 1866 they settled in East Feliciana Parish, a county bordering Mississippi. There Lanier resumed his prewar agricultural pursuits and started a cotton plantation. He and Annie would have six children. In 1873 he won election as clerk of his parish's district court, a position he held for fifteen years, and he served as registrar of lands for Louisiana from 1892 to 1896. Active in politics as a Democrat, he became chairman of the state party's central committee in 1888. He belonged to several fraternal orders, including the Masons and Knights of Pythias. His wife, three sons, and a daughter survived him when he died, in 1900 at the age of sixty-one.[226]

A Lieutenant's Tearful Request

AN IRISHMAN DRIVING A WAGON-TURNED-AMBULANCE heard the sorrowful groans of the grievously wounded lieutenant he was transporting from the battlefield of Gettysburg. "Poor boy, I hope we'll soon reach your hospital," he said, trying to comfort the officer, whose right leg had been shattered below the knee by canister shot from Union artillery during the fighting on July 1, 1863. They soon reached their destination, and attendants carefully lifted the lieutenant out of the wagon and placed him on a pile of straw. "I knew my leg would have to be amputated, but did not wish it done by the surgeon of our regiment," he wrote. "I wanted Dr. Evins, the brigade surgeon, to perform the operation, and, with tears streaming down my cheeks, begging him to do it, which he promised he would."[227]

It is no surprise that the lieutenant requested the veteran physician by name. Many appreciated Dr. Thomas Evins for his skill and ability as a surgeon and his compassion as a caregiver.[228] Born in Spartanburg, South Carolina, he grew up in a family of Scotch-Irish descent. According to legend, his ancestors had spelled their name "Evans." Then, after a disagreement with an early ruling house of England by the same name, the family changed the second vowel in order to distinguish themselves.[229] Other branches of the family preferred the original spelling, and the individual who inscribed Evins's *carte de visite* used that version, incorrectly. Evins studied under his physician-uncle, then attended college and graduated with a medical degree. He opened a practice in Anderson, South Carolina, where he forged "a close and sacred intimacy with the families of this community," and became known as a man of "refined taste and correct principles."[230]

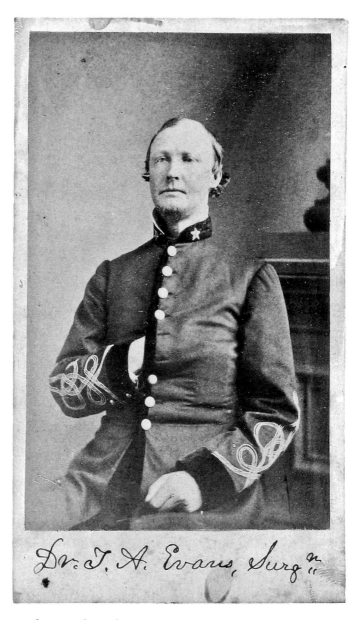

Surg. Thomas Alexander Evins, First South Carolina Rifles (Orr's)

Carte de visite by Charles J. Quinby (life dates unknown) & Co. of Charleston, S.C., about 1861–1862. Collections of South Caroliniana Library, University of South Carolina, Columbia.

In 1861, he left his practice to accept an appointment as a surgeon in the Confederate army. Three months later he joined "Orr's Rifles," a regiment named by its founder and first colonel, James L. Orr. It was also known as the state's First Rifles in recognition of its having the honor to be the first such regiment raised there. Dr. Evins earned a sterling reputation for the manner in which he managed his staff and tended to his patients. He advanced to chief surgeon of his brigade[231] and was serving in this capacity at Gettysburg. On the first day of the battle, he encountered the lieutenant who begged for his help. Evins evidently made good on his promise to aid the young officer, who survived the amputation of his leg and ultimately the war. The doctor survived the war, too. He surrendered as acting chief surgeon of his division at Appomattox Court House in April 1865.

He returned to his Anderson practice and married in 1866. In early 1872, kidney disease slowed him down and forced him into retirement. After a few months he became confined to bed, and he died before the end of the year, at age forty-seven. His wife, three children, and several siblings, including his brother, future U.S. Congressman John Evins, survived him.

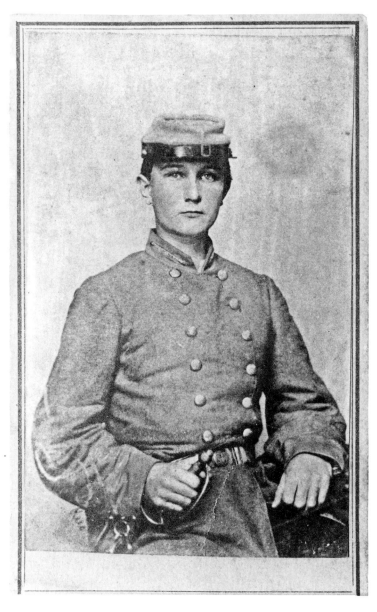

1st Lt. George David Raysor, Company G, Fifth Florida Infantry

Carte de visite by Charles R. Rees (life dates unknown) & Brother of Richmond, Virginia, about 1865. Robert L. Baldwin collection, U.S. Army Military History Institute.

Ordered in after Pickett's Charge

SHORTLY BEFORE THE ILL-FATED CHARGE OF MAJ. GEN. George E. Pickett's division on the third day of the Battle of Gettysburg, along a slope between the two armies, the tattered remnants of a brigade of Floridians, including 2nd Lt. George Raysor, lay flat against the ground in the blistering heat, as a furious bombardment raged above them.[232]

Born in South Carolina, the second of the five sons of John Raysor, a former Palmetto State legislator and ardent secessionist, young George moved with his family to Florida in 1846. They settled in Jefferson County, located along the eastern edge of the state's panhandle. After the war started, almost all of the Raysor men joined the army. One regiment chose George's father to be its colonel, but he resigned soon after the election due to heart disease; he died in 1863. Four of his five sons, including George, were of military age, and they enlisted in the "Aucilla Guards," which became Company G of the Fifth Florida Infantry.

The Fifth left for Virginia soon after its organization in early 1862. In his first year with the regiment, George rose from private to second lieutenant and fought in three major battles: Antietam, in which he sustained a slight wound and one of his brothers died,[233] Fredericksburg, and Chancellorsville.

On July 1, 1863, the Fifth and two other Florida regiments comprising a brigade commanded by Col. David Lang marched through the Pennsylvania countryside toward the sound of heavy firing at Gettysburg. The brigade went into action the following day, leading a charge against federal troops along the Emmitsburg Road, between the Rogers House and the Codori farmstead. After initial success, the Floridians fell back with heavy losses. Union troops had inflicted casualties on about half

of their number, including the captain of Company G, who was wounded and captured.[234] George Raysor took his place.

Early the next afternoon, Confederate cannon commenced a massive bombardment intended to soften up enemy positions before "Pickett's Charge." Union artillery responded. Iron and lead from both sides poured over the heads of Raysor and his comrades, who lay between the lines in support of their artillery. After Pickett's attack failed, the Floridians were ordered in. "The noise of artillery and small-arms was so deafening that it was impossible to make the voice heard above the din, and the men were by this time so badly scattered in the bushes and among the rocks that it was impossible to make any movement," stated Col. Lang.[235] Overwhelmed, the brigade withdrew. Raysor survived, but many of his comrades did not. In two days, the brigade lost 455 of its 700 men, the highest casualty rate of any gray brigade at Gettysburg.[236] The Fifth left the field with its colors—the only regiment in its brigade to do so.

Raysor advanced to first lieutenant and acting regimental adjutant.[237] He suffered a slight wound during the battles around Petersburg. Having obtained a furlough in the autumn of 1864, he went home and did not return. In May 1865 he surrendered at Tallahassee and signed the oath of allegiance.

Then, he married, moved to Quitman, Georgia, and found a job in the mercantile business; he also farmed and worked in saw milling. He and his wife had three daughters. In 1870, fellow Democrats nominated him for the post of county sheriff. He later joined the Populist Party. In 1898, he received a commission as Clerk of the Superior Court, an office he still held in 1909 when he died, at age sixty-six.[238]

Fighter from "The Bloody Eighth"

ON THE THIRD DAY OF THE BATTLE OF GETTYSBURG, 1st Sgt. Kirkbride Taylor and his comrades in the Eighth Virginia Infantry formed on the eastern slope of Seminary Ridge and waited for orders from its division commander, Maj. Gen. George E. Pickett. If any group of men could break the well-fortified Yankee line in front of them, it would be the battle-hardened veterans of this regiment, known as "The Bloody Eighth."[239]

An aspiring physician, Taylor hailed from a Quaker household in Goose Creek, a hamlet near the Potomac River in Loudoun County. His paternal grandfather, Jonathan, had helped establish the Loudoun Manumission and Emigration Society in 1824; the organization encouraged slave owners to free their slaves and send them to Haiti. His father, Benjamin, had served as a county delegate to Virginia's first annual convention for the abolition of slavery, in 1827.[240] After the war started, Taylor left his medical studies and joined the army. It is not known if his decision to be involved in the war conflicted with his religious beliefs. He enlisted as a first sergeant in Company D of the Eighth Infantry. The regiment fought in many early battles in Virginia, including the June 30, 1862, Battle of Glendale (Frayser's Farm), where Taylor sustained a minor wound.

One year later at Gettysburg, the Confederates launched an all-out artillery bombardment to soften up Union positions, and the men of the Eighth lay down on the slope of Seminary Ridge, awaiting the order to charge. After the bombardment ended, the men sprang forward in two battle lines alongside their brother regiments in the all-Virginia brigade commanded by Brig. Gen. Richard Garnett, and the rest of Pickett's Division. The Eighth

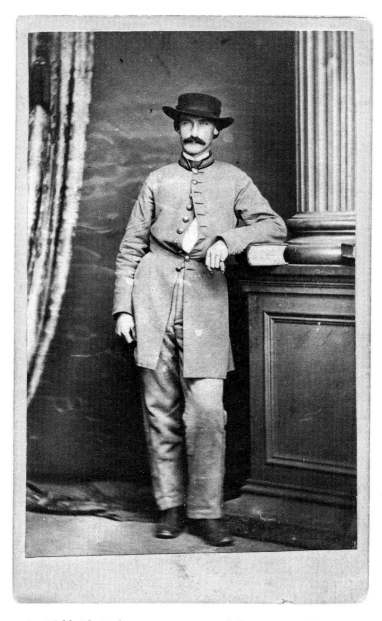

1st Lt. Kirkbride Taylor, Company H, Eighth Virginia Infantry

Carte de visite by Charles R. Rees (life dates unknown) & Co., Richmond, Virginia, about 1864–1865. Collection of the Museum of the Confederacy, Richmond, Virginia.

went in with about two hundred officers and men, Taylor's company leading the way as skirmishers. They charged enemy troops positioned behind a stone wall bordering a copse of trees. Federal fire decimated the regiment. As Taylor neared the wall, a minie bullet struck him in the side of the head but did not penetrate his skin. He fell back with a small group of survivors. The Virginians lost their battle flag to a Vermont regiment.[241]

Taylor made his way back to Virginia and went on to become an officer. In June 1864, he suffered his third wound of the war, a gunshot to the right side of his chest. The bullet did not cause serious injury but did require a brief hospital stay. He was hospitalized one more time during the war, but not for a battle wound; in March 1865, doctors in Richmond treated him for syphilis.[242] He returned to duty on April 2, the day before the capital city fell to Union forces.

After the war he returned to his family in Goose Creek, completed his medical studies, and became a physician. In the 1870s he married a woman about fifteen years his junior and settled in West Virginia, where their two children were born. Taylor lived until age seventy-three, dying in 1913. Upon the head of his lifeless body could still be seen an unusual indentation caused by the bullet that struck him during "Pickett's Charge."[243]

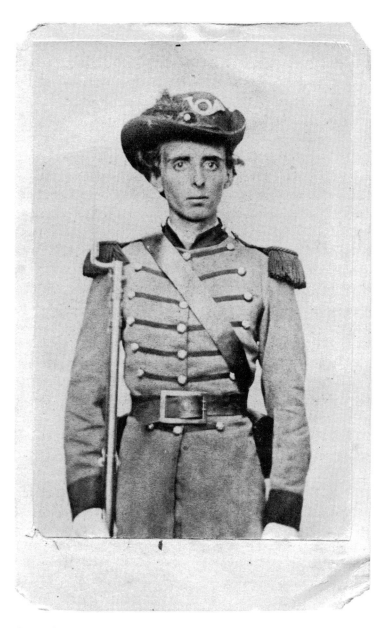

Chap. Thomas Dwight Witherspoon, Forty–second Mississippi
Infantry

Carte de visite by Bingham (life dates unknown) & Bros. of Memphis, Tennes-
see, about 1866. David Wynn Vaughan collection.

Captured on a Beautiful Sabbath Day

"I WAS CAPTURED IN THE AFTERNOON OF A BEAUTIFUL Sabbath day, the 5th of July, 1863, in a hospital tent, on the battlefield of Gettysburg, in the midst of a religious service, surrounded by the wounded on every hand, to whom I was ministering, and at whose urgent solicitation I had voluntarily remained within the enemy's lines," wrote Chaplain T. Dwight Witherspoon of the Forty-second Mississippi Infantry; "for a few never-to-be-forgotten days this ministry was permitted me, and then our field hospital was broken up, the few surviving wounded were removed to the field-hospitals of the Federal army, and the Confederate surgeons and chaplains transported to Northern prisons."[244]

Witherspoon did not accompany the other chaplains. Instead, with his captors' permission, he hurried off to a private home in Gettysburg, where his colonel, Hugh Miller, lay in the throes of death after suffering gunshot wounds to the chest and knee while leading his men in "Pickett's Charge." "I reached his bedside just in time to receive his dying expression of faith in Christ and his readiness to depart,"[245] he later reported. Actions like this contributed to Witherspoon's reputation as one of the "most devoted, untiring, self-sacrificing, and efficient chaplains that we had in the army," according to a fellow preacher.[246]

"There was something strangely spiritual about him that made us show him reverential respect,"[247] observed one writer, referring to a presence Witherspoon had probably exhibited since his days studying at the University of Mississippi at Oxford. He graduated with honors in 1856 and then entered the Presbyterian Seminary in Columbia, South Carolina. Ordained in 1860, he returned to Oxford and became pastor of the local

congregation. On April 30, 1861, after preaching a sermon on Psalm 20:7 ("Some trust in chariots, and some in horses; but we will remember the name of the Lord our God."), Witherspoon exchanged his minister's garb for the uniform of a Confederate private. He joined the "Lamar Rifles," which became Company G of the Eleventh Mississippi Infantry. He left the regiment in the summer of 1861 to accept an appointment as chaplain of the Second Infantry. About a year later, he transferred to the Forty-second Infantry and later advanced to brigade chaplain.[248]

"He was ever found at his post of duty, even when that was the outpost of the army or the advance line of battle," recalled a peer.[249] Such was the case at Gettysburg when he fell into enemy hands. After his colonel succumbed to his wounds, Witherspoon and the late colonel's son, Sgt. Edwin Miller,[250] accompanied the body to Baltimore, and the son continued with the remains to Richmond. The chaplain expected to be released upon his own recognizance, but Union authorities imprisoned him at Fort McHenry.[251] He endured several months in confinement before receiving a parole in late 1863.

The faces of the countless soldiers he influenced and inspired in camp, on the battlefield, and, after the war, in his congregations and seminary classes, were no doubt forever burned into his memory. The image of Edwin Miller, the colonel's son, may have symbolized the young warriors of his generation. In an unfinished account of his Gettysburg experience, Witherspoon described Miller as he stood at a Baltimore depot waiting with the casket that contained his father's remains: "A boy of apparently sixteen summers of slender frame and almost womanly delicacy & beauty of feature & his neat but almost threadbare uniform of Confederate gray, buttoned closely about him to shield him from the pelting rain. The quivering of the lips & the occasional tremor which passed over the slender form, telling of the mute agony of the boy whose form had stood unflinching amidst all the storm of the three days battle of Gettysburg, but who now found himself burdened with the thought that he must bear

home to his mother at once the tidings of her loss & the fearful confirmation of it."[252]

Reverend Witherspoon lived until age sixty-two, dying in 1898. Admirers remembered him as a genial man and graceful speaker who "was justly reputed one of the greatest preachers of his generation."[253]

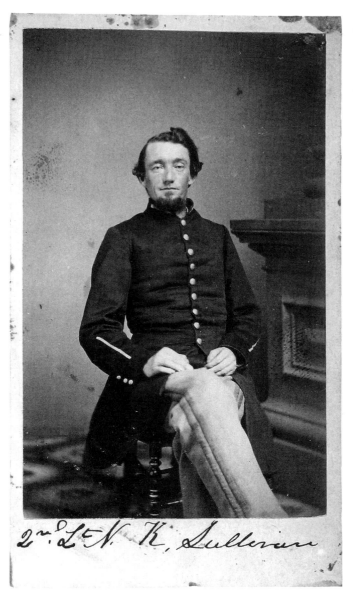

1st Lt. Nimrod Kelley Sullivan, Company C, First South Carolina Rifles (Orr's)

Carte de visite by Charles J. Quinby (life dates unknown) & Co. of Charleston, S.C., about 1861–1862. Collections of South Caroliniana Library, University of South Carolina, Columbia.

"A Most Unfortunate Affair"

TWO DIVISIONS OF EXHAUSTED AND HUNGRY GRAY IN-
fantrymen spent a miserable night trudging through the Mary-
land countryside in torrential rain, bogged down in mud and
muck up to their knees. Soon after daylight on July 14, 1863,
the men halted near the Potomac River at Falling Waters. They
stacked arms and fell asleep. "Before long a body of cavalry
were discovered approaching from the direction we had just
left," wrote an officer.[254] "They carried the stars and stripes of
the United States, but the color of their uniforms seemed to be
Confederate, and their manner of moving (by the flank, and lei-
surely) confirmed all in the belief that they were our own cav-
alry." They were wrong. The material of their mud-spattered
uniforms was Yankee blue. The federals quickly deployed in line
of battle and rushed the weary infantrymen. Many became ca-
sualties in the fast and ferocious fight that ensued, including 1st
Lt. Nimrod Sullivan.

Thirty-four-year-old Sullivan had left his family in Anderson
Court House, South Carolina, two years earlier and joined the
army as a second lieutenant in an outfit originally known as the
"Mountain Boys." It became Company C of the First South Caro-
lina Rifles, or "Orr's Rifles." In the spring of 1862, he departed
with his regiment for Virginia and received a promotion to first
lieutenant. He fought in all of the regiment's major battles, in-
cluding Chancellorsville, where almost half their number be-
came casualties. One month later at Gettysburg, commanders
held Orr's Rifles in reserve while the rest of the brigade partici-
pated in the attack that drove the federal First Corps from the
grounds of the Lutheran Seminary and through town on the
first day of the battle. During the withdrawal after Gettysburg,

the Army of Northern Virginia became trapped on the Maryland side of the Potomac River, which had been made impassable by heavy rains. The waters receded enough to allow the crossing of a pontoon bridge spanning the river at Falling Waters after dark on July 13.

It was the next morning when the Confederate rear guard, which included Sullivan and his regiment, were caught unaware by the surprise Union cavalry attack.[255] "The enemy dashed in, firing pistols and sabering everything in their way," wrote an officer. "The din was horrible, the confusion inextricable. There was fighting, flying, shouting, robbing dead men, all at once. Finally, the enemy retired, with a small loss. It was a most unfortunate affair."[256] Union troopers captured Sullivan and many others.

Nimrod Sullivan spent almost two years in captivity. The federals transported him to Baltimore, and then to Ohio, where they imprisoned him at Johnson's Island. He gained his release after signing the oath of allegiance to the U.S. government in June 1865. According to a cousin, he made his way to New York City. Although he was dressed in ragged clothing, barefoot, and longhaired, an old friend and business acquaintance recognized him in a chance meeting. His friend arranged for him to be cleaned up and properly clothed and then said, "'Nimrod, I want you to go back to Anderson and open up your mercantile business. A great day is ahead for business in the South.' 'But,' said Nimrod, 'I have no money; everything that I had has been swept away.'" His friend offered to underwrite the business and give him credit.[257]

Sullivan took him up on the generous offer and established the Sullivan Hardware Company. After he died, in 1881 at age fifty-one of a heart attack, his wife and four children carried on the family business.

"Hasten to Our Support!"

ON JULY 23, 1863, 2ND LT. JOHN ELLS AND THE MEN OF
the Third Georgia Infantry hunkered down behind a broken
rail fence overgrown by a tangle of grapevines and briars. The
soldiers, who belonged to a brigade led by Brig. Gen. Ambrose
Wright, watched as a large column of federals advanced on their
position along the heights of Virginia's Blue Ridge Mountains.
Commanders sent an urgent request for assistance: "Wright's
Brigade, of 600 muskets, occupying Manassas Gap protecting
the flank of Hill's Corps . . . have no cavalry or artillery . . . en-
emy in immediate front numbering from 10–20,000 . . . hasten
to our support!"[258]

The bluecoats attacked before reinforcements showed up.
"When they arrived within three hundred yards, our Enfield
rifles commenced fire upon them, and as they steadily ad-
vanced, our boys kept up a continuous fire, which often broke
their ranks, and turned them back in confusion. But the fresh
columns supporting their advance came on, until out-flanked
and borne down by the weight of numbers, our regiment was
ordered to fall back to the supporting line behind us. The Yan-
kees did not pursue, being checked by our artillery, which had
by this time gotten into position," noted a soldier-turned-histo-
rian.[259] But the enemy had inflicted many casualties, including
the wounding of Ells, who fell after a bullet tore into his right
hip.

The Union soldier who shot Ells could not have known that
he injured a man who had lived and married in the North. In
the late 1840s, Georgia-born Ells and his family moved from
their home in Bibb County, to Troy, New York—his grandpar-
ents and other relatives lived in the area. There he met Margaret

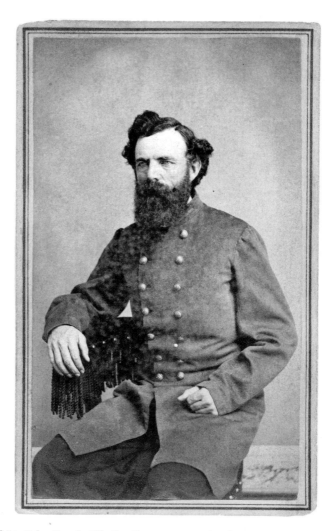

2nd Lt. John Lewis Ells Jr., Company G, Third Georgia Infantry
Carte de visite by Broocks (life dates unknown) of Augusta, Georgia, about 1863–64. David Wynn Vaughan collection.

Rickards, and they married in 1849. She gave birth to their first child, a son, in 1850. A daughter soon followed. About 1858 the young family returned to Georgia, settling in Savannah.[260]

When the war began, they had recently moved to Augusta. At the outbreak of hostilities, Ells enlisted in the city's "Confed-

erate Light Guards," which became Company G of the state's Third Infantry. The regiment was dispatched to Virginia, where several companies, including Ells's, received orders to report to the North Carolina coast, in a failed attempt to repel federal invaders. They returned to Virginia in the spring of 1862 and fought in key battles with the Army of Northern Virginia, including Antietam, where Ells suffered a minor wound.

At Gettysburg on July 2, 1863, the Third and three other units in Wright's Brigade charged the foe posted along the Emmitsburg Road, north and south of the Codori homestead, and captured cannon manned by two federal batteries. Pressing forward up a gentle slope, the Georgians closed on Yankees posted behind breastworks fronting the Copse of Trees, which would be the focal point of heavy fighting the next day during "Pickett's Charge." As the Confederates prepared to push on, the Union soldiers rose up and counterattacked. Overwhelmed, and unsupported on their left flank by brigades that failed to come up, the Georgia infantrymen fell back with heavy losses and abandoned the captured cannon.[261] The next day, the brigade covered the retreat of Maj. Gen. George Pickett's division after its failed charge. Ells survived the battle without injury only to be shot down two weeks later during the Confederate withdrawal at Manassas Gap.

The musket ball that struck him lodged near the hip joint of his right leg. Surgeons at a Richmond hospital operated but were unable to extract the bullet. He received a furlough to recuperate at his Augusta home. The wound remained unhealed four months later, "producing great pain and inability to walk without stick or crutch."[262] He bounced in and out of the hospital over the next year and a half. In December 1864 he left the army.

Ells eventually recovered from his wound and returned to work as a newspaperman in Augusta and Atlanta.[263] When a third child, another daughter, was born, she was named Jefferson Davis "Jeffie" Ells. The family later moved to Maryland and settled in Baltimore, where Ells continued his newspaper career.[264] He lived until 1889, dying at about age sixty.

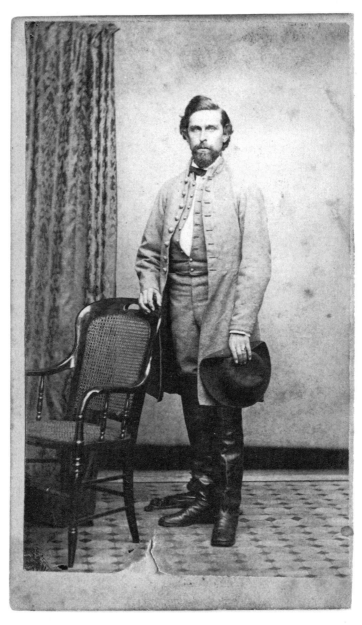

2nd Lt. Addison Ball Chinn, Company A, Eighth Kentucky Cavalry

Carte de visite by Cargo (life dates unknown) of Pittsburgh and Allegheny, Pennsylvania, about 1863–1864. William A. Turner collection.

"His Example Was of the Very Highest"

ON JULY 19, 1863, YANKEES CAPTURED 2ND LT. ADDISON Chinn of the Eighth Kentucky Cavalry and hundreds of other Confederate horse soldiers at Buffington Island, Ohio, during Brig. Gen. John Hunt Morgan's failed foray into the Buckeye State. Chinn spent the next two years in prison. "He bore his sufferings with calmness and uncomplaining endurance," recounted a biographer. "In prison his example was of the very highest. In camp he won the love of his comrades, on the field he won their admiration, and in prison he increased this admiration and affection."[265]

The son of a War of 1812 veteran, Chinn grew up in Lexington. His father, a physician and surgeon, served a stint as mayor. During Addison's teen years, the family moved to another Lexington—in Missouri, along the Missouri River. There he attended Masonic College.[266] He returned to Kentucky, married sometime around 1854, and found work as a dry goods store clerk. In 1860, he enlisted as a private in the "Lexington Chasseurs," a company of the state guard.

The war divided his family: His father supported the Union, but Addison joined Confederate Capt. Jo Shelby's band of horse soldiers. In 1862, he enlisted in the Eighth Kentucky Cavalry, starting as a second sergeant in Company A and advancing to second lieutenant. The regiment participated in Morgan's raids, but it dissolved after the 1863 defeat at Buffington Island resulted in its capture.

Chinn wound up in Pittsburgh's Western Penitentiary. Union authorities transferred him to Point Lookout, Maryland, in March 1864, and a few months later to Fort Delaware. He was among the six hundred Confederate prisoners sent to Morris Is-

land, South Carolina, and confined in a stockade in the line of Confederate artillery fire for forty-five days. An historian later referred to the group of officers as "The Immortal Six Hundred" in honor of their sacrifice, and the name has stuck. Chinn survived the ordeal and, after also suffering the harsh conditions of Savannah's Fort Pulaski, was returned to Fort Delaware. He gained his release after signing the oath of allegiance in June 1865.

Chinn returned to Lexington and resumed his job as a dry goods store clerk. He later became sole proprietor of the business. After his wife died in 1869, he remarried. He played an active role on the city's board of education and joined his local United Confederate Veterans camp. In 1902, two burglars, their faces covered by blue handkerchiefs, broke into Chinn's home. They found him in bed and demanded money. He told them he had no cash to give, and one of the men shot and killed him with a pistol.[267] He was sixty-nine. His wife and two children survived him. The murderers confessed, and the state executed them by hanging. Friends remembered him as "A gentleman and a Christian—simple, unostentatious, charitable, upright. In all the relations of life he was precisely the same man that he was during the four years of war, bearing with patience and courage whatever had to be borne, furnishing an example of what was best in life to those who came in contact with him."[268]

Iron Man

"THROUGH HABIT I HAVE ACQUIRED A MORBID FONDNESS for action. Nothing short of being continually strained up to the full extent of my mental and physical capacities will satisfy me at all," wrote Tom Webber to his folks about the "restless determination and nervous temperament" that drove him to be a furious fighter with a fanatical devotion to duty. In the same letter home, he closed with a phrase that could have been his motto: "Let it be Foreward! Foreward! Foreward!"[269]

Some knew him as the "Iron Man,"[270] a nickname given to him by another officer in recognition of his heroic actions during John Hunt Morgan's Ohio Raid. After the gray cavalrymen were defeated at Buffington Island on July 19, 1863, the survivors were reorganized into two brigades. Webber took charge of the first and set about the task of getting them home. He led his troopers against overwhelming odds: "Worn down by tremendous and long sustained exertion, encompassed by a multitude of foes, and fresh ones springing up in their path at every mile, allowed no rest, but driven on night and day; attacked, harassed, intercepted at every moment," recalled one commander. Webber drove his men with an "unflinching steadiness."[271]

Webber's leadership may have been indicative of a formally educated soldier, but before the war he had worked as a dry goods merchant and postmaster in Byhalia, Mississippi. He moved there in the 1850s, leaving his preacher father and the rest of his family in Tennessee. He had opposed secession, but he changed his mind after the 1860 presidential election. Fearing a loss of rights under the new administration, he wrote, "Let us go out together and show Lincoln and the world that we will not submit to his despotism," and added, "The sound of the drum-

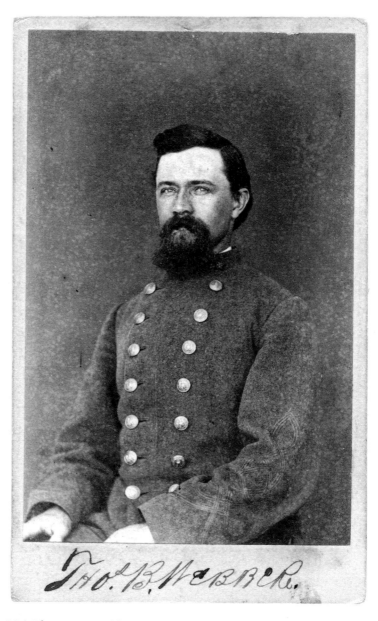

Maj. Thomas B. Webber, Second Kentucky Cavalry

Carte de visite by John Lawrence Gihon (1839–1878) of Philadelphia, Pennsylvania, about 1864. John Sickles collection.

mer must take the place of the hammer and spinning wheel."[272]

In March 1861, he enrolled as a private in the "Jeff Davis Rifles," refusing to accept pay. The "Rifles" became a company in Mississippi's Ninth Infantry. His younger brother also served in the regiment. Assigned to duty in Florida, Tom Webber might have spent his entire enlistment with the regiment. However, his brother fell mortally wounded in battle at Santa Rosa Island on October 9, 1861, and Tom accompanied the body home to his family. He did not rejoin the Ninth.[273]

In 1862, Webber organized a local cavalry company and became its captain. He boasted that his men were "of the finest material of the country."[274] His troopers joined the Second Kentucky Cavalry, which belonged to Gen. Morgan's command. The general referred to the Second as his "Regulars," out of respect for their fighting abilities.[275]

Webber advanced to major, rode with "Morgan's Raiders" into Ohio, and fell into enemy hands on July 22, 1863, near Nelsonville on the Hocking River, two days after he took brigade command. His captors held him at several locations in the Buckeye State, including in solitary confinement at the Ohio State Penitentiary, after he wrote a letter in support of the execution of black Union soldiers and their white officers taken in battle.[276] Webber saw his position as consistent with the law, and it changed with the law: A slave named Lee, given to Webber by his father, accompanied him when he returned to war in 1862. After President Lincoln issued the Emancipation Proclamation, according to Lee, "the major . . . told me I was a free man, and could do as I pleased." Lee stayed and served Webber until the latter's capture seven months later.[277]

In March 1864, Union authorities transferred Webber to Fort Delaware. In June he and fifty-four other officers were sent to Charleston Harbor to be imprisoned in front of Union batteries on Morris Island.[278] The plan was not completed, and they remained confined on a steamship in stifling heat for five weeks. They were then exchanged for fifty federal officers and released.

Webber rejoined his command, fought until the fall of Richmond, and joined the escort for President Jefferson Davis as he fled the federals. Webber and about seventy-five of his troopers were surrounded at Washington, Georgia, in May 1865, but eluded their pursuers. They rode for Texas to join the last gray army in the field and had traveled as far as Columbia, Mississippi, before learning that those forces, E. Kirby Smith's Trans-Mississippi Department, had surrendered.[279] Webber disbanded his command and returned home without signing the oath of allegiance.

Webber married in 1866. The Iron Man died just three years later, at age thirty-five, of "softening of the brain," which may indicate a stroke.[280]

He Endured Cold and Hunger

PRIVATE JOHN COLEMAN STOOD IN THE PHOTOGRAPHER'S studio, his head held still by an iron brace placed discreetly behind him (its legs are barely visible behind his feet). He steadied himself by gripping the back of a chair with his right hand. The camera operator exposed a chemically treated glass plate to the light for a matter of seconds. Prints were made from the resulting negative, and John soon had copies to give to family, friends, and army comrades. On the back of one of these prints is written his name and the date, August 25, 1863—his third full day at Camp Douglas, the overcrowded, disease-ridden prisoner of war camp on the south side of Chicago. The photographer likely visited the captured Confederates in camp.

He had likely given little if any thought to the possibility of his being captured when he enlisted nine months earlier. In November 1862, he left his home—parents, siblings, and about twenty-five slaves who worked the family farm—near O'Bannon, Kentucky, and joined the army. "With but little drilling or training," noted one writer, "Coleman was assigned to a cavalry command,"[281] Company C of the Second Kentucky Mounted Rifles. It became Company K of the Seventh Cavalry, one of the regiments that composed the force commanded by Brig. Gen. John Hunt Morgan.

Coleman participated in Morgan's raids, including the incursion into Ohio that ended in defeat—and his capture—at Buffington Island on July 19, 1863. Federal authorities first sent him to Camp Morton near Indianapolis, Indiana, then to Camp Douglas. According to one report, he suffered "much hardship from cold and hunger," during his imprisonment.

In March 1865, his captors transferred him to Point Lookout,

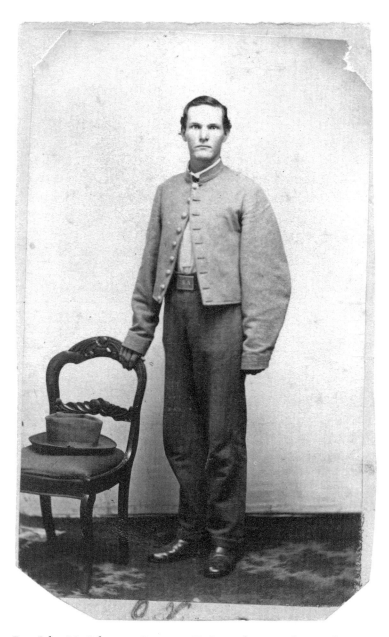

Pvt. John M. Coleman, Company K, Seventh Kentucky Cavalry

Carte de visite by D. F. Brandon (life dates unknown) of Camp Douglas, Illinois, 1863. Author's collection.

Maryland, from where he and about 3,500 other paroled Confederates were shipped to City Point, Virginia, and exchanged. Medical personnel admitted him to a hospital after his arrival. He later rejoined the Seventh and remained with his regiment until the end of hostilities.[282]

He returned to Kentucky, married, and fathered two sons. "For a few years after the war he was a tobacco man of Louisville," according to a comrade in his United Confederate Veterans camp, "later conducting a general store at O'Bannon and keeping up his farming interests." He lived until age eighty, dying in 1924 at the home of one of his sons. His obituary described him as "a Christian gentleman and citizen."[283]

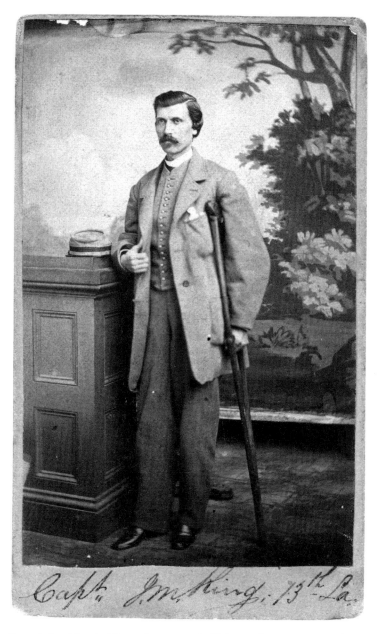

Capt. John Martin King, Company C, Thirteenth Louisiana Infantry

Carte de visite by unidentified photographer, about 1863. William A. Turner collection.

Old Wound

Surgeons agreed that Capt. John King's leg must be amputated. Months had passed since he had sustained a gunshot wound in his right thigh, and the wound had not healed properly. On September 8, 1863, the young officer prepared for the coming ordeal. At this critical time, there is no doubt that he would have benefited from the support of his friends and family. However, they could not join him, for he was a prisoner of war, and the man about to perform his surgery was a Union physician in a military hospital in occupied Nashville—far from his Louisiana home.[284]

A New Orleans resident, King had enlisted in the Fifth Company of the "Governor's Guards" during the summer of 1861. The men in the ranks elected him one of their officers. The company later became a unit in the Thirteenth Louisiana Infantry. The regiment participated in several major engagements early in the war, including the Battle of Stone's River, Tennessee, where he suffered his injury.

On January 2, 1863, in a wooded area on the east bank of Stone's River, near Murfreesboro, the Thirteenth attacked and initially drove back enemy forces. But it ran into concentrated infantry and artillery fire that savaged the regiment's ranks and forced it to abandon its early gains. The Thirteenth's commander, Col. Randall Gibson, blamed well-directed enemy fire "for the extraordinary loss we sustained, and for the fact that nearly all our wounded and killed were left on the field." Half of the regiment's twenty-eight line officers became casualties, including King. In a report written after the battle, his colonel recognized him and five other officers for displaying "distinguished steadiness and courage" during the fight.[285]

Union soldiers likely captured King where he fell. They sent him to Nashville, where he entered a military hospital. His case drew the attention of a high-ranking surgeon, the one who amputated the leg.[286] Postoperative problems plagued him after his release from prison in September 1864. He spent the fall and winter in and out of hospitals in Charlottesville and Richmond, Virginia. Military authorities placed him on the retired list in January 1865 and assigned him to the Invalid Corps, which had been organized by the Confederate government for men disabled in the line of duty. On February 20, 1865, he autographed his *carte de visite* for his old commander, Randall Gibson.[287] It is his last known signature.

Chickamauga Casualty

On September 19, 1863, Pvt. Felix Arroyo and the other gunners in the Washington Artillery forded Chickamauga Creek at Glass's Mills and hastily made their way across the north Georgia landscape, where enemy artillery posted on high ground waited to meet them. As they unlimbered their cannon, a federal round slammed into Arroyo's gun. The shell also ripped through the body of his lieutenant and felled another private, blowing off part of his face and one of his arms. Both died. A shell fragment struck Arroyo in the head, and he slumped to the ground. As he lay amidst the carnage, the wheel of a runaway horse-drawn limber rolled over his back.[288]

Thirty-eight-year-old Arroyo had served in the artillery for a short time before his wounding. A college-educated Creole descended from a family that had lived in Louisiana under Spanish rule, he had worked as a clerk and sugar agent in New Orleans. He had also served as a first lieutenant in a local militia unit, the "Orleans Guard." After federal forces occupied the city in May 1862, the Yankees gave him the option of either pledging allegiance to the U.S. government or being banished. He chose the latter, leaving behind his wife and enlisting in the Fifth Company of the Washington Artillery.[289] Chickamauga was his first major battle.

Confederate medical personnel admitted him to a nearby hospital after his wounding, and he was soon able to return to his company. Two months later, he narrowly escaped a second wounding, at Missionary Ridge in Chattanooga, Tennessee. During the battle he became fatigued, having not fully recuperated from his injury. His lieutenant replaced him with a new man, who soon fell after being shot in the neck.[290] Arroyo went on

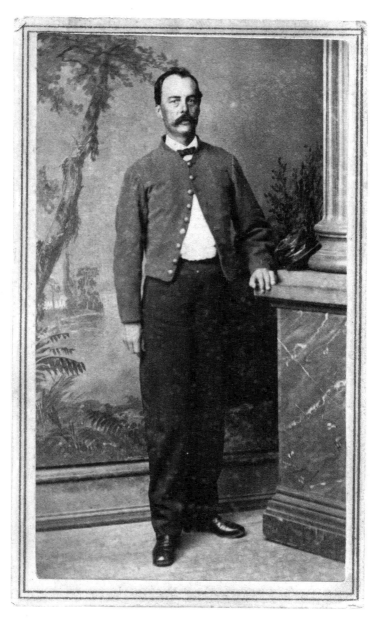

Corp. Felix Arroyo, Fifth Company, Washington Artillery
(Louisiana)

Carte de visite by unidentified photographer, about 1864–1866. William A.
Turner collection.

to fight in the Atlanta Campaign and, afterwards, in Tennessee and Alabama. He surrendered with his company and received a parole at Meridian, Mississippi, in May 1865. He left the army as a corporal.

Arroyo returned to New Orleans and rejoined his wife; in time, they had a son and a daughter. He worked as a clerk at an insurance company. His health fell into decline beginning in 1873. Progressive paralysis, attributed to the back injury he suffered at Chickamauga, gradually consumed him. He died at home in 1891, crippled and blind, at age sixty-six.[291]

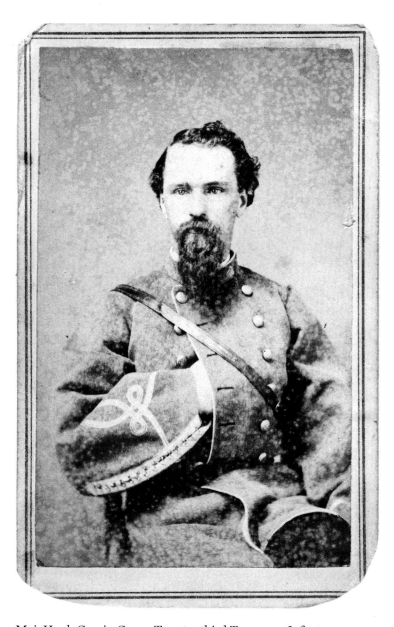

Maj. Hugh Garvin Gwyn, Twenty–third Tennessee Infantry

Carte de visite by unidentified photographer, about 1865. Collection of the Museum of the Confederacy, Richmond, Virginia.

"True to the Last"

THE TWENTY-THIRD TENNESSEE INFANTRY, A REGIMENT
in Maj. Gen. A. P. Stewart's "Little Giant Division," rolled over
its opposition at Chickamauga, Georgia, on September 19, 1863.
The Tennessee soldiers engaged in the day's most intense fight-
ing along Missionary Ridge. "The firing was heavy, and the ene-
my's massive columns were hurling against our wearied heroes,"
recounted the Twenty-third's brigade commander. "Here officers
and men behaved most gallantly. Appeals to love of home and
wounded comrades and the peril of the moment were made,
and never did men rush forward more eager, daring, desper-
ate and defiant."[292] They drove the federals from the field. Many
sustained wounds that day, including Adjutant Hugh Gwyn.[293]
Reports do not specify the exact nature of his injury. His superi-
ors praised him for his conduct.[294]

Gwyn belonged to a family with divided loyalties. An older
brother, James, became colonel of a Union regiment. Both were
born in Londonderry, Ireland. Hugh, the eleventh of fifteen chil-
dren, arrived in America in 1850 at age twelve.[295] According to
one biographer, "While yet a minor, he joined a force of railway
engineers operating in southern Kentucky and northern Ten-
nessee, and then became a soldier of the Confederacy."[296] Gwyn
recalled his first military experience as taking place at Bowling
Green, Kentucky,[297] where the Twenty-third relocated after its
organization for state service in October 1861. The regiment
participated in key battles in the region over the next two years,
including Shiloh, Perryville, Stone's River, and Chickamauga.

In January 1864, he requested a transfer to the staff of Brig.
Gen. John Hunt Morgan. According to one account, he aided
Morgan in a reorganization of his command and served on his

staff until the general's death on September 4, 1864.[298] He then joined the staff of Morgan's successor, Brig. Gen. Basil Duke. In the waning days of the war, Duke obtained for Gwyn a promotion to major for his "inestimable assistance."[299] Reflecting on his military service in the summer of 1865, Gwyn wrote with pride, "I had remained true to the last."[300]

"At the end of the war Maj. Gwyn turned his natural energy to the arts of peace, and he has made as good a citizen as he was a soldier," noted an old army comrade.[301] He married and, by 1870, resided in Mississippi. A decade later, he lived in Nashville, Tennessee, where he worked as a railroad supply agent. His marriage dissolved, and in 1887 he moved to San Diego, California. His employment there included a partnership in an insurance business with his brother-in-law and being postmaster of the San Diego suburb of Coronado. He formed the John H. Morgan Camp of the United Confederate Veterans. At age eighty-one, in 1921, he remarried; his wife died two years later. After another two years, he died, in 1925, from shock and heart failure after refusing surgery to clear an intestinal obstruction. He objected to the operation on the grounds of his Christian Scientist beliefs.[302] A son from his first marriage survived him.

A fellow veteran remembered Gwyn as a kind man who led "a life full of helpfulness to others. His unselfish, fearless spirit incited others to do likewise, and he became the center of innumerable, ever-widening waves of action so that thousands have been encouraged and aided by his splendid spirit. Therefore, his life is immortal, for he never will be forgotten."[303]

A Hero of Fort Sumter

AT 4 A.M. ON NOVEMBER 24, 1863, A SENTINEL AT FORT Sumter reported to Capt. Frank Harleston that the tide had washed away a section of the sharply-pointed *chevaux de frise*[304] placed along the outside of the fort's battered walls for defensive purposes. He was the perfect man to inspect the damage: intelligent and highly respected, he had graduated from the South Carolina Military Academy at the head of the Class of 1860. "Young Harleston is one of our best Citadel boys," asserted Confederate congressman and former Charleston mayor William Porcher Miles.[305]

After South Carolina's secession from the Union, Harleston had joined the academy's corps of cadets at Morris Island in Charleston Harbor and received an appointment as an officer in the state's First Artillery. Assigned to the garrison at nearby Fort Moultrie, he was ordered to man a floating ironclad battery at Cummings Point shortly before the momentous bombardment of Fort Sumter. On April 12, 1861, an officer observed Harleston and another lieutenant "working their guns with all the rapidity which the order of firing permitted," during the historic attack.[306]

After Sumter fell, he returned to Fort Moultrie and served for a time as adjutant of that post. Later that year he became an aide-de-camp to Brig. Gen. Roswell Ripley. He left this position in early 1862 and went to Fort Sumter as captain of the First Artillery's Company D. His responsibilities included the training of recruits, a task that tried his patience but resulted in producing expert artillerists.[307]

Harleston and his gunners would be put to the test in the summer of 1863 after the enemy established heavy artillery bat-

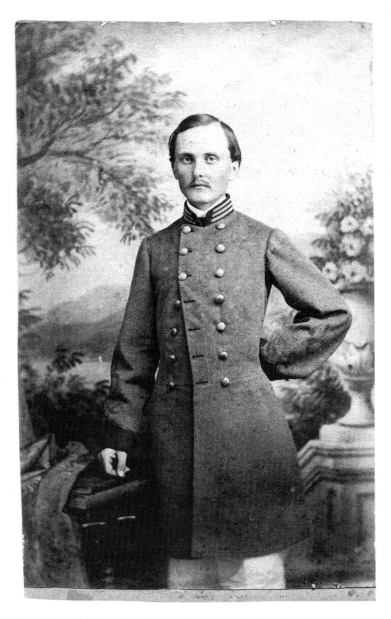

Capt. Francis Huger Harleston, Company D, First South Carolina Artillery

Carte de visite by George Smith Cook (1819–1902) of Charleston, South Carolina, about 1861. William A. Turner collection.

teries on Morris Island. Shells from these guns, and others from Union warships, crashed through Sumter's brick and mortar walls "as though they were made of paste-board." Slightly wounded by one shell, Harleston hunkered down with his men as enemy fire reduced the fort to rubble. In early September they were withdrawn for a well-deserved break.[308]

A few weeks later, Harleston and his command reoccupied Sumter, which continued to be bombarded. His term of duty expired on November 21, but the post commander asked him to stay a while longer. He agreed. Three days later he received the report about the missing section of *chevaux de frise* and made his way outside the fort's walls to inspect the damage. Fifteen minutes later, a detail of men went to find him, since he had not returned. They found him lying on the wet rocks near the water's edge, writhing in agony; a shell fired from a massive Parrott gun had smashed into the rocks and burst. Its fragments had ripped into his thighs and an arm, terribly mangling his body. "He was borne into the fort that he had fought for so gallantly, and his heart's blood flowed upon her stones," wrote a biographer. He lingered for hours before succumbing to his mortal injuries at age twenty-three.[309]

An officer later eulogized him: "What a beautiful character that young man had, so gentle and so strong. I think his death was more regretted than that of any other man whom I came in contact with during the war. He was so much respected by his commanders, and so truly loved by his equals and subordinates."[310] Word of his death made its way up the chain of command to Gen. P. G. T. Beauregard, who ordered that a gun emplacement located on James Island be renamed "Battery Harleston" in his honor.[311]

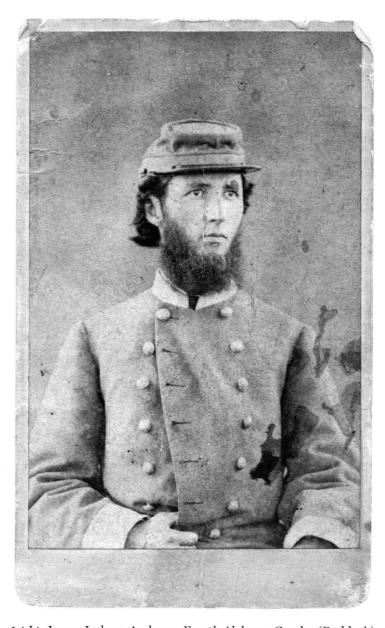

1st Lt. James Jackson Andrews, Fourth Alabama Cavalry (Roddey's)

Carte de visite by John Lawrence Gihon (1839–1878) of Philadelphia, Pennsylvania, about 1864. Collection of the Museum of the Confederacy, Richmond, Virginia.

Captured in Alabama

BRIGADIER GENERAL PHILIP RODDEY'S BRIGADE OF
cavalry flustered federal forces who had been chasing his elusive
gray horsemen through northern Alabama in the fall of 1863.
"Roddey ought to be caught," wrote one frustrated Yankee briga-
dier on November 30.[312] The next day, the Ninth Illinois Cavalry
found part of Roddey's command along the Tennessee River
near the railroad town of Florence and attacked them, driving
the troopers across the river and capturing forty men, including
one of Roddey's aides, 1st Lt. James Andrews.

Andrews was on his home turf. He had lived in Florence be-
fore the war and had made a bundle of money when he sold his
interest in a cotton mill there. "His first thought when any good
fortune occurred to him was to share it with his friends," recalled
a childhood pal, who remembered him as a man of compassion
ever ready to help those in need.[313]

He sprang to the aid of his home state after war came, donat-
ing five hundred dollars to help the widows and orphans of Flor-
ence.[314] Then he enlisted as a second lieutenant in "The Rebel
Troopers." This outfit became Company F of the Fourth Alabama
Cavalry, a regiment commanded by Roddey. Andrews's army ca-
reer almost came to an end in the winter of 1862 after a doctor
diagnosed him with tuberculosis. He resigned with a medical
discharge. However, his health improved,[315] and he joined Rod-
dey's staff as a first lieutenant and aide-de-camp in early 1863.
Later that year, the Illinois cavalrymen captured him.

His captors sent him to Fort Delaware by way of Tennessee,
Kentucky, and Ohio. In August 1864, he became one of the six
hundred officers sent to Morris Island, South Carolina, and
confined in a stockade in the line of Confederate artillery fire

for forty-five days who later became known as "The Immortal Six Hundred." On October 21, Andrews and the others were removed to Georgia and imprisoned at Fort Pulaski, located on Cockspur Island at the mouth of the Savannah River. Overcrowded conditions subsequently caused the removal of 197 men, including Andrews, to nearby Hilton Head Island. Shortly before Christmas, he received a parole and gained his release.

After the war, he settled in northern Mississippi and worked as an agent for a New Orleans–based cotton company. He married in 1870 and fathered two children. When he died, in 1896 at age fifty-eight, a boyhood friend wrote that he "was one of the noblest hearted men that ever lived," and added, "Although God could have made a better man, he probably never did."[316]

The Capture of a Yankee Gunboat

ON JANUARY 31, 1864, CAPT. NATHANIEL STURDIVANT and his patrol arrived at Cherry Grove, a landing along Virginia's James River with an unobstructed view of occupied Norfolk. Their mission was to report on enemy activity. He observed nothing unusual and decided to return to their winter quarters. On the way back, he unexpectedly crossed paths with Union troops who had been dispatched from Norfolk to investigate reports that Confederates had been spotted in the area. After a brief exchange of fire, the federals withdrew to the nearby river town of Smithfield, where they waited overnight for the gunboat *Smith Briggs* to pick them up. Sturdivant continued on with his men.

The next day, a messenger intercepted Sturdivant and delivered a note from a local farmer: The Yankees were "bottled up" in Smithfield and could easily be captured.[317] Sturdivant met the farmer, who guided him to high ground on the outskirts of town, and could see the vulnerability of the enemy. Sturdivant immediately sent a message to the federals, "demanding instant surrender."[318] He signed it as a brigadier, probably a ruse to convince them that he had with him a large force. In reality, he commanded a small number of men—two companies of infantry, a few cavalrymen, and gunners with a pair of cannon.[319] The Yankees responded with a request for an interview, and Sturdivant became convinced that his adversary was playing for time: The rising tide would likely bring the *Smith Briggs* to the rescue. He renewed his demand for surrender. The Union leader refused his offer.

Sturdivant and his force entered Smithfield and attacked. As the fight raged, the booming of distant cannon erupted. The big guns belonged to the *Smith Briggs,* en route to Smithfield. The

ship pulled up alongside the town's wharf, and anxious federal troops began to board her. Sturdivant's men stormed the dock. His artillerists set up a cannon on the wharf and blasted the gunboat. It "sent a shot through her and right into her steam chest. She instantly surrendered."[320] About ninety men and the ship's crew were captured, and the Confederates burned the vessel to prevent its recapture.[321] Sturdivant instantly became a hero. One

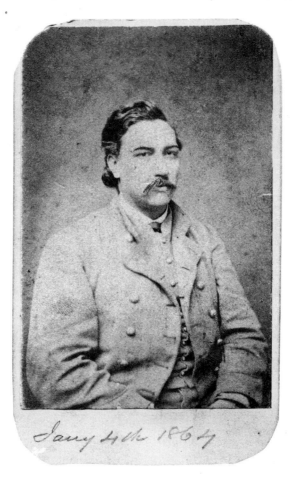

Maj. Nathaniel A. Sturdivant, Sturdivant's Battalion Reserve Artillery

Carte de visite by unidentified photographer, about 1864. William A. Turner collection.

of his men noted: "It was the first time Captain Sturdivant was under fire, and no veteran could have displayed greater coolness. He sat his horse and gave his commands with apparent calmness. It was his demeanor that put confidence in his men, and all stood at their posts."[322]

Those who knew him would probably not have been surprised by his conduct. A self-made man, the Petersburg, Virginia, native grew up in poverty, educated himself, and had worked his way from mechanic to physician by his early twenties. He moved to Richmond about 1852, became a lawyer, and gained prominence as a lecturer and the editor of a temperance newspaper. At the start of the war he ranked as one of the city's top attorneys.[323] In 1862, he organized an artillery company that took his name.

A few months after the action at Smithfield, Sturdivant's Company joined a battalion. Assigned to protect Petersburg, Sturdivant and two of his guns were overwhelmed by a federal assault that led to the capture of a mile-long section of batteries along the defensive perimeter of the city on June 15, 1864. Initial reports listed him among the dead. In fact, he survived the attack, but he fell into enemy hands. He spent the next four months as a prisoner at Fort Delaware. After his release, he returned to his company and advanced to major and battalion commander.[324]

In April 1865, the citizens of Richmond voted him mayor, but he did not serve: U.S. officials prevented the war hero from taking office. He then won election as the commonwealth's attorney for the city, and government authorities again prevented him from serving. Out of options, he resumed his law practice. His health failed near the end of the decade, and he traveled to Bath County in 1869 for the healing waters of its hot springs. They did not relieve his symptoms, and he succumbed to "a severe and protracted illness" at age thirty-four. He never married.[325]

His obituary paid tribute to his character: "Sincere, candid, and possessed of the strictest sense of honor. His warm and sympathizing nature, his great fidelity as a friend, his pleasant and genial manners, and his honorable bearing, made him one of the most popular men in Richmond."[326]

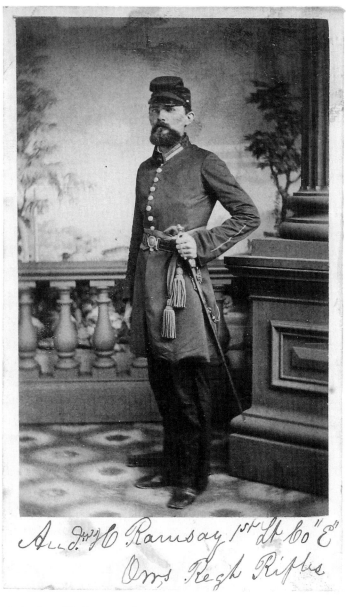

Capt. Andrew H. Ramsay, Company E, First South Carolina Rifles (Orr's)

Carte de visite by Charles J. Quinby (life dates unknown) & Co. of Charleston, South Carolina, about 1861–1862. Collections of South Caroliniana Library, University of South Carolina, Columbia.

Absent without Leave

By 1864, Capt. Andrew Ramsay's days in the army were numbered. Scheduled to return from a thirty-day furlough on March 30, he did not show up until the middle of April. Authorities filed a charge against him of being absent without leave. Moreover, a question of character influenced his case.

Georgia-born Ramsay, a twenty-nine-year-old married father of five, started the war as a first lieutenant in the "Oconee Riflemen," one of four Pickens District, South Carolina, companies that became part of the First South Carolina Rifles, or "Orr's Rifles." In the spring of 1862, he departed with his regiment for Virginia. He advanced to captain after his company commander died in action at the Battle of Second Manassas. Ramsay's leadership ability became the subject of hushed conversation after he took command. Murmurings of discontent may have come from the rank and file, or observations by his fellow officers may have been brought to the attention of the regimental staff. An order dismissing him for lack of courage became mired in bureaucracy.[327]

Ramsay's failure to return on time from his furlough provided a convenient reason to remove him from command. On April 21, 1864, the charge of being absent without leave was filed against him. He resigned rather than fight the charge, but he remained on the regiment's rolls for another four months. The majority of that time he spent in hospitals in Richmond, undergoing treatment for general debility, diarrhea, and dyspepsia.[328]

After his discharge from the hospital, Ramsay returned to Walton's Ford, a community on the border of South Carolina and Georgia, and rejoined his family, which grew to include six sons and four daughters. He lived until 1909, dying at about age seventy-seven.

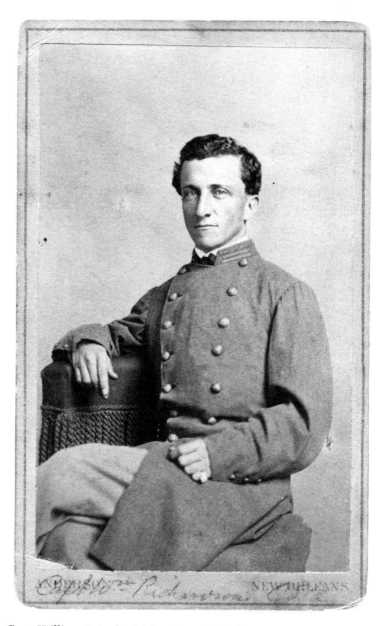

Capt. William Priestley Richardson, Confederate States Army

Carte de visite by Samuel Anderson (b. 1825) & Augustus Austin Turner (1831–1866) of New Orleans, Louisiana, about 1864–1866. William A. Turner collection.

Artilleryman Turned Infantry Officer

In February 1864, Brig. Gen. Randall Gibson needed a new ordnance chief for his brigade staff. He selected twenty-three-year-old Louisianan William Richardson, a young man with excellent credentials. The second of four sons born to wealthy planter and Bermuda native Henry Richardson and Catherine Priestley of Louisiana, he attended primary school in Massachusetts, spent his freshman year at Yale, and transferred to Harvard for his sophomore year.[329] But the war interrupted young Richardson's studies. He returned to his family in New Orleans and enlisted as a private in a company that became an independent command, the Louisiana Guard Artillery Battery.[330]

Richardson did not remain with the battery long. In 1862 he became a second lieutenant in Company H of the Thirteenth Louisiana Infantry, a regiment led by Gibson, then a colonel. A few months after Richardson's arrival, his company's first lieutenant resigned, and the men elected him to fill the vacancy. Gibson advanced to general in January 1864 and transferred Richardson to his staff as captain and ordnance officer. He served in this capacity for the rest of the war, including the Atlanta Campaign, battles in Tennessee, and the campaign and siege of Mobile, Alabama, where he received praise from his commanding officer for intelligence and untiring energy.[331] He surrendered with the rest of the troops in the Department of Alabama, Mississippi, and East Louisiana in May 1865 and gained his release after signing a parole of honor at Meridian, Mississippi.

Richardson returned to New Orleans after the end of hostilities and worked as an insurance agent and state lottery cashier and became an active member of the United Confederate Veterans. He did not pursue the sort of intellectual interests that

distinguished two other family members: His maternal great grandfather was Joseph Priestley, who discovered the existence of oxygen and founded the first Unitarian Church in America. His brother, Henry Hobson Richardson, became one of the greatest architects of the United States in the late nineteenth century.[332]

Richardson married in 1867 and fathered six children—four daughters and two sons. He died of liver disease in 1910 at age seventy.[333]

Wounded in the Wilderness

On May 6, 1864, Sgt. William Smith and his comrades charged through a dense wood of scrubby oaks, tangled underbrush, and knee-deep bogs, and struck enemy frontline positions in Virginia's Wilderness. The attack surprised the Union troops, who fell back in confusion. The Confederates continued on, although swirling smoke from musketry and rapidly spreading ground fires limited their visibility. As they approached a road reinforced by wooden planks, Smith fell with what he described as "a slight, but very painful wound" to his right ankle that took him out of action.[334] His injury deprived the regiment of a loyal fighter who had served with distinction since its formation.

In April 1861, red-haired and blue-eyed Smith had left his home in Nashville, Tennessee, and traveled to his birthplace, Petersburg, Virginia. There he reunited with his parents, both Scottish immigrants, and his brothers and sisters. He enlisted in the "Petersburg Grays," which became Company B of the commonwealth's Twelfth Infantry. Two of his younger brothers also joined the regiment, and served in separate companies.[335]

His brothers survived the war unharmed, but William suffered two injuries. On September 4, 1862, he had sustained a minor wound to his shoulder and fallen into enemy hands during the engagement at Crampton's Gap, part of the Battle of South Mountain during the Antietam Campaign. His captors paroled him after the battle ended. Within two weeks he had returned to Virginia and rejoined the Twelfth, following a brief stay in a Richmond hospital.[336] After the ankle injury occurred in the Battle of the Wilderness, Smith struggled three-quarters of a mile to his regiment's field hospital, where he remembered

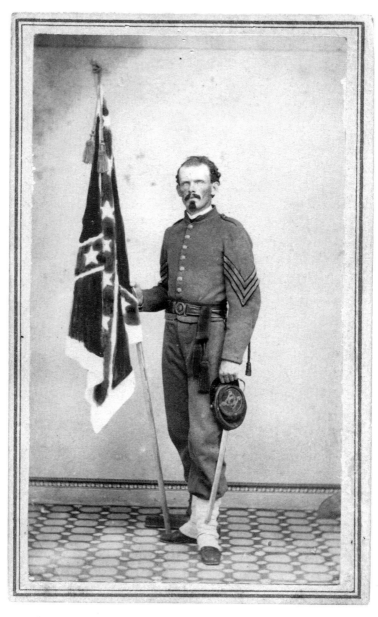

Sgt. William Crawford Smith, Company B, Twelfth Virginia Infantry
Carte de visite by E. S. Lumpkin (life dates unknown) & Co., Richmond, Virginia, about 1865–1866. William A. Turner collection.

"lying in a tent bathing my foot, which had become very much swollen" while his comrades spent an uncomfortable night on the battlefield amidst the screams of wounded men unable to escape the fires that consumed the woodlands.[337] The next day, May 7, 1864, the Twelfth and its brigade, under the command of Maj. Gen. William Mahone, received orders to move out. "Being unable to walk, and being unwilling to be left behind," Smith recalled, "I sent word to Hugh, my brother, the adjutant of the Twelfth Virginia, to send me his horse, that I wanted to keep up with the army. He complied with my request, and I went along with the brigade to Spotsylvania Courthouse, where I rejoined my company, though my wound was painful, and took part in that engagement."[338] He later had a homecoming of sorts when he fought in the Petersburg Campaign, including the Battle of the Crater. He surrendered with his surviving comrades at Appomattox Court House on April 9, 1865.[339]

William Smith returned to Nashville, married, and became an architect and contractor. Buildings on the campus of Vanderbilt University and a reproduction of the Parthenon erected for the Tennessee centennial World's Fair in 1897 are credited to him. He served in the National Guard and joined the Masons. It is reported that he liked to read during his free time.[340]

In 1898, a sixty-year-old Smith, his hair turned from red to gray, fought in the Spanish-American War as colonel of the First Tennessee Infantry. He became head of a military district on the Philippine Islands. On the morning of February 5, 1899, while leading his men into action against insurrectionists in the vicinity of Manila, he suffered a stroke and fell from his horse, dead. Medical examiners attributed his death to extreme heat and exposure.[341] His men fought in the subsequent Battle of Santa Mesa and captured an enemy flag.

His son George, the regiment's sergeant major, accompanied his father's body home to Nashville, where citizens hailed the late colonel as a hero and honored him with a state funeral.[342] Veterans named a Spanish-American War veterans' camp for him.

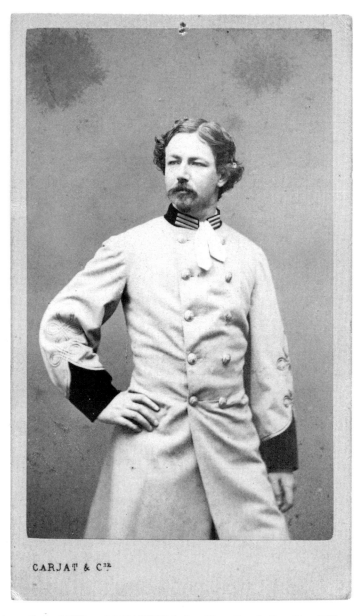

Asst. Surg. William McNeill Whistler, First South Carolina Rifles (Orr's)

Carte de visite by Etienne Carjat (1828–1906) & Co. of Paris, France, about 1866. William A. Turner collection.

Cool Courage

At Spotsylvania, Virginia, on May 12, 1864, enemy artillery fire rained down on Asst. Surg. William Whistler and his comrades in the First South Carolina Rifles, also known as "Orr's Rifles." The doctor dismounted his horse, placed it in the care of his personal servant, and ordered both to the safety of a rear position. Whistler remained with the men until they entered the area later named the "Bloody Angle," for its desperate fighting. At this point, explained one veteran, Whistler "was detained to look after such as had fallen in the charge. He thus established himself in the hearts of his comrades, and made a reputation for cool courage and fidelity to duty."[343]

Whistler had had a tough time getting into the military. In the spring of 1861, he left his home in Baltimore, traveled to Richmond, and initially failed to get a commission as an assistant surgeon. "Being a physician by profession, I felt that the only true position for me was on the medical staff, as the want of any military education disqualified me for any other office," he wrote from the Confederate capital at the end of the year.[344]

His army service would have been much different had he followed in the footsteps of his father, George Washington Whistler, a West Point–trained engineer who had died of cholera in 1849. His widowed mother, Anna Matilda, raised the family, which included twelve-year-old William, called "Willie," and his older brother, acclaimed artist James Abbott McNeill Whistler. Willie spent the fifties in school and graduated with honors from the University of Pennsylvania. In 1860 he married Georgia-born Ida King. She "made Willie a thorough secessionist," according to Whistler's mother.[345]

Late the following year in the Confederate capital, Willie

had resigned himself to not getting a commission. Another year would pass before he received an assistant surgeon's appointment and assignment to Libby Prison.[346] With Ida at his side—she had accompanied him from Baltimore—he no doubt looked forward to the future. But her health began to fail, and she died in March 1863. The loss of her devastated him.

About a year later, he received orders to leave Richmond for field duty. He temporarily served a heavy artillery garrison on the outskirts of the city, then, in April 1864, joined the veteran First South Carolina Rifles. One month later, he was meeting the medical needs of his new command at Spotsylvania and earning the respect of the soldiers. He further distinguished himself during the Petersburg Campaign. According to one writer, "Dr. Whistler was constantly on the line, sharing the hardships, dangers, and scant rations of the men. The humblest private received the same professional attention from him as did the highest officer."[347]

Whistler remained with the regiment until February 1865. Exhausted and in ill health, he received a leave of absence and reported to Richmond. He left the capital soon after to visit his mother and artist brother in England, taking with him "certain dispatches of importance" from the government. Traveling under an assumed name and dressed in civilian clothes, he endured a perilous adventure by land and sea. He arrived in Liverpool and delivered the dispatches before joining his family in London. One week later he learned of the surrender of the Army of Northern Virginia.[348]

He never returned to America. Whistler wandered through Russia and other countries for about a year, then worked for a time in Paris before settling permanently in London. He became senior physician of the London Throat Hospital, an institution he helped establish. In 1876 he gained admission to the Royal College of Physicians and the College of Surgeons of England. That same year he married a Greek national, Helen Euphrosyne Ionides. She survived him after his death at age sixty-three in 1900.[349]

He Stayed at His Post

A FINE MIST, INTERRUPTED BY INTERVALS OF RAIN, FELL upon Capt. George Fullerton and the other infantrymen in his brigade as they slogged across soft, muddy fields at Spotsylvania, Virginia, on May 12, 1864. They struggled through quagmires of muck as the rain increased, and then broke into a run as enemy artillery shells slammed into the ground close to their feet. Cascades of mud and water splashed into the air. Musketry crackled as they filed into trenches. They had just paused to catch their breath when Maj. Gen. Robert Rodes walked up and asked them who they were. "McGowan's South Carolina brigade," was the reply. "There are no better soldiers in the world than these!" cried Rodes.[350] Fullerton personified the general's words, for the war had shattered his health, and yet he stayed at his post.

Fullerton, a first generation Irish American,[351] had possessed a weak constitution all his life. However, it did not prevent him from leaving his clerical job in 1861 to join Company F of the First South Carolina Rifles, "Orr's Rifles." He started as a lieutenant and advanced to captain. In 1862, Col. James Orr tapped him for a stint as the regiment's adjutant. The colonel commented favorably on Fullerton's administrative performance: "He has been my adjutant & behaved very well especially at Fredericksburg, where he sustained a wound."[352] Although medical personnel did not record the exact nature of his injury, they did note his admission to a Richmond hospital for a brief stay.

Fullerton rejoined his regiment, but the wound and the exposure to army life took a toll on his already frail health. In February 1863, he wrote to Col. Orr, who had recently left the regiment to serve as a South Carolina senator, "I find that I will be compelled to resign my Commission in the Army sooner or

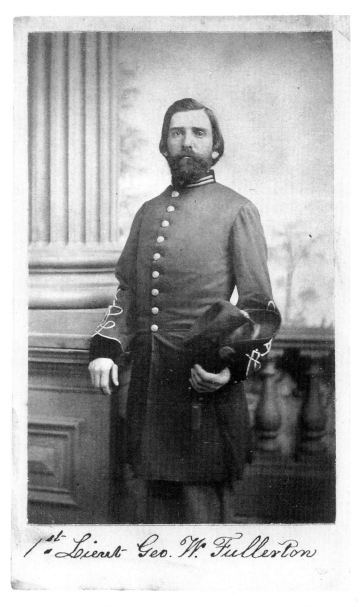

1st Lieut. Geo. W. Fullerton

Capt. George W. Fullerton, Company F, First South Carolina Rifles (Orr's)

Carte de visite by Charles J. Quinby (life dates unknown) & Co. of Charleston, South Carolina, about 1861–1862. Collections of South Caroliniana Library, University of South Carolina, Columbia.

later as I cannot with safety to myself undergo the hardships of the campaign much longer." He added, "I am anxious to remain in some department of the Service," and he suggested a clerical position in the Treasury Department. Orr agreed and forwarded the request to the proper authorities. He attached a letter of endorsement, which praised him as "a very temperate, sensible, competent, worthy man. His honesty & integrity is above suspicion."[353] No one acted upon the request. Clerks filed the letter, and Fullerton remained with his company.

At Spotsylvania the following year, he and his regiment, with the rest of McGowan's Brigade, fought an eighteen-hour death struggle against wave after wave of attacking enemy troops. The combat took place in the trenches of the "Bloody Angle," which were filled with water puddles crimson with blood and clogged with corpses.[354] Capt. Fullerton did not survive the battle. A bachelor about thirty-one years old, he left behind grieving parents and siblings.

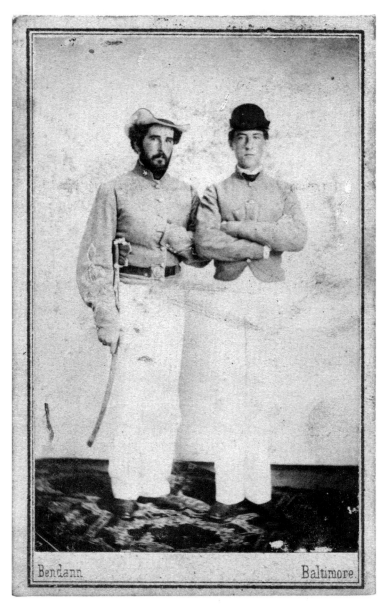

Capt. Samuel Sprigg Shriver (*right*) and Brother, Company F,
Eighth Battalion Confederate Infantry

Carte de visite by Daniel Bendann (1835–1914) and David Bendann (1841–
1915) of Baltimore, Maryland, about 1864. William A. Turner collection.

In the Vanguard at New Market

INCESSANT RAIN TURNED THE VIRGINIA COUNTRYSIDE around New Market into an ankle-deep slough of mud, and across this sodden landscape slogged the cadets of the Virginia Military Institute, as fighting raged all around them on May 15, 1864. The inclement weather, combined with thick drifts of smoke from artillery and musket fire, made it difficult at times to see anything but bright flashes from enemy guns.

The cadets struggled on. Company C approached an orchard and the Bushong family home. "We went through the yard very close to the house," recalled one cadet, "and it seems to me that a short distance beyond this house we were ordered to lie down behind the remnant of a worm-fence, about two rails high."[355] The boy looked up and noticed his company commander, Sam Shriver, on his feet and moving forward through the dense smoke and mist as the Yankees laid down a furious fire a couple hundred yards ahead. "I followed him," stated the boy, "and when about 30 yards in front of the line I saw him fall, or, as I supposed at the time, lie down for protection."[356] A musket ball had struck down Shriver. His wounding deprived the cadets of one of their best and brightest.

Shriver stood fourth in the V.M.I. Class of 1864 and led Company C with the rank of cadet captain. He was born and raised in Wheeling to a prosperous merchant father, who hailed from Maryland, and his mother, a native of New Jersey. In 1856, at about age thirteen, he and his family moved to Louisiana, where his father owned and managed a sugar plantation called Greenwood. The Shrivers returned to Wheeling in 1858. Young Sam entered the Catholic College at Georgetown in the District of Columbia.[357] In January 1862, he became a V.M.I. cadet.[358]

About two and a half years later, on May 10, 1864, Shriver and the other cadets were summoned to duty, and within days were fighting at New Market. The Confederates met with early success, but after a frontal assault stalled, the battle's momentum started to shift. "It was at this deadly moment that the Cadets of the Virginia Military Institute pushed out into the orchard beyond Bushong's house," noted one historian, and they helped turn the tide of battle and score a Confederate victory.[359] In the vanguard of the advance marched Shriver. According to a family member, a shell fragment struck him in the left elbow and knocked him down. He recovered, stood up, and advanced to the head of his company. Then a musket ball hit him on the same elbow and he fell to the ground again.[360]

The wounds caused Shriver's arm to remain permanently stiff, but this did not prevent him from returning to active duty. In August 1864, he joined the Virginia Reserve Forces as second lieutenant and drillmaster.[361] Four months later, he became captain of a company in the Eighth Battalion Confederate Infantry, a unit composed of "galvanized" Union prisoners—men who traded their loyalty for release from captivity.[362] Shriver wound up in Georgia at war's end and there signed the oath of allegiance to the federal government in May 1865.

He moved to Baltimore and studied law under fellow Wheeling resident and former Confederate congressman Charles Russell. Shriver gained admission to the bar but never practiced. Instead, he settled on a thousand-acre family farm near Suffolk, Virginia. In the late 1870s he served a two-year term in the Virginia legislature, following in the footsteps of his older brother, Daniel (pictured with him in this *carte de visite*), who left the army during the war to serve as a state representative.[363] Sam left politics in 1878. He died three years later at the age of thirty-eight. He had never married.

Capture of a Union Patrol

ONE DAY IN EARLY JUNE 1864, AT A PLACE BETWEEN the Bull Run Mountains and Hopewell Gap in Northern Virginia, a twelve-man Union patrol made their way, unaware that Capt. Julian Lee and another member of Lt. Col. John S. Mosby's Rangers had spotted them.[364] The two Confederates acted quickly. They enlisted the support of a half dozen comrades and, according to one account, easily captured the bluecoats. Lee's quick and decisive action added to the Rangers' reputation for daring and contributed to the disruption of order in the Yankee-occupied region.

Lee operated in Virginia throughout the war. He may be the same Julian Lee that, under the alias John Blackwood, was named on a list of suspected and disloyal persons at the Old Capitol Prison in Washington, D.C, in the autumn of 1861.[365] He joined the army as a private and advanced to captain and staffer in the Adjutant General's Department, the rank and duty he held when Union troops captured him in Prince William County in December 1863. Federal authorities sent him to the Old Capitol Prison—it may have been his second stint there—then to Baltimore's Fort McHenry, then to Point Lookout, Maryland. He was exchanged after three months in captivity.[366]

At some point Lee joined Mosby's command. The capture of the Union patrol in June 1864 is the only account of his service with the Rangers. About six months later, on Christmas Day, he fell into enemy hands again. Details of his capture went unreported. Federal authorities confined him in Fort Delaware for the duration of the war. According to a fellow inmate, Lee was one of "the brave men who to the last have refused to sign the

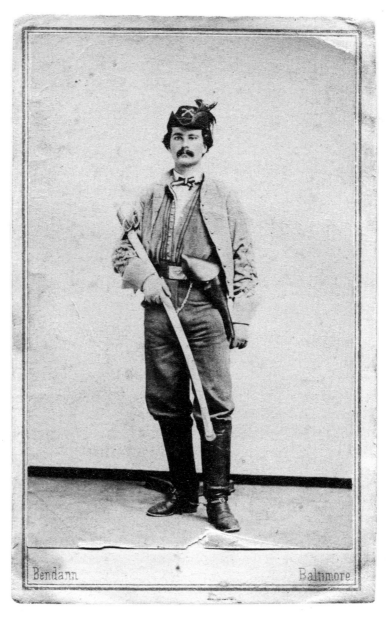

Capt. Julian Prosser Lee, Forty-third Battalion Virginia Cavalry
(Mosby's Rangers)

Carte de visite by Daniel Bendann (1835–1914) and David Bendann (1841–
1915) of Baltimore, Maryland, about 1864–1866. William A. Turner collection.

oath of allegiance" to the U.S. government.[367] He finally signed on June 12, 1865, and gained his release from prison.

A native of St. Louis, Missouri, he opted not to return to his home state. He moved to Virginia, the birthplace of his grandfather, prominent politician Richard Bland Lee, and his great uncle, Revolutionary War cavalry commander Henry "Light Horse Harry" Lee—the father of Robert E. Lee. Julian settled in Warrenton, became a merchant, and married in 1871. He and his wife would have three daughters and two sons. He married again, about 1896, presumably as a widower, to a woman fifteen years his junior. They lived together until his death in 1901 at age sixty-one.[368]

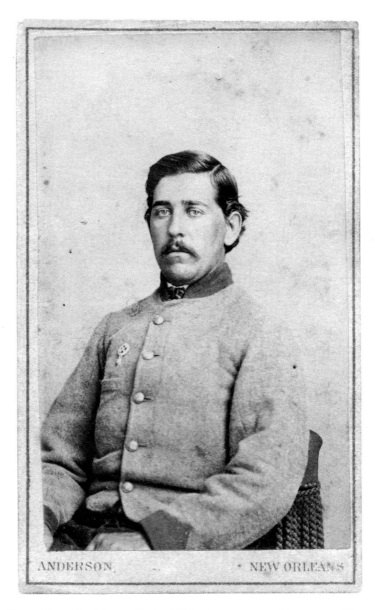

Corp. Alexander Pierre Allain, Fifth Company, Washington Artillery (Louisiana)

Carte de visite by Samuel Anderson (b. 1825) & Augustus Austin Turner (1831–1866) of New Orleans, Louisiana, about 1864–1866. William A. Turner collection.

"Cool Efficiency"

LATE IN JUNE 1864 NEAR ATLANTA, FIERCE ARTILLERY duels erupted along the Kennesaw Mountain Line during the days before a futile frontal assault by federal forces. In one action, Union shells wreaked havoc on the earthen parapet that protected the Confederate guns and crews. Heaps of dirt blocked a sapling-lined opening through which one of the cannon had been firing. A member of the crew, Pvt. Alex Allain, sprang into action. According to one account, he leaped into the clogged opening, "called for an ax and spade, and, despite the deadly fire of the enemy's battery and sharpshooters, he drove the stakes down, put back sapling poles and dirt out of the range of the gun, then jumped down and resumed firing. His escape was miraculous."[369]

Allain's display of bravery added to his already sterling reputation as a model soldier. More than two years earlier, he had left school in Bardstown, Kentucky,[370] returned to his home state of Louisiana, and at age seventeen enlisted in the Fifth Company of the Washington Artillery, along with an older brother.[371] They fought in their first big battle at Shiloh, Tennessee, where Allain "revealed the gallantry which distinguished him throughout the war," noted one writer.[372] He served in all the key battles in which his company participated, including Perryville, Stone's River, and Chickamauga.

In another incident on the Kennesaw Mountain ridge, an enemy shell slammed into the ground, lodged itself against the axle of his cannon, and exploded. The repercussion knocked down the entire crew. According to Allain, "Every man was at his post[;] none was hurt seriously with the exception of my brother and myself." He did not state the nature of his brother's

wound but mentioned that he himself had suffered an arm injury. Allain remained in the ranks although his wound caused him pain for some time afterward.[373] He earned his corporal's stripes for his courage and "cool efficiency."[374]

Allain narrowly escaped another injury on September 1, 1864, in action at Jonesboro, Georgia, when a bullet tore a large hole in his pants.[375] He went on to fight in several more battles during the remaining eight months of the war without additional injury. He received a parole at Meridian, Mississippi, in May 1865, after the surrender of the army.

Allain returned to Louisiana. According to a biographer, "He struggled bravely in helping to overthrow the carpet-bag rule over his native State."[376] He managed a sugar cane plantation in Jeanerette, named Albania. He died there of heart failure in 1910 at age sixty-six. His wife, whom he had married in 1880, two sons, and two daughters survived him. Brother Masons and comrades in the United Confederate Veterans mourned his death. The family interred his body in one of the forty-eight vaults inside the Tomb of the Army of Tennessee in New Orleans' Metairie Cemetery.[377]

"Sir, You Are a True Cavalier"

CHAOS REIGNED ON THE STREETS OF THE PENNSYL-vania town of Chambersburg on July 30, 1864, after Confederate troops torched houses and businesses in retaliation for recent Yankee depredations in Virginia—the state from which hailed one of the officers ordered to carry out those burnings, twenty-one-year-old Fred Smith. According to a story passed down through his family, when he approached one residence he met a woman who begged him not to set fire to her home. He explained that orders were orders and that if he did not follow through he would be arrested and replaced by someone else. However, he reasoned that the contents of the houses were not included in the order. So, he offered to have soldiers remove furniture and other possessions before destroying her home. Grateful for his generosity, she accepted his offer with the words, "Sir, you are a true cavalier," and presented him with two silver goblets as a token of her appreciation.[378]

A Chambersburg minister told a very different version of the events. According to Rev. Benjamin Schneck, Smith and a squad of cavalrymen targeted Norland, the stately home of Alexander K. McClure, a prominent Keystone State Republican. Smith found McClure's wife quite ill, informed her that her home would be burned, and "stated that she should have ten minutes to get the family out of the house and away; and to prove his sincerity he at once fired the house on each story." He then plundered Norland of valuables, including McClure's gold watch and the two goblets Smith later claimed to be gifts.[379]

Smith had aspired to be a soldier since his boyhood in Warrenton, Virginia. "My strongest preferences incline to the profession of arms, & I have been satisfied I could find contentment

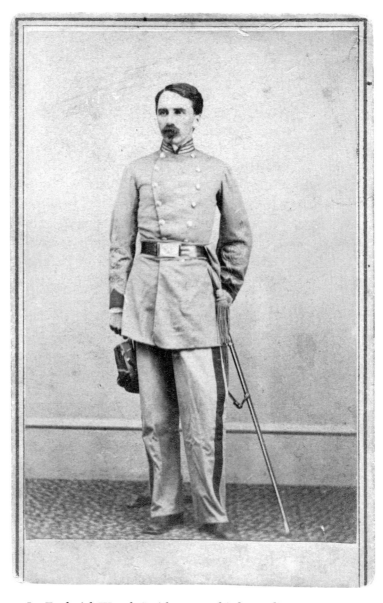

1st Lt. Frederick Waugh Smith, Forty–third Battalion Virginia Cavalry (Mosby's Rangers)

Carte de visite by Alexander Gardner (1821–1882) of Washington, D.C., about 1865. William A. Turner collection.

in no other proféssion," he stated. His goal came within reach in 1860 when he secured an appointment to West Point. "The place however was promptly declined because like any other good Southerner I was utterly averse to receiving favors from a Government on the eve of becoming bitterly hostile to my own people."[380] Disappointed but not defeated, he entered Virginia Military Institute but found it impossible to continue his studies after the war started. He left V.M.I., enlisted in the Forty-ninth Virginia Infantry, and advanced from private to sergeant-major. His father, a former governor, Col. William "Extra Billy" Smith, commanded the regiment.

Young Fred was "about the strongest marked case of second edition I ever saw," noted one officer of the resemblance between father and son.[381] They served together in many battles, including Antietam and Fredericksburg; at the latter, Fred suffered a wound, the nature of which went unreported.[382] In the spring of 1863, he received an appointment as a cadet, or junior officer, with the rank of first lieutenant and aide-de-camp to his father, who had recently received a promotion to brigadier general. They fought their last battle together at Gettysburg. Smith's father left the army in January 1864 to serve another term as governor of Virginia.[383] Fred continued in the army as a staff officer to two brigadiers: fellow Virginian Gabriel Wharton, who noted that Fred's "daring & cool courage won the admiration of all," and who praised his "rare capacity" for controlling the men under his command during the Shenandoah Valley Campaign; and V.M.I. alumnus John McCausland, the general in charge of executing the order to burn Chambersburg.

In early 1865, Fred applied for and received a promotion from cadet to regular army first lieutenant. Further, he asked to join Col. John S. Mosby for duty with his Rangers. Officials granted both requests.[384] He likely served with Mosby until the war's end.

Afterwards, he left America for South Africa and remained there for the rest of his life. He lived until age eighty-five, dying in 1928. His wife, Emily, whom he married in 1900, survived him. His remains rest in a Capetown cemetery.[385]

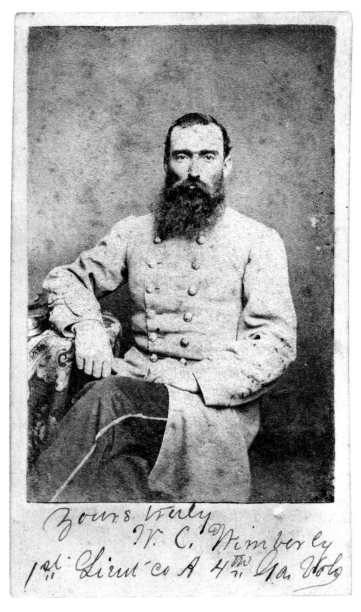

Capt. William Crawford Wimberly, Company F, Third Georgia
Militia Infantry

Carte de visite by unidentified photographer, about 1861–1862. David Wynn
Vaughan collection.

Local Defender

In the spring of 1861, Talbot County, Georgia, planter William Wimberly left his wife, two daughters, and the twenty slaves or so who lived on his family farm[386] and joined the locally raised "Southern Rifles," which became Company A of the Fourth Georgia Infantry. He served as first lieutenant for a one-year term. The regiment spent most of this time in Virginia and saw no enemy action. Wimberly resigned after his enlistment expired, citing his age, thirty-five, as a factor. Illness may have played a role in his decision, too, as he spent about a month in the regimental hospital suffering from fever.[387]

Wimberly returned to Georgia in the spring of 1862. He rejoined the army in the fall and served in several militia organizations, including as captain of Company F in the Third Infantry.[388] He belonged to this regiment in July 1864 when the state's adjutant general ordered him to mobilize local recruits and conscripts for the defense of his home county.[389] About ninety miles north, Union Maj. Gen. William T. Sherman's army had arrived on the outskirts of Atlanta. Wimberly organized the men and fought with them against Sherman's army as it marched to Savannah. On November 22, 1864, Wimberly suffered slight wounds in the arm, leg, and thigh in a sharp skirmish near Griswoldsville, a hamlet outside Macon.[390]

Wimberly continued to earn his livelihood as a farmer after the war and to raise his family. He died at about age sixty-nine in 1895. Nine years later a monument was constructed and dedicated to him and others from Talbot County who had fought for the Confederacy.

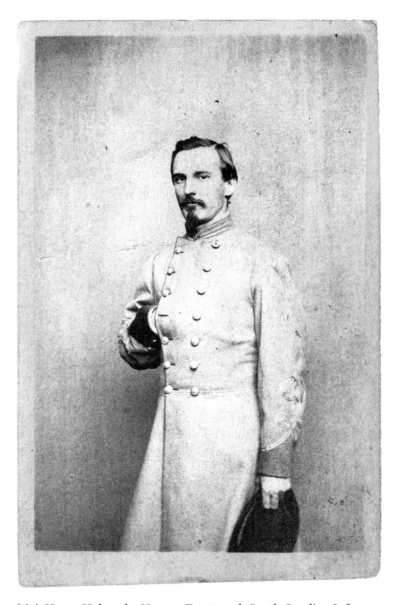

Maj. Henry Holcombe Harper, Fourteenth South Carolina Infantry

Carte de visite by Daniel Bendann (1835–1914) and David Bendann (1841–1915) of Baltimore, Maryland, about 1864. William A. Turner collection.

Captured at Deep Bottom

A FEDERAL BATTERY POUNDED AWAY AT McGOWAN'S Brigade of South Carolinians as it advanced through the marshy, muddy terrain at Deep Bottom, Virginia, on July 28, 1864. The Confederates charged the artillerists, forced them back, and captured one cannon. According to a Northern newspaper, a Yankee lieutenant "continued to fire his piece until the enemy were within fifteen feet of him, and then, after capturing a rebel major charging his gun, succeeded in making his escape." The Confederate major, Henry Harper, served in the Fourteenth South Carolina Infantry.[391]

Harper hailed from Abbeville District, a county bordering the state of Georgia, where he lived with his wife and children on a 1,400-acre farm in Lowndesville. He owned forty-two slaves. He had entered politics in 1858 as one of five county delegates elected to a two-year term in the state's general assembly.[392] Harper was serving a second term in November 1860 when a meeting in Abbeville sparked the movement that led to the state's declaration of secession the following month.

In the summer of 1861, Harper became captain of a company of Lowndesville boys formed as "McCalla's Rifles," named for the local farmer who had donated their uniforms. This unit became Company I of the Fourteenth Infantry. Harper commanded the company during its baptism under fire: in January 1862, enemy gunboats shelled the Fourteenth at Port Royal Ferry near Beaufort.[393] A few months later, the regiment left for Virginia, arriving in time to participate in the Peninsular Campaign, where Harper suffered a wound in action during the fight at Glendale (Frayser's Farm). His record does not detail the nature of his injury, but in a report written ten days after the battle, his colonel,

Sam McGowan, expressed the fear that it was very serious.[394] Harper's injury kept him out of action for many months. When he returned to duty in 1863, authorities detailed him on administrative assignments, including courts martial duty and a stint as brigade inspector. In October he received a promotion to major and returned to a combat role.[395]

Harper's capture at Deep Bottom in July 1864 cut short his tenure on the regimental staff. Initially sent to the Old Capitol Prison in Washington, D.C., he was shortly transferred to Fort Delaware in August. He languished there for the rest of the war.[396] He signed the federal oath of allegiance and gained his release in July 1865—two months after President Jefferson Davis had recognized the defeat of Southern arms at a meeting in Abbeville, where he had briefly stopped with his entourage as they fled from Union forces after the fall of Richmond. This meeting gave rise to the popular claim that Abbeville was the birthplace and deathbed of the Confederacy.

Harper returned to his family in South Carolina and resumed life as a farmer. He joined the "Red Shirts," a controversial paramilitary political organization that played a key role in the election of former Confederate general and anti-Reconstruction Democrat Wade Hampton as governor in 1876. Harper returned to the general assembly from 1878 to 1880 as an Abbeville delegate.[397] He died at age fifty-eight in 1886.

Washington Doctor

ASSISTANT SURGEON BODISCO WILLIAMS FELL ILL WITH
dysentery at Petersburg, Virginia, in the summer of 1864 and
wound up in a Richmond hospital, depriving the Thirty-Fourth
North Carolina Infantry of medical aid they badly needed. He
had only recently joined the Tarheel troops, and his sickness at
the start did not bode well for the twenty-three-year-old physi-
cian from Georgetown, along the banks of the Potomac River in
the District of Columbia.

A young man possessed of a "fine presence, winning manners,
and generous impulses," he had been named for his mother,
Caroline de Bodisco.[398] She was related to Baron Alexander de
Bodisco, a Russian diplomat and the Czar's representative to the
United States for many years. Raised in Georgetown, Bodisco
attended medical school, then cast his lot with the South, after
graduation in 1862. The decision divided the family. His older
brother, Lloyd,[399] a career Union navy engineer, left the service
after contracting rheumatism during his only wartime cruise, in
the Gulf of Mexico.

Bodisco joined the Confederate army in 1863 as an acting as-
sistant surgeon at a Richmond-area hospital. He posed for his
photograph with a fellow doctor, Richard Emory of Baltimore,
about that time.[400] In the spring of 1864, Williams became an
assistant surgeon and reported for duty to the Thirty-fourth. Af-
ter his inauspicious beginning of being sidelined by dysentery
for a month, he returned to his regiment and remained with it
until the surrender of the Army of Northern Virginia in April
1865.[401]

Williams returned to Washington, D.C., and practiced medi-
cine. Any wartime animosity that might have existed between

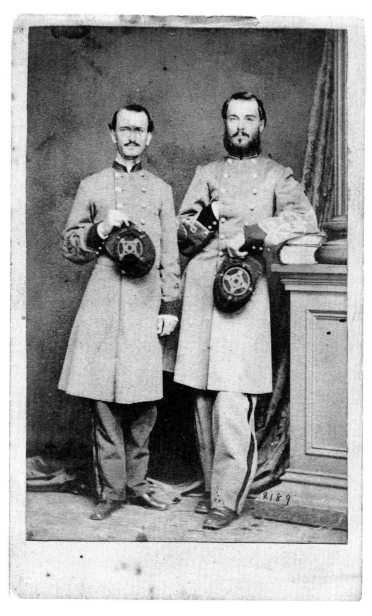

Asst. Surg. Bodisco B. Williams, Thirty-fourth North Carolina Infantry (*left*) and friend

Carte de visite by Charles R. Rees (life dates unknown) & Co. of Richmond, Virginia, about 1865. William A. Turner collection.

him and his brother Lloyd must have been resolved, as both lived in the family's stately Georgetown home.[402] Bodisco fell sick in December 1873 and died two days before Christmas at age thirty-two. The local newspaper reported that his unexpected death had "cast a gloom over the community, as was fully attested by the numerous attendance at his funeral," which included fellow physicians and brother Masons. Two days after the burial, his brother Lloyd also suddenly died. "In view of the intensification of grief occasioned by this double bereavement in one household in so brief a period," noted his obituary, "we can only trust that He who in His inscrutable ways sent the chastening, will lighten the burden and make the blow less oppressive to the mourners."[403]

Lee McMurtry (*right*) and friend, Quantrill's Guerrillas
Carte de visite by unidentified photographer, about 1865–1866. William A. Turner collection.

Fighting under the Black Flag

"I FOUGHT UNDER THE BLACK FLAG FOR TWO YEARS, AND I tell you it's a might dangerous business," noted Lee McMurtry of his experience as a guerrilla fighter during the war. Considered one of the bravest of the company commanded by Capt. William "Bloody Bill" Anderson, McMurtry earned respect for quick action, remaining calm in desperate situations, and "successful ruse to avoid detection."[404] He displayed these traits in an incident that occurred outside Fayette, Missouri, in 1864.

McMurtry and five fellow guerrillas rode to the home of a family sympathetic to their cause and were welcomed with forage for the horses and a bountiful dinner. After the meal, one of the attractive young hostesses asked the boys to enjoy some music. They readily accepted her invitation; in the excitement of the moment, they failed to post a picket outside the house. After an hour of piano playing, song, and laughter, one of McMurtry's comrades happened to glance out a window and saw death approaching: About 200 Yankee horse soldiers streaming onto the property through a gate off the main road.

"FEDERALS," shouted the guerrilla, and then bolted outside through a back door. The bluecoats spotted the fleeing guerrilla and started shooting. Then the rest of the men ran from the house, except McMurty, who remained inside with the ladies. The soldiers surrounded the house. McMurtry realized he could not escape and acted quickly. He removed his gun belt, handed it to one of the hostesses, and said, "Buckle these around your waist, beneath your dress skirt, and when the 'Feds' come in address me as 'brother.'" He pulled off his over-shirt and stuffed it inside the piano case, then donned an old straw hat hanging on a wall. The Yankees rushed in. The young lady and her "brother"

played their roles convincingly and the soldiers left. He rejoined his comrades and learned that two of the five had been killed.[405] Although McMurtry succeeded in this situation by a ruse, his preferred method of dealing with the enemy involved terror and killing. He engaged in forays in Missouri and Kansas that frustrated federal forces and contributed to the instability of civil and military authority. He saddled up for numerous raids, including the August 21, 1863, "Lawrence Massacre," which involved the sacking and burning of that Kansas town and the murder of some of its inhabitants. In September 1864, he participated in a failed raid on Fayette and suffered a serious wound. According to one account, he fell near the enemy's position and became pinned down while the fighting raged around him. Two comrades braved the fire and rescued him. One of the rescuers was his close friend, future outlaw Jesse James, whom he likely knew before the war in Clay County, Missouri.[406] Both fought with "Bloody Bill" and his crew, and later served under guerrilla mastermind William C. Quantrill.[407]

McMurtry's activities after the war are sketchy. One report alludes to dealings with Jesse James and his band of outlaws. McMurtry fled to Mexico upon the breakup of the James gang and later returned to the United States, resided in New Mexico for a time, and settled in Wichita Falls, Texas. There he found a job that might have put a smile on the faces of his former guerrillas—lawman. "He made the best sheriff the country thereabouts had ever known," reported the local newspaper. "He was absolutely fearless and enforced the law to the letter."[408]

He lived until age sixty-six, dying in 1908 after a sudden illness.[409]

Chickamauga Casualty

THE SOLDIERS OF THE NINTH KENTUCKY INFANTRY, ONE
of the hard-fighting regiments in the Kentucky "Orphan" Bri-
gade,[410] claimed their first major victory at the Battle of Chicka-
mauga on September 19-20, 1863.[411] Perhaps their most mem-
orable moment occurred during their final assault against the
Yankees, on September 20: "We marched under the fire of the
enemy right up to and over their works, they breaking and flee-
ing in great disorder," wrote the regiment's commander.[412] The
Ninth paid a high price for this success. About half of its men
became casualties: 102 of 230 men were killed, wounded, or
missing. The list of those injured included Corp. John Smarr of
Company D, a farmer from Scott County, just outside Lexing-
ton.

Smarr had appeared on a casualty list once before. In April
1862 he fell into enemy hands during his first big fight, at Shiloh,
Tennessee. Federal authorities sent him to Camp Douglas in
Chicago, Illinois, where he sat for his *carte de visite* portrait.

Released from detention late in the summer of 1862, he re-
joined his comrades in the Ninth and participated with them in
the Battle of Stone's River in Tennessee (Dec. 31, 1862–Jan. 2,
1863) and the Siege of Jackson in Mississippi (July 1863). About
two months after Jackson, the Ninth got its big win at Chicka-
mauga, and Smarr his wound. Authorities described his injury
as slight, but it was serious enough to land him in the hospital.
He eventually rejoined his company and received a promotion
to third corporal. He made second corporal on March 4, 1864.
Exactly six months later, Union troops captured him again—
this time outside Jonesboro, Georgia, where the Ninth and its
brigade fought federals during their final push to take Atlanta.

Corp. John T. Smarr, Company D, Ninth Kentucky Mounted Infantry

Carte de visite by Terrill's (life dates unknown) Sunbeam Gallery of Chicago, Illinois, about 1862. John Sickles collection.

His captors released him a couple of weeks later—about the time the Ninth was converted from foot soldiers to horsemen and was assigned to a Kentucky cavalry brigade in a corps commanded by Maj. Gen. Joe Wheeler. The regiment went on to fight against Union forces led by Maj. Gen. William T. Sherman. Smarr surrendered at Washington, Georgia, in May 1865.[413]

He signed the oath of allegiance to the U.S. government, returned home, and worked on the family farm for the rest of his days.[414] The commander of his local camp of United Confederate Veterans reported his passing in 1897, at which time he would have been about sixty years old.

Pvt. Philip Evan Thomas, Company E, Fifth South Carolina Cavalry

Carte de visite by unidentified photographer, about 1862. John Sickles collection.

The Sexton and the Soldier

ON AN AUTUMN DAY IN 1864, IN ELMIRA, NEW YORK, A church sexton thrust his shovel into the earth in the cemetery under his charge and began digging a grave for the remains of a Confederate soldier. Both sexton and soldier were far from home. The sexton, runaway slave John Jones, had fled his master in Virginia more than twenty years earlier and made his way to freedom in the North.[415] The soldier, cavalryman Philip Thomas of South Carolina, had succumbed to typhoid fever in the nearby Union prison camp.

Thomas, who hailed from the prosperous rice-growing Georgetown District, a coastal county north and east of Charleston, had signed up to fight more than two years earlier. In March 1862, he enlisted as a private in the "St. James, Santee Mounted Riflemen," also known as Company A of the Sixth Battalion South Carolina Infantry. In early 1863, about the time he had his photograph taken, authorities divided the company in two. One group, including Thomas, joined a new organization that became Company E of the Fifth South Carolina Cavalry.[416] The regiment was spread out across the Carolinas, serving as detached commands assigned to coastal defense duties.

Everything changed in the spring of 1864, when the Fifth received orders to report to Virginia. It joined an all–South Carolina cavalry brigade[417] and became actively engaged in the defense of Richmond and Petersburg. On May 16, 1864, the regiment dismounted and fought as infantry in the Battle of Drewry's Bluff. According to a news report, the troopers were "thrown against the foe unsupported, driving them from their cover in a dense forest, fighting them desperately and against heavy odds for six hours" until forced to withdraw after a supe-

rior number of federal troops overwhelmed both flanks.[418] An historian added, "The chief fighting was done on foot and with the rifle, but there was not wanting the brilliant dash and the headlong charge with sabre and pistol, the shock of which the enemy seldom waited to meet."[419] The regiment received praise from the department commander for performing "admirable service."[420]

Union forces captured many rebel soldiers that day, including Pvt. Thomas. He spent the next ten weeks at Fort Monroe in Virginia and then Point Lookout, Maryland. In July, the federals transferred Thomas to the Elmira prison camp, where he died two months later. Sexton John Jones buried him in grave number 527 on a plot of land at Woodlawn Cemetery set aside for prisoners. He was one of 2,973 Southern soldiers interred there between July 1864 and August 1865 "with kindness and respect" by the former slave.[421]

Career Setbacks

HEAVY CAVALRY SKIRMISHING ERUPTED IN VIRGINIA'S Shenandoah Valley on October 8, 1864, and 1st Lt. Wilber Reid fell desperately wounded after Yankee lead ripped into his left thigh. Medical personnel amputated his leg the next day,[422] and he left his comrades in the Twenty-fifth Virginia Cavalry to convalesce. During his absence, another officer received a promotion that Reid thought should have been his. The loss chagrined him, and it may have caused him to reflect on previous career setbacks.[423]

One such incident had occurred six years earlier. Shortly after he graduated from the Virginia Military Institute—second of nineteen cadets in the Class of 1858—he received an appointment there as assistant professor of mathematics. Two days after he arrived on campus, he became intoxicated at a dinner party and used intemperate language, something uncharacteristic of the highly respected Reid. Friends urged him to resign to preserve his honor. He did, and school authorities accepted his resignation.[424] He found a new position as superintendent of a coal and oil company in Charleston, Virginia.

After the war started, he became a first lieutenant in the state's provisional army and received orders to recruit men from Charleston and the surrounding Kanawha Valley. His efforts contributed to the formation of two regiments, which mustered into the Confederate army as the Twenty-second and Thirty-sixth Virginia Infantries.[425] The rank and file of the latter organization elected Reid lieutenant colonel. In the winter of 1861-1862, he and his troops were dispatched to Tennessee. On February 15, 1862, in the failed fight for Fort Donelson, Reid suffered his first wound of the war when a musket ball hit him

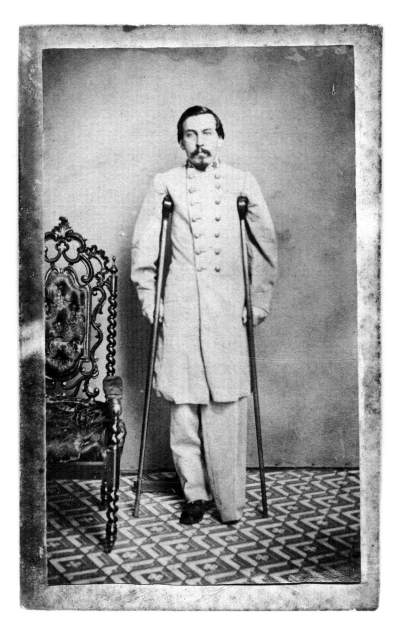

1st Lt. Legh Wilber Reid, Company E, Twenty-fifth Virginia Cavalry
Carte de visite by unidentified photographer, about 1865–1866. William A.
Turner collection.

in the shoulder; it was a minor injury.[426] He soon returned to the Thirty-sixth, which had been reduced to fewer than three hundred men.[427] A captain from the regiment, who had remained behind in Virginia on sick leave, raised six hundred new recruits.[428] The Thirty-sixth reorganized to accommodate them and held new elections for officers. Reid lost his lieutenant colonelcy to the captain.

Reid returned to the army in September 1862 as part of a battalion of horsemen that later became the Twenty-fifth Cavalry regiment.[429] He served as first lieutenant and adjutant, but he longed for higher command. In the summer of 1864, he applied to be a brigade staffer, but the subsequent loss of his leg halted his advancement. He lobbied without success for several command slots, including the colonelcy of a regiment of black troops he offered to organize. The Confederate Congress approved the recruitment of black soldiers during the war's final weeks, but the fall of Richmond and the surrender of the Army of Northern Virginia occurred before action could be taken.[430] It was about this time that he posed for his *carte de visite*, wearing his lieutenant colonel's uniform coat.

Reid married in 1865, settled in Alexandria, and began a family that grew to include a daughter and two sons. One of his boys would graduate from V.M.I., and the other would serve in the U.S. Navy. In 1868, Reid replaced his father as secretary of a regional railroad company, where he advanced to become its president. In the 1880s he served a stint as assistant registrar of the U.S. Treasury Department. He became active in local politics, the Episcopal Church, and the United Confederate Veterans, and lived until age seventy-five, dying on Thanksgiving Day 1908.

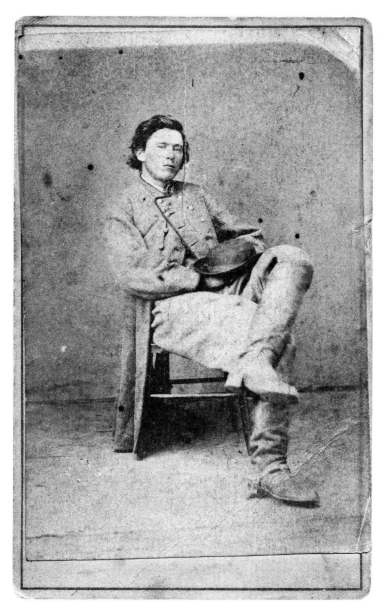

Capt. Jesse Cunningham McNeill, Capt. McNeill's Partisan Ranger
Company, Virginia Cavalry

Carte de visite by George W. Parsons (b. 1845) of Piedmont, West Virginia,
about 1865. William A. Turner collection.

Determined to Carry Out His Father's Desire

DASHING AND DARING CAVALRYMAN CAPT. JOHN HAN-
sen "Hanse" McNeill fell mortally wounded after being shot,
probably accidentally by one of his own troopers, during a raid
near Mt. Jackson, Virginia, in early October 1864.[431] Upon his
death, command of his company of partisan rangers passed to
his son, Jesse, a volatile twenty-three-year-old described as raw,
unmanageable, hot-tempered, and impetuous. Because he was
not considered officer material, uncertainty spread throughout
the rangers' ranks. News of his advancement made it up the
chain of command to Lt. Gen. Jubal Early, who hesitated to give
him full control of the company. Jesse chafed under the lack of
confidence, for he had always been a loyal soldier.[432] He was "an
excellent shot with both pistol and rifle, a good rider who always
was on his father's heels in previous engagements," noted an his-
torian, and "had the heart and courage of his father."[433]

Jesse had jumped into the war along with two older brothers
in the summer of 1861. They left the family farm in Missouri and
joined a cavalry company formed by their father. Together they
fought in the battles of Carthage, Wilson's Creek, and Lexing-
ton during the next few months. At Lexington, their father sus-
tained a wound and one brother died. Jesse's surviving brother
ended his service and went back home to help their mother tend
the farm. Their father left the army to recuperate, and Jesse ac-
companied him; they went into hiding. Both were later captured
and wound up in a St. Louis prison in December 1861. Jesse
escaped soon after their arrival and fled to family in Virginia;
his father escaped six months later and joined Jesse. The elder
McNeill formed McNeill's Rangers, in September 1862, from
men recruited in his home county, Hardy, and the surrounding

South Branch Valley, which lay west of the Shenandoah Valley. Jesse signed on as second lieutenant. Over the next two years, the Rangers harassed Union operations in the region, much to the consternation of the federal commander, Maj. Gen. Benjamin Kelley. Upon taking command after his father's death in November 1864, Jesse set out to prove his detractors wrong. He recollected his father's "long-cherished desire" to capture his nemesis, Gen. Kelley. "I determined to carry out this desire," stated Jesse, "and if possible add to the reputation the command had gained under his leadership." He devised a bold plan with the help of trusted subordinates: The Rangers would ride through the night into Union-occupied Cumberland, Maryland, where thousands of federal troops guarded the city. Once inside, they would kidnap Kelley and Maj. Gen. George Crook, who commanded the Department of West Virginia. Jesse knew exactly where both men slept—one of his men, a Cumberland native, had slipped into the city and brought back this information and other valuable intelligence.[434]

As the mission approached, Jesse noted, "I felt the weight of responsibility resting on me as I recalled a lecture which my father gave me on his deathbed about my rashness or foolhardiness, as he termed it, and telling me to look well for a getting-out place before going in. I knew that should we fail and be captured the blame would fall on me and I would be censured, and with this responsibility I was cautious beyond my usual habit."[435]

Jesse and about sixty-five Rangers put the plan in motion during the night of February 20–21, 1865.[436] Two six-man teams entered the separate hotels in downtown Cumberland where the generals were staying and roused them from their beds about 3:00 a.m.[437] The surprised officers, along with Gen. Kelley's adjutant[438] and a selection of horses, were carried off to Virginia by the detachment. They left behind a smashed telegraph set. The Rangers knew that they had pulled off a "fantastic exploit," wrote an historian, adding, "The men all sensed it and smiled from time to time" on the way back to Virginia.[439]

News of the captures made major newspaper headlines. "It is a very mortifying thing to all of us," wrote Brig. Gen. Rutherford B. Hayes, one of Crook's subordinates and a future U.S. president, who was in town that night. Maj. William McKinley, another president-to-be, was lodging at the same hotel as Gen. Kelley.[440]

Confederates hailed the mission as a spectacular success. Jesse's critics were silenced. He had proved his ability as a leader, and he earned his captain's bars. "He was no less daring and successful than his father," asserted a comrade.[441] Jesse remained reticent for many years to comment on the events of that night, but he broke his silence in 1906: "I ascribe all honor, and I cherish it as a pleasant memory that I was called to the command of such a brave, heroic band of men, and I shall carry with me to my grave the kindest and warmest feelings for all whom I had the honor to command."[442]

Jesse McNeill died at age seventy in 1912 after a year-long illness at his home in Illinois, where he had settled in the 1870s. His wife and six of their thirteen children survived him.[443]

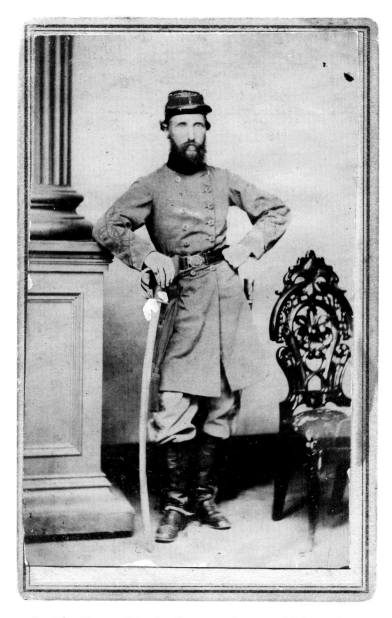

1st Lt. John Newton Murphy, Company G, Forty–third Battalion
Virginia Cavalry (Mosby's Rangers)

Carte de visite by Gustavus B. Horner (life dates unknown) of Warrenton,
Virginia, about 1861–1862. William A. Turner collection.

On Behalf of a Union Drummer Boy

IN THE NORTHERN VIRGINIA HAMLET OF RECTORTOWN on the morning of November 6, 1864, about twenty-seven Union prisoners, most of whom were cavalrymen who belonged to the command of Brig. Gen. George Armstrong Custer, stood in a line and listened as Lt. Col. John S. Mosby's adjutant read aloud the order that sealed their fate: in retaliation for recent executions of seven of "Mosby's Rangers," which Confederates blamed on Custer, seven of their number would die.[444] Death warrants would be determined by lottery. A hat filled with paper slips passed down the line of anxious troopers; a blank paper indicated a trip to Libby Prison, and a marked slip, death. Seven souls were doomed by this process,[445] including a young drummer. The boy's selection upset one of Mosby's officers, John Murphy.

Murphy had come to know the youthful Yankee after his capture. According to a comrade, the almost full-grown drummer easily passed for a soldier in the ranks. "He was mounted on a very sorry horse, which lagged behind in coming off the field, and Lieutenant Murphy, who was in rear in charge of the prisoners, rode beside him. The boy told him an artless story, —that he was a drummer boy; and showed a little silver badge with his drum and sticks upon it, which he said his mother had given him. He asked Murphy if he would not be allowed to keep this token—that we might take everything else. Murphy told him to hide it in his boot and no one would see it."[446]

The condemned boy's plight stirred Murphy into action. He approached a senior officer, Adolphus "Dolly" Richards, and told him the story, "saying he did not think Mosby wanted to hang a drummer boy."[447] Richards went to Mosby, who decided

the drummer should not have participated in the lottery, and released him from his sentence. Mosby ordered a second drawing to replace him and ordered the death sentences to be carried out the following day, November 7. The Rangers ultimately put three of the seven to death.[448]

Murphy likely pled the drummer's case with skills he had mastered as an attorney in Westmoreland County, the birthplace of Robert E. Lee and George Washington. Murphy had left behind a wife and daughter and his law practice in the summer of 1861 and became first lieutenant and later captain of a company assigned to the Ninth Virginia Cavalry. His service was interrupted when he resigned in late 1862 after a three-month bout of chronic diarrhea, but he had regained his health within months and determined to get back into the war. Three attempts to rejoin the army over the next year and a half failed: a desk job at a military court did not pan out; an attempt to organize a cavalry command for the Bureau of Conscription failed; and an effort to raise a company of partisan rangers came to naught.[449] Murphy finally signed on with the Forty-Third Battalion Virginia Cavalry, Mosby's Rangers.[450]

Less than a month after he interceded on behalf of the drummer boy, Murphy became first lieutenant of Company G, a promotion granted at the request of "Dolly" Richards and another top-ranked officer.[451] Murphy is documented as having fought in one engagement with the Rangers, a failed attack against Union cavalry near Upperville, Virginia.

He returned to Westmoreland County after the war, rejoined his family, had a son and four more daughters, all of whom lived to maturity, and resumed his law career. Murphy died in 1897 at age sixty-two.

Young Reservist Struck Down by Disease

SOME OF THE CITIZENS OF MACON, GEORGIA, WERE NOT
pleased to be the home of Camp Oglethorpe. "At a time when it
is difficult to feed our own population, we are *blessed* with the
presence and custody of 900 prisoners of war," stated one writer
in the local newspaper. "We have no place to hold them—no food
to give them—nobody whose time can be well spared to guard
them—nor, except in the mere matter of hostages for the safety
of our own prisoners in Lincoln's dominions, can we conceive of
any object in holding them as prisoners."[452]

Camp Oglethorpe included a one-story hospital and a num-
ber of sheds and stalls. A twelve-foot stockade constructed of
rough boards enclosed the fifteen-to-twenty-acre site, whose
water supply was a small stream. The wall separated blue and
gray soldiers, but it did not prevent disease from spreading
through the ranks on both sides. Among those who fell ill was
young James Means, a private in the Fifth Georgia Reserve In-
fantry.

Seventeen-year-old Means had left his family farm in Hous-
ton County in the spring of 1863, made the short trip to Macon,
and enlisted in the Ordnance Guard, which became Company
A of the Fifth Reserves. He and his company patrolled Macon's
national armory and Camp Oglethorpe. During his first winter
in the army he contracted an undisclosed illness; he had recov-
ered and rejoined his company by the summer of 1864. Reports
indicate that he was present for duty on July 30, the day his
regiment joined a small force led by Gen. Howell Cobb and suc-
cessfully defended Macon against a Union cavalry raid.

Sometime after this event Means contracted typhoid. The
disease ran rampant among the prisoners and guards at Camp

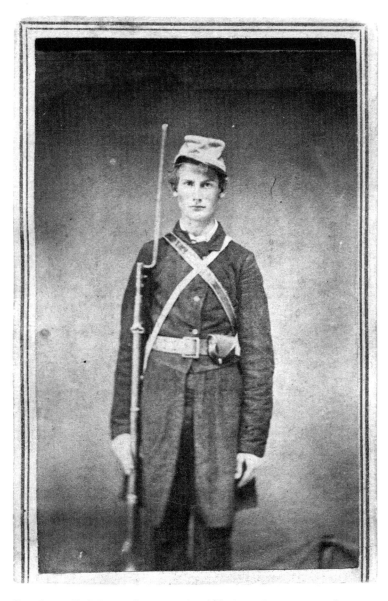

Pvt. James D. Means, Company A, Fifth Georgia Reserve Infantry

Carte de visite by unidentified photographer, about 1863–1864. David Wynn Vaughan collection.

Oglethorpe. In the fall of 1864 he returned home to recuperate, but his condition worsened. His physician father could not save him. On November 19, a few weeks shy of his nineteenth birthday, Means succumbed to the disease while elsewhere in town Confederate troops prepared to defend Macon against an expected attack by Union cavalry under Brig. Gen. Hugh Judson "Kill Cavalry" Kilpatrick, who were screening the right wing of Maj. Gen. William T. Sherman's invading army on its "March to the Sea."

The writer of the young man's obituary noted that he "was obedient and very affectionate to his parents," and added, "his conduct as a soldier in the army is spoken of in terms of high approbation by his Captain and many others."[453]

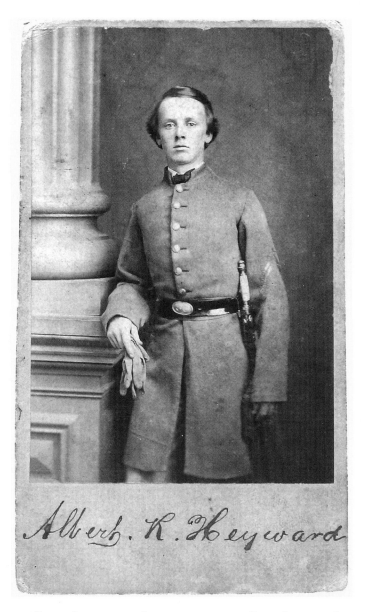

Albert. R. Heyward

Pvt. Albert Rhett Heyward, Company A, Battalion of State Cadets, South Carolina

Carte de visite by unidentified photographer, but possibly by Charles J. Quinby (life dates unknown) & Co. of Charleston, South Carolina, about 1865. Collections of South Caroliniana Library, University of South Carolina, Columbia.

Cadet Wounded in Action

At sunrise on December 7, 1864, a skirmish line composed of a most disparate group of soldiers advanced across a frosty field at Deveaux's Neck, South Carolina. Three companies from a veteran Georgia regiment, the men hungry, some shoeless, and most clad in threadbare clothes, marched side-by-side with fresh-faced boys dressed in natty, gray wool uniforms with all the accoutrements. The ranks of young men, all cadets from the South Carolina Military Academy in Charleston,[454] included Albert Heyward.

A descendant of one of the state's elite, slaveholding plantation families, Heyward hailed from Colleton District, a county adjacent to Charleston. Pursuing a military education, he had become a cadet at the Academy. On July 10, 1863, classes were suspended after Union forces captured part of nearby Morris Island. All the cadets, including seventeen-year-old Heyward, were activated for military service.[455] He was ordered to Columbia about a month later to guard the buildings and other public property that composed the Arsenal Academy, a sister school.[456]

Heyward returned to Charleston in late 1864. On December 4, military authorities dispatched him and the other cadets in his battalion to the Beaufort area, where Yankee invaders were preparing to cut the Charleston and Savannah Railroad in advance of Maj. Gen. William T. Sherman's approach to Savannah. Fighting erupted a couple of days later. The students marched through the rain in double-quick time to the sound of battle three miles away, but the federals had withdrawn by the time the young soldiers arrived. The cadets took refuge in a nearby field and slept with their muskets.[457]

The next morning, marching alongside the grizzled Geor-

gians, the cadets went into action. The boys skirmished for three hours, successfully holding the Yankee invaders at bay. According to the district commander, the cadets, "who for the first time felt the fire of the enemy, so bore themselves as to win the admiration of the veterans who observed and served with them."[458] Eight casualties were reported, including Heyward, who suffered a slight wound. Their efforts kept the railroad under Confederate control for another month. In mid-January 1865, troops belonging to Sherman's army advanced inland from Beaufort, captured nearby Pocotaligo, and seized a lodgment on the vital railroad.[459]

Railroads played a key role in Heyward's life after the war as well. He worked for a railway in Columbia, where he spent the rest of his days. He married in 1871. His wife gave birth to nine children over the next twenty years. Heyward lived until age sixty-four, dying in 1910 after suffering a fall from a horse while hunting, possibly the result of a stroke.[460]

A North Carolina Family Goes to War

IN THE PREDAWN HOURS OF MARCH 25, 1865, THOUSANDS
of gray infantrymen emerged from a labyrinth of entrenchments
and bombproof shelters along the front lines at Petersburg, Vir-
ginia. They charged 150 yards towards Hare's Hill and assaulted
Fort Stedman. The federal stronghold, its garrison, and three
nearby batteries were quickly overpowered before Union troops
counterattacked and forced them to withdraw. The Confeder-
ates were caught in a murderous crossfire. Casualties for the
engagement, which were heavy, included Capt. Bryan Cobb of
the Second North Carolina Infantry, who fell with an abdominal
injury—his seventh wounding of the war.[461]

Cobb's first recorded injury occurred in 1863 at the Battle of
Gettysburg when a musket ball ripped into his thigh during the
first day's fighting, taking him out of action for several months.
He suffered multiple wounds in three 1864 battles. He received
a gunshot wound in the other thigh at Spotsylvania Court House
in May. In mid-September, an injury (or injuries) occurred after
the Third Battle of Winchester. On October 19, Cobb sustained a
contusion on the right side of his head in action at Cedar Creek.
He also suffered a wound that fractured his tibia just above the
ankle, but the circumstances of the injury were not reported.
His war record prompted one veteran to remark, "No braver sol-
dier went from North Carolina than Bryan Cobb."[462]

One of four members of the Cobb family who fought with
distinction, Bryan and two of his brothers, John and William,
enlisted a few days after the bombardment of Fort Sumter. They
joined their hometown militia unit, the Wayne County "Golds-
boro Rifles." It became Company A of the state's Twenty-seventh
Infantry. They later transferred to the Second Infantry as com-

missioned officers. The fourth brother, Needham, became a chaplain in the Fourteenth Infantry.

While the brothers were away, the rest of the Cobb family put everything they had into the war effort. Two of their four sisters became nurses in Richmond. Their father and a brother-in-law

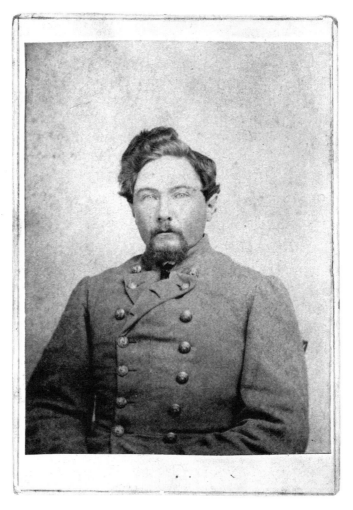

Capt. Bryan Whitfield Cobb, Company H, Second North Carolina Infantry

Carte de visite by unidentified photographer, about 1862–1864. David Wynn Vaughan collection.

served in the home guard, and an uncle commanded a local militia regiment. Their father converted the acreage surrounding their plantation, named Mt. Auburn for the heavy red clay deposits in the soil, from stock farming to cotton production to provide material for uniforms.

The assault on Fort Stedman had special significance for the Cobbs. Had it succeeded, the nine-month siege of Petersburg might have been broken, and reinforcements might then have been sent to North Carolina, which could have changed the family's future. But the attack failed. Cobb entered Stuart Hospital in Richmond; he had suffered an abdominal contusion on his left side, which may have been caused by a shell fragment or spent bullet. Surgeons treated the injury with a simple dressing. Meanwhile, Union troops penetrated North Carolina and reached Mt. Auburn. Maj. Gen. William T. Sherman and his staff rested at the plantation, and afterwards his soldiers ransacked the house and destroyed the property, according to one of the Cobb sisters, Harriet.

Cobb returned to duty on April 2, 1865, one day before the fall of Richmond. He received a parole soon after the surrender of the Army of Northern Virginia at Appomattox Court House. He returned to Mt. Auburn and reunited with his brothers and "heart-broken and virtually bankrupt parents." His father died later that year, and his mother passed away in 1867. The children divided the family home and property. "None of us wanted to live there," stated Harriet. They moved away and rented the land to neighbors and former slaves.[463]

Cobb forever abandoned agricultural life. He crisscrossed the state as a sales agent for the *Carolina Messenger*.[464] His modest savings did not cover his expenses after he stopped working, however, and he gained admission to the North Carolina Soldiers' Home at Raleigh in 1905. He died a year later at age sixty-seven. He never married.

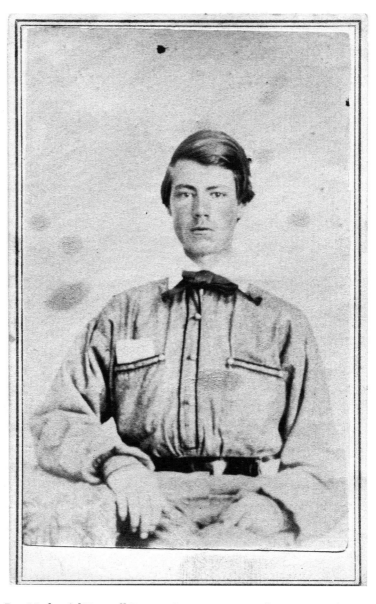

Pvt. Nathaniel Burwell Logan, Company I, Fourth Virginia Infantry
Carte de visite by Julian Vannerson (b. 1825) & Charles Jones (life dates unknown) of Richmond, Virginia, about 1865–1866. William A. Turner collection.

A *"Liberty Hall Volunteer"*

A MINIE BULLET BLASTED FROM A MUSKET WHIZZED across the rugged frontline defenses at Petersburg, Virginia, and ripped into the right leg of Nathaniel Logan, a private in the Fourth Virginia Infantry. Logan was transported to a nearby hospital, where medical personnel determined that his leg was beyond saving and amputated the mangled limb.

Although Logan's records do not state in which engagement he suffered his injury, he was admitted to the hospital on March 25, 1865; and on that day, his regiment participated in the assault on Fort Stedman, a last-ditch attack made by nearly half of the Army of Northern Virginia. They failed to break the formidable Union defenses. Five soldiers from the Fourth were wounded during the assault and its aftermath.[465]

At the time of his wounding, Logan remained one of the few soldiers from his original company present for duty. Back in the spring of 1861, eighteen-year-old Logan and other students at Washington College[466] in Lexington had formed the "Liberty Hall Volunteers," which became Company I of the Fourth Infantry. Authorities assigned the regiment to a brigade commanded by Thomas J. Jackson, who would soon earn the nom de guerre "Stonewall" for his stubborn defense of Henry Hill at the First Battle of Manassas. Many of the students were familiar with Jackson from before the war, as he walked across their college campus daily to attend to his duties as a professor at nearby Virginia Military Institute.[467]

Logan would see more of Jackson during the war. In the fall of 1861, the Liberty Hall Volunteers were detailed as headquarters guard for the general. The following spring, Logan went to work as a clerk at Jackson's brigade headquarters. He served in

this capacity for about six months, and then left for a clerical position on the corps level. While Logan toiled behind the lines, his comrades in the Volunteers fought with distinction until most of the company and the rest of the brigade were captured at the "Bloody Angle" during the Battle of Spotsylvania on May 12, 1864.

The survivors were consolidated with the remnants of other depleted brigades and went on to fight at Petersburg. Logan joined them sometime in late 1864. Within months he suffered the grievous wound that resulted in the amputation of his leg. Nine days later, on April 3, 1865, victorious Union forces entered Petersburg and Richmond, and captured Logan and the other soldier patients at Fair Grounds Hospital.[468]

Within a week, on April 9, Gen. Robert E. Lee surrendered the Army of Northern Virginia at Appomattox Court House. Logan never received the news. He had died three days earlier. Workers buried his remains on the hospital grounds. About twenty-two years old, he left behind a grieving family in Botetourt County.[469]

Devoted Aide-de-Camp

NEAR DAYBREAK ON APRIL 9, 1865, ABOUT A HALF-MILE west of Appomattox Court House, Virginia, Maj. Gen. Fitzhugh Lee's cavalrymen formed for what would be their last charge. They attacked around sunrise and drove back aggressive Yankee horse soldiers as musket balls whistled about Lee and his staff. One minie bullet ripped into the upper body of the young lieutenant at his side—Charlie Minnegerode, his favorite aide-de-camp. As Minnegerode lay writhing on the ground with blood oozing through the small round hole in his uniform coat, more enemy units arrived on the scene and advanced rapidly towards their position. Lee's surgeon hastily scribbled a note with Charlie's name and rank and pinned it to his jacket, and all abandoned the grievously wounded aide to his fate. The general and his surviving staff, some with tears welling in their eyes, rode away to the sound of Charlie groaning in pain and begging to be put out of his misery.[470]

Charlie had joined the war effort in 1861 at age fifteen as a clerk at the Richmond Arsenal. He rose to chief clerk and confidential secretary to a major, who wrote, "I have never known a young man of more precocious or better balanced mind, or one of nobler traits of character. He is intelligent industrious and accurate."[471] The major also discovered his natural abilities as a soldier. In late 1862 he wrote, "He was with me in two of the great battles around Richmond and manifested great coolness and courage under a hot fire."[472]

Minnegerode's father, Charles Sr., a German-born minister who preached from his pulpit in Richmond's St. Paul's Episcopal Church to President Jefferson Davis, Gen. Robert E. Lee, and other dignitaries, worried that his boy was too young to

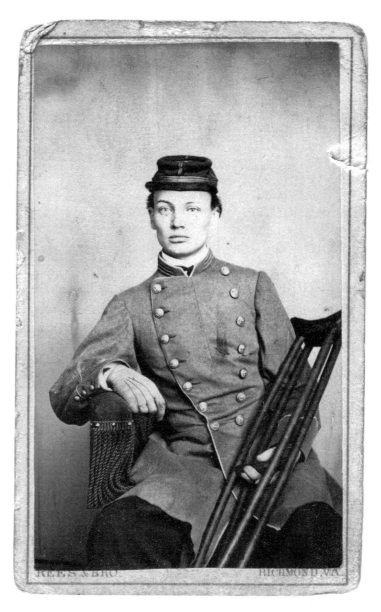

1st Lt. Charles Frederick Ernest Minnegerode Jr., Confederate States Army

Carte de visite by Charles R. Rees (life dates unknown) & Brother of Richmond, Virginia, about 1865. Collection of the Museum of the Confederacy, Richmond, Virginia.

fight a man's war.[473] But, the father said, he "could not find it in my heart to forbid" his son's service after receiving glowing reports of his actions.[474] The young man joined the military family of Fitz Lee and endeared himself to all with his friendly disposition. Lee took a liking to him, and he returned his commander's kindness with loyalty. Over the next three years they campaigned in Virginia.[475] According to the general, young Charlie passed "unharmed through the many battles fought by the two principal armies in this State (for an impetuous spirit often carried him where the fire was hottest)."[476]

His wound-free battle record ended at Appomattox. The bullet that struck him passed entirely through his upper body. After Lee and his staff left him where he fell, Charlie pulled himself together and started to write a farewell letter to his mother. About this time Federal soldiers captured him and carried him to a field hospital.[477] He miraculously survived and posed for his portrait wearing his bloodstained uniform coat.

Charlie remained a loyal and devoted friend to Fitz Lee after the war. In 1881, both attended the New Orleans dedication of a monument honoring the Louisiana Division of the Army of Northern Virginia. An observer noted that Charlie "took naturally to his old vocation in serving General Lee."[478] At this time, Charlie lived in New Orleans, where he had arrived a year earlier armed with introductions to top traders and manufacturers provided by former president Jefferson Davis. Charlie and a brother established a business.[479]

Charlie's business fell into decline, and financial troubles plagued him. He later returned to Virginia. On the afternoon of January 25, 1888, in his home in Alexandria, he placed the muzzle of a pistol just above his right ear and pulled the trigger. He died soon after at age forty-two. His wife and eight children survived him.

On the night of his death, the bullet that struck him down at Appomattox Court House was found in his pocket. He had carried it as a talisman for almost twenty-three years.[480]

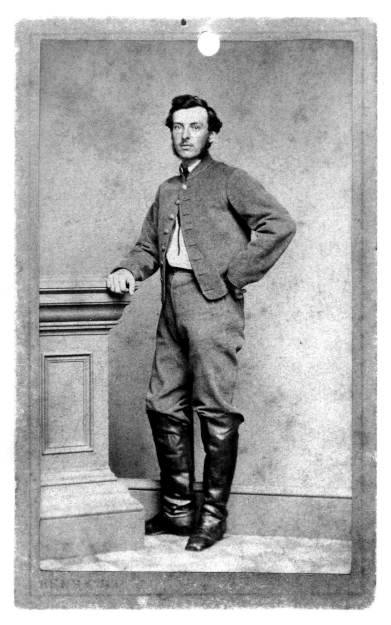

Corp. Oscar Vincent Smith, Third Company Richmond Howitzers

Carte de visite by Charles R. Rees (life dates unknown) of Richmond, Virginia, about 1862. Collection of the Museum of the Confederacy, Richmond, Virginia.

"A Bold and Enterprising Spirit"

ANYONE WHO KNEW O. V. SMITH AFTER THE WAR WOULD probably not have been surprised to learn that he had remained in the ranks of his artillery company with the Army of Northern Virginia until its surrender. Honored as he was for his "sterling integrity" and admired for his "fidelity in the performance of duty,"[481] there can be no doubt that these traits were tested in his years of military service.

A native of Richmond, Virginia, Smith moved to Portsmouth with his family in his youth. He went to work for the Seaboard and Roanoke Railroad before returning to the city of his birth to attend Richmond College.[482] During the second spring of the war, he enlisted as a private in Company B of the First Virginia Artillery. The unit participated in major campaigns with Gen. Robert E. Lee's army.

Pvt. Smith did not miss a single action during his three years in uniform. Perhaps his greatest contribution came at the Battle of Gettysburg. He arrived with his battery late on July 1, 1863. Over the next two days, his company's four rifled cannon blasted Yankee positions with 314 rounds of ammunition. Many of the shots were fired in the furious artillery bombardment preceding "Pickett's Charge," and its guns kept firing during and after the failed attack. "The officers and men performed their duties with coolness and courage," stated the regiment's commanding captain.[483] In a reorganization of the army after the battle, Smith received his corporal's stripes. He served at this rank for the rest of the war, during which time his company became an independent battery formally designated the Third Company Richmond Howitzers.[484]

After receiving a parole at Appomattox Court House, Smith

went to Richmond for a short time, then returned to Portsmouth and went back to railroading. "A man who possessed a bold and enterprising spirit,"[485] he advanced to manager of a railroad system stretching from New York to Atlanta. Around 1870 he became president of the Portsmouth Insurance Company. He ranked as a prominent leader in civic organizations and in the Episcopal Church.

In 1893, at about age fifty, he fell sick with an unidentified illness and traveled to Europe to rest. His condition worsened. He returned to Portsmouth, where he died early the following year. His wife and two children survived him. The governor of Virginia, prominent railroad men, and several former Confederate officers served as pallbearers at his funeral.[486] A resolution of respect passed by the Portsmouth Insurance Company paid homage to his character: "As a citizen, his life long walk and conversation among and with our people is his best eulogy."[487] His remains were laid to rest inside the church where he worshiped.

Retained by the Union Army

THE SURRENDER OF THE ARMY OF NORTHERN VIRGINIA at Appomattox Court House on April 9, 1865, ended the military service of most of its soldiers. The vast majority of Confederate prisoners would soon be on their way home to reunite with family and friends—but not Surg. Alexander Bell. His Yankee captors, in sore need of doctors, pressed him into service in a Union hospital.[488] Details of the events that led to his surrender and capture are sketchy. The likely scenario would have unfolded in Richmond a week earlier.

On April 3, Union forces entered and occupied the Confederate capital and captured many soldiers, including Bell. What had brought him to the city is unclear. He may have accompanied wounded men from front line positions at nearby Petersburg, where artillery from his command, Breathed's Battalion, had been in action.[489] He may have become caught up in the confusion as the capital's defenses collapsed. Whatever the reason, federal forces captured him and locked him up in Libby Prison. There he tended patients in the prison hospital. Six days later, on April 9, federal authorities commandeered him as an assistant surgeon. According to a comrade, "Dr. Bell was a very skillful surgeon, performing the most difficult operations with success even with the crude surgical appliances of those trying days," and for this reason, the Union army desired his services.[490]

Dr. Bell had earned a degree from the College of William and Mary in 1858. The Portsmouth, Virginia, native then left for New York, where he went to work as a resident physician in a hospital. He resigned after the war began, returned to his home state, and received an appointment as a Confederate assistant

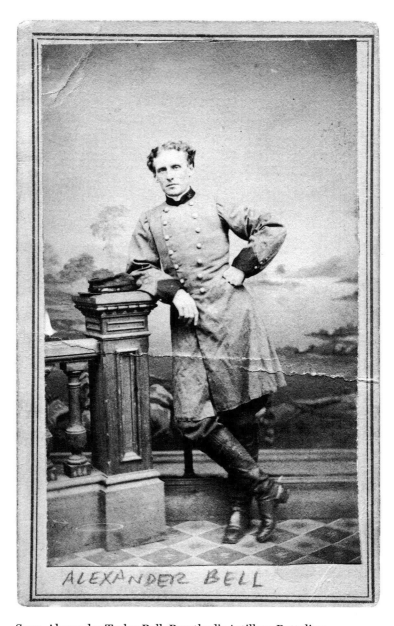

Surg. Alexander Taylor Bell, Breathed's Artillery Battalion

Carte de visite by T. W. Clark (life dates unknown) & Co. of Norfolk, Virginia, about 1864–1866. William A. Turner collection.

surgeon in the summer of 1861. The following May, he was assigned to the Third Virginia Cavalry. He transferred to an artillery battery in 1863,[491] and it joined a battalion commanded by another physician, Maj. James Breathed, one of the army's finest artillery officers. A biographer noted that Bell "was in every general engagement in which the Army of Northern Virginia participated, and was oftener seen at the gun among the boys than with his ambulance."[492] He rose to surgeon and served in this capacity until his capture in Richmond and assignment by the U.S. military to work in a federal hospital.

After his release in October 1865, he settled in Baltimore and established a large practice that emphasized homeopathic medicine. He became active in the United Confederate Veterans, serving for several years as his camp's assistant surgeon. Eventually, "owing to ill health and the infirmities of age," noted a friend, "he was compelled to enter the Confederate States Home, in Pikesville, Maryland. He was very useful while at the Home, where he gave all his medical skill and knowledge to the service of his old comrades." He died in 1913 at age seventy-seven. His wife and a daughter survived him.[493]

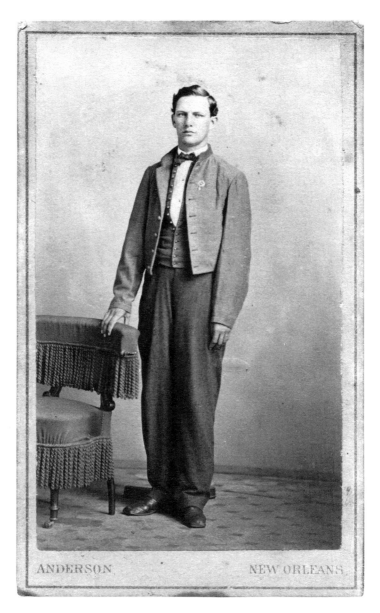

Corp. James Clarke Jr., Fifth Company, Washington Artillery
(Louisiana)

Carte de visite by Samuel Anderson (b. 1825) & Augustus Austin Turner
(1831–1866) of New Orleans, Louisiana, about 1864–1866. William A. Turner
collection.

He Never Missed a Campaign

IN LATE APRIL 1865, CORP. JAMES CLARKE AND THE veteran gunners of the Washington Artillery set up camp at Cuba Station, Alabama. Twenty-five miles away, in Meridian, Mississippi, Lt. Gen. Richard Taylor was negotiating with his Union counterpart during the surrender of the Confederate military department that included the Washington Artillery. That the surrender was in process was common knowledge, and, in recognition of it, the men named their new campsite "Camp Farewell."[494] As he faced the end of the war, Clarke may have reflected on his time in the army, during which he had participated in every campaign with his command.

Born in Kentucky, Clarke and his family had moved to Louisiana in the fifties and settled in New Orleans. In 1860, at age sixteen, he worked as a clerk in the Crescent City. In early 1862 he enlisted as a private in the Washington Artillery and served as a loyal member of the Fifth Company for the next three years. He maintained an almost perfect attendance, with the exception of two furloughs, and fought in key campaigns throughout the southeast, and in the Battles of Perryville, Stone's River, Chickamauga, and Chattanooga, among others. In 1864, he received his corporal's stripes.[495]

"Camp Farewell" was aptly named. Less than a month after the Washington Artillery moved in, the negotiations for the surrender of all forces in its military department concluded. On May 7, 1865, the gunners broke camp and marched for nearby Meridian, where they received paroles.[496]

Clarke returned to New Orleans. By 1880 he had become a coffee dealer, and was the head of a household that included his widowed mother, an aunt, several cousins and nephews, and

three domestic servants.[497] During that year he married Emma Williams, a Mississippi native about fourteen years his junior. He lived until his early seventies, dying of Bright's Disease, an acute kidney ailment, in 1907.[498]

From Private to Staff Officer

IN ATHENS, GEORGIA, ON MAY 8, 1865, JOHN LABOU-
isse received a parole and left the Confederate army, bringing
to an end a four-year stint during which the Louisianan had
risen from infantry private to cavalry captain. "I do not believe
there ever lived a man of a higher sense of honor,"[499] declared a
friend.

Labouisse was among the earliest enlistees in the Confederate
army. In 1861, he joined one of the first companies to organize in
response to Louisiana's call for volunteers. These companies are
said to have included the finest gentlemen of New Orleans,[500]
and with his impressive lineage and resume, Labouisse fit the
description. His father, a New Yorker who had moved to New
Orleans as a young man, had married a local girl and become
a leading cotton broker. His great-great-grandfather, Scottish-
born John Witherspoon, had served in the Continental Congress
and signed the Declaration of Independence as a representative
of New Jersey.

An excellent student, young Labouisse had attended Harvard
University. The war interrupted his college career, and he "re-
turned home at the completion of his junior year, to enlist in
the name of the confederacy."[501] He enrolled as a private in the
Louisiana Guard but left after a few months to help organize
the "Gladden Rifles," which became Company H of the Thir-
teenth Louisiana Infantry. The men elected him first lieutenant
in September 1861. He advanced to captain in mid-1862 after
the original company commander received a promotion.[502]

Labouisse spent only a few months in charge of Company H.
In early 1863, officials detached him from regular duty to serve
as an assistant adjutant and inspector general on the staff of his

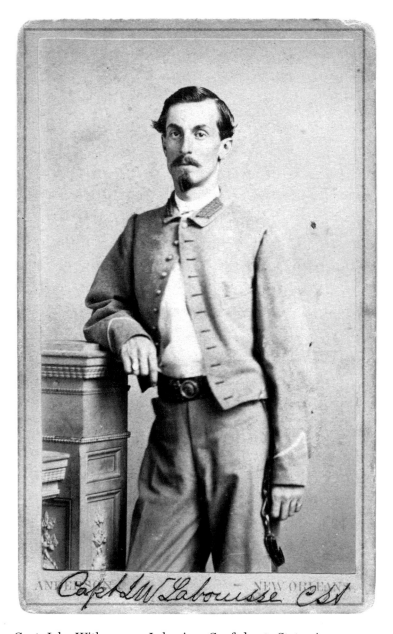

Capt. John Witherspoon Labouisse, Confederate States Army

Carte de visite by Samuel Anderson (b. 1825) of New Orleans, Louisiana, about 1865. William A. Turner collection.

regiment's brigade. In the fighting at Chickamauga, Georgia, on September 20, 1863, he aided in positioning troops on the battlefield and received praise from his commanding general for being "ever prompt and efficient."[503] In 1864, he joined a brigade staff[504] in the cavalry corps of Maj. Gen. Joe Wheeler, later becoming the general's assistant adjutant. Labouisse served in this capacity until his parole in May 1865, with the exception of a seven-week stay in a Macon, Georgia, hospital. According to the hospital register, he suffered from syphilis.[505]

Labouisse returned to New Orleans after the war and followed in his father's footsteps as a cotton broker. He helped establish the city's Cotton Exchange, which opened in 1871, and later served on its board of directors. Praised for his ability to reason clearly and speak forcefully, it was said that "his word was his bond."[506]

In 1896, at the zenith of his career, Labouisse died after a brief and unexpected illness. He was fifty-five. Shocked friends and business associates expressed profound regret at his loss. The main entrance of the Cotton Exchange building and the city's Memorial Hall were both draped with mourning crape. His wife and six children survived him.[507]

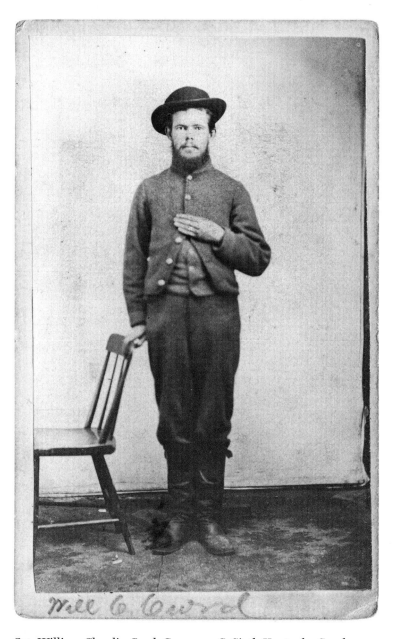

Sgt. William Chaplin Curd, Company C, Sixth Kentucky Cavalry

Carte de visite by unidentified photographer, about 1862. William A. Turner collection.

Escorting Jefferson Davis

DURING THE EARLY DAYS OF MAY 1865, A CHAOTIC MIX of men of war traveled through the South Carolina and Georgia countryside. Ragtag bands of unarmed, recently paroled Confederates on their way to formally surrender passed comrades making their way home. Among these travelers was a convoy of wagons bearing President Jefferson Davis and other Confederate government officials who had fled the capital. Five brigades of cavalrymen escorted the convoy, including a son of Kentucky, Sgt. Will Curd. Alert Yankee patrols spotted the convoy and closed in. Union troops had captured Curd once before, and he no doubt hoped to avoid a repeat of the experience.[508]

Back in 1863, Curd and his regiment, the Sixth Kentucky Cavalry, had set out on Brig. Gen. John Hunt Morgan's raid across the Ohio River into Indiana and Ohio. On July 13, as the raiders were navigating around enemy troops in Cincinnati, Yankees nabbed Curd in the city's outskirts and sent him to Camp Chase prison in Columbus. His captors transferred him to Chicago's Camp Douglas a month later.[509] He faced prison life with an inner strength fostered by his childhood.

Raised in Pulaski County, Curd grew up in a home "where every good man and woman was greeted with the heartiest of the truest Kentucky hospitality," according to one writer. Tragedy struck the family in 1850 with the death of his father, a hotelkeeper and merchant. His mother raised fourteen-year-old Will, his kid brother, and two younger sisters alone.[510] A year or two later, Curd left home and worked as a law clerk until the summer of 1862, when he enlisted as a private in the Sixth Cavalry. He had advanced to sergeant shortly before his capture near Cincinnati.[511]

Curd spent most of his imprisonment at Camp Douglas. In March 1865, he received a parole. He rejoined Morgan's Cavalry, now commanded by Brig. Gen. Basil Duke following Morgan's death the previous year. Duke and his horse soldiers became part of President Davis's escort as he and his entourage sought to reach Texas and from there continue the hopeless struggle. When the Northern troops discovered the convoy, Confederate commanders ordered most of the men, including Curd, to surrender, which they did in the village of Washington, Georgia, on May 9. Davis continued on with a smaller escort, and Union troops caught up with him the next day at Irwinsville.

Curd was not imprisoned. He signed the oath of allegiance about two weeks later, then returned to Kentucky. After working for a short time as a drug store clerk, he began the study of law and was admitted to the bar in 1867. Nicknamed "Captain Will" although he had not attained that rank in the army, he served stints as Pulaski County attorney and master commissioner. He belonged to the Democratic Party and the Methodist Church. In 1869 he married and started a family that grew to include six children. He lived until age sixty-five, dying in 1901. His wife, two sons, and two daughters survived him.

The Mexican Incident

IN JANUARY 1867, RADICAL REPUBLICANS IN THE U.S. Congress resolved to investigate a murder allegedly committed by Texas representative-elect George Chilton during the recent war. Chilton and his command reportedly had crossed the Mexican border, hunting for three Union officers whom they meant to kill. They captured all three and lynched one. Chilton also allegedly ordered that the head and right arm of the victim be cut off and sent home as a war trophy.[512] There was some truth to the charges. The hot-tempered, militaristic Chilton often found himself at the center of controversy. Lawyer, politician, and aggressive, he was a man of action. An eloquent orator, he spoke "in a plain, unostentatious, conversational manner."[513] His handsome looks were discussed publicly, and his natural abilities helped him gain statewide recognition after he moved to Texas in about 1850. Kentucky born, his father was former U.S. representative Thomas B. Chilton. After military service in the Mexican War,[514] George Washington Chilton settled in Tyler, Texas, married, and started a family. A proslavery zealot, he owned five slaves. He became a state legislator and, in 1859, at the Texas Democratic Convention, introduced a resolution that could have reopened the African slave trade.[515] He joined the Knights of the Golden Circle, a secret organization committed to the establishment of a slave empire that would have included Mexico and other nations. Named to the state's Secession Convention in early 1861, Chilton was the legislator who presented the resolution withdrawing Texas from the Union to Gov. Sam Houston.[516]

After the outbreak of hostilities, Chilton recruited a hundred men and marched a hundred miles with them to a place

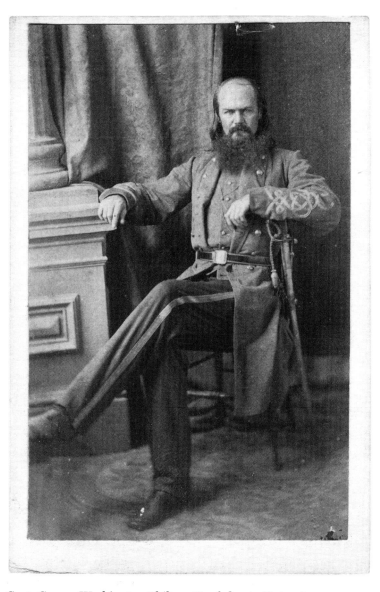

Capt. George Washington Chilton, Confederate States Army

Carte de visite attributed to A. G. Wedge (life dates unknown), Fort Brown, Texas, 1863. Lawrence T. Jones III collection.

of rendezvous—all in six days. "The genius of the man leads him to promptness and his energy will ensure success," noted one newspaper.[517] He became major of the Third Texas Cavalry—his preferred branch of the military.[518] He fought with distinction in two victorious battles in 1861. On August 10, he led a battalion against federal troops at Wilson's Creek, Missouri. On December 26, he suffered a minor wound when a rifle ball struck him in the head in a battle against pro-Union Creek and Seminole warriors at Chustenahlah, Indian Territory.[519]

In May 1862, the Third's one-year enlistment expired. When the regiment reorganized, Chilton was not reelected as their major, and he left the army. He returned, as captain and ordnance officer to Brig. Gen. Hamilton Bee, in 1863—the year he engaged in the incident that would lead to the 1867 congressional investigation. During the night of March 14-15, Chilton led about 150 troopers on an unauthorized manhunt for three Texans who were officers in the First Texas Cavalry, a federal outfit composed of volunteers loyal to the United States. He led his troopers into Mexico, captured the Union officers, and hanged one man, Capt. William W. Montgomery.[520] Mexican authorities protested the incursion, and Chilton received a rebuke but not a dismissal from the army. He served until the war's end and signed the oath of allegiance to the U.S. government in July 1865.[521]

The lynching of Montgomery tarnished Chilton's reputation and dogged him for the rest of his days. He became an alcoholic and went on periodic binges.[522] Radical Republicans made political hay of the story, embellishing it with the war trophy detail,[523] after his election to Congress in 1866. He never took his seat, but this had little to do with the Mexican incident. The Radicals protested the seating of the entire Texas delegation as part of an effort to punish the former Confederate states. Chilton died in 1884 at age fifty-six. His wife, daughter, and son, Horace, a future U.S. senator, survived him.

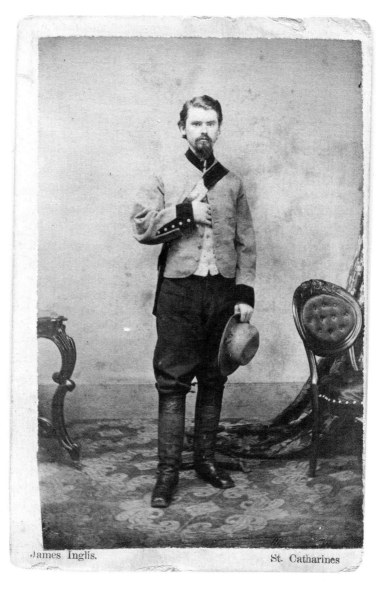

James Inglis. St. Catharines

1st Sgt. Frederick Beall, Company A, Tenth Mississippi Cavalry

Carte de visite by James Inglis (life dates unknown) of St. Catharines, Ontario, about 1865. William A. Turner collection.

Confederate and Commander for Life

GRAY-BEARDED CAPT. FRED BEALL WAS CONSPICUOUSLY absent from the 1920 ceremony dedicating a memorial amphitheater at Arlington National Cemetery. The influential commander of the Washington, D.C., camp of United Confederate Veterans refused to attend after organizers excluded his group from the event's planning. Moreover, only the names of federal leaders had been inscribed on the walls of the structure, prompting Beall and others to lament that the omission of prominent Confederates ran counter to the spirit of what claimed to be a memorial to American patriots from all states.[524]

Beall's rise to respected veterans' camp commander had begun eight decades earlier. Born in Georgia, raised in Alabama, and educated in Tennessee,[525] he settled in Mississippi and became a math teacher. He married a natural sciences instructor in 1859. In the spring of 1862, he left his pregnant wife and infant daughter and joined a company of partisan rangers. It later became part of the state's Tenth Cavalry.[526]

"In our first battle the first sergeant of the company was demoted while the battle was raging, when [my captain] ordered me to take charge of the company as first sergeant," recalled Beall, who likely referred to the action at Iuka, Mississippi, in September 1862.[527]

"I never missed a fight from the time I enlisted till the close of the war." His attendance was jeopardized in 1864 after authorities reassigned him as quartermaster for a detachment of men ordered away from the regiment on special duty in Alabama. "Some time later news came to us that General Sherman was marching through Georgia. I asked to be relieved, that I might go to my command, then pursuing Sherman," he explained. His

commanding officer denied the request. "After some argument, I stated to him that I had never known a soldier to be punished for going to the front, that I was going, with or without his consent, and, saluting him with 'Good-by,' I at once started for the front."[528]

"We followed Sherman through Georgia and South Carolina into North Carolina, and I was with my command when Gen. Joseph E. Johnston surrendered" his army on April 26, 1865. The war ended for many Confederates that day, but not for Beall. He eluded Union authorities and joined the force charged with escorting President Jefferson Davis and his entourage as they fled the federals. "At Lawrenceville, S.C., I was detailed to dispose of all horses, mules, and camp equipage, and my horse also got sick, so I was not able to keep up with the command," he remembered. This turn of events proved fortuitous, as his comrades fell into enemy hands while he lagged behind. Having evaded capture, he set out for Alabama. Upon his arrival, he learned that the army there had also laid down its arms. "There was nothing to do but go home, which I reached on the 17th of May, 1865, and never surrendered. I am still a Confederate, as devoted to the cause as ever."[529]

Beall became an attorney in West Point, Mississippi. After his wife died in the 1870s, he remarried. The family moved to Washington, D.C., in 1893. Beall continued his law career and became involved with the local United Confederate Veterans camp. By 1916 he had risen to its top post, and his comrades honored him as Life Commander in 1924. "Capt. Fred Beall, is one of God's chosen ones, whom we will not let give up the command," noted one U.C.V. member.[530]

Beall lived to be ninety-one, dying in 1929. Three daughters survived him. He was buried in the Confederate section of Arlington National Cemetery. His grave is located in the fourth of six rings that encircle an imposing bronze memorial dedicated by the United Daughters of the Confederacy. In the distance, and visible from his tombstone, stands the amphitheater against which he protested.[531]

Notes

Biographical information on enlisted men and officers was obtained from the National Archives and Record Service, Washington, D.C., and from Boatner's *The Civil War Dictionary* (New York: David McKay Company, 1962) unless otherwise noted.

Abbreviations

CV: Confederate Veteran Magazine, 40 vols. Nashville, Tenn., 1893–1932.

NARS: National Archives and Record Service. Washington, D.C.

OR: U.S. Government. *The War of the Rebellion: A Compilation of the Official Records of the Union and Confederate Armies,* 128 vols. Washington, D.C., 1880–1901. The *Official Records,* established by federal law in 1864, contain reports written and filed by commanders within days, weeks, or sometimes months of the events. The volumes are arranged in four series: Volumes I–III make up Series 1 and consist of official battle reports for the Union and Confederate armies. The remaining three series contain correspondence relating to prisoners of war, conscription, blockade running, and other communications. Most citations of this source include four numbers—series, volume, part, and page—and name the author of the cited report.

SHSP: Southern Historical Society Papers, 52 vols. Richmond, Va., 1876–1959.

1. The writings of British historians Thomas Macaulay and Thomas Carlyle inspired this statement. Carlyle's comment, "History is the essence of innumerable biographies," from his essay "On History," is especially significant.

2. Numbers are based upon an analysis of figures included in population returns from the 1860 Census and Fox's *Regimental Losses.*

3. Griffith, *Yours Till Death,* pp. vi–viii.

4. In an e-mail dated August 18, 2005, Milne responded to a request to verify these numbers by stating, "I would say that is about right," and added: "It is not an accurate count but a good generalization."

5. E-mail to the author, January 16, 2007.

6. Riggs, *21st Virginia Infantry,* p. 2.

7. Steiner, *Men of Mark in Maryland,* pp. 188–191.

8. Hartzler, *Marylanders in the Confederacy,* p. 29.

9. Richard C. Hoffman military service record, NARS.

10. Brugger, *Presidents of the Maryland Club;* Steiner, *Men of Mark in Maryland,* pp. 188–191; Marquis Publications, *Who Was Who in America,* vol. 1, p. 575.

11. Henderson, *12th Virginia Infantry,* p. 3.

12. McEnery's paternal grandfather, Mathew McEnery, lived in Baltimore, Maryland. This family connection may explain the photographers listed on the back of his *carte de visite.*

13. Henderson, *12th Virginia Infantry,* pp. 1, 141.

14. Congratulatory orders from Brig. Gen. Henry A. Wise, Confederate States Army. *OR,* I, XXXVI, 2: 316.

15. The regimental history confuses his death date with that of his father (June 19, 1881). Other records incorrectly list his death date as June 19, 1861.

16. Carroll, *Custer in the Civil War,* pp. 68–69, 89–90.

17. Ibid., pp. 89–90.

18. Ibid.

19. Wert, *Custer,* p. 28.

20. Schaff, *Spirit of Old West Point,* p. 159.

21. Sickles, "Custer's Roommate at West Point."

22. Ed Bearss, Chief Historian Emeritus, National Park Service, to the author, Feb. 6, 2007; Roberts and Moneyhon, *Portraits of Conflict,* p. 105; James P. Parker military service record, NARS.

23. 1900 U.S. Census; Mark Nero, curator of the Percha Bank Museum, Kingston, New Mexico.

24. *The Albany (Georgia) Patriot,* May 23, Nov. 7, 1861.

25. Thomas, *History of the Doles-Cook Brigade,* p. 86.

26. Ibid.

27. Daughters of the American Revolution, *History and Reminiscences of Dougherty County Georgia,* pp. 176–177.

28. Hunsicker, "Rayburn the Raider."

29. R. D. Keever to Lawrence T. Jones, Feb. 20, 1980. Doc's image was published in the 1981 Confederate Calendar. Lawrence T. Jones, Confederate Calendar Works.

30. An April 1862 application for an arrest warrant in Texas was issued for Rayburn and others riding with him. The charge was assault with the intent to kill civilians. There is no record that the arrest was made. Adkins-Rochette, *Bourland in North Texas and Indian Territory,* p. A-213; Baker, "Yellow Doc, The Ranger: An Arkansas Legend."

31. Hunsicker, "Rayburn the Raider."

32. Ibid.; 1850, 1860 U.S. Census.

33. The Twelfth was also known as Parsons's Regiment Mounted Volunteers (named for its commander, Col. William Henry Parsons), the Fourth Texas Dragoons, and the Fourth Texas Volunteers. Howell A. Rayburn

military service record, NARS; Milton V. Rayburn military service record, NARS.

34. Baker, "The Story and Legend of Doc Rayburn."

35. Report of Maj. James M. Pomeroy, commanding detachment of the Ninth Kansas Cavalry. *OR*, I, XLI, 2: 330.

36. On one of these adventures, he stole a black horse named Limber Jim. This story conflicts with the description of the horse Doc rode into Des Arc. Edwards, "Doc Rayburn, A Daring Confederate Hero."

37. Report of Brig. Gen. Christopher C. Andrews. *OR*, I, XLI, 4: 557.

38. Hunsicker, "Rayburn the Raider"; Edwards, "Doc Rayburn, A Daring Confederate Hero"; Baker, "The Story and Legend of Doc Rayburn."

39. Tobias Gibson to Mrs. Young, Apr. 6, 1862, Gibson and Humphreys Family Papers.

40. Capt. John McKinley died on the Crawford Expedition in 1782. According to the National Park Service's "The Revolution Day By Day" Web site, Col. William Crawford led the expedition that bears his name. It left for the Ohio frontier in May 1782. On June 6, Crawford's command fought warriors of the Wyandot Indian tribe. About 250 of the soldiers were killed, and Crawford was captured, scalped and burned.

41. Tobias's great-grandfather, Gideon Gibson of South Carolina, is at the center of a genealogical controversy. Some believe that he was a free man of color married to a white woman. Others maintain that his race will never be known due to fragmentary records, or that political opponents of Randall Gibson, McKinley's brother, used the race issue to attack him.

42. DeBow, "Terrebonne Parish."

43. McKinley's attitude towards slaves is suggested in two letters to his father, written nine years apart. In 1855, McKinley, curious about the sale of one of the family plantations in Louisiana, wrote, "I want to know how much you got for it and what you did with all the negroes." In 1864, as the Confederate economy was crumbling, he wrote, "There is no such thing as satisfying a Negro without slavery. They do not know their own wants and unless there is some one to teach them, they are but as little children. I hope they may in some way be made to feel that they are not the superiors of the whites." John McKinley Gibson to Tobias Gibson, Jan. 14, 1855, Gibson and Humphreys Family Papers; John McKinley Gibson to Tobias Gibson, Mar. 12, 1864, Collection of the Gilder Lehrman Institute of American History.

44. He attended Phillips Academy. According to its Web site, it is the oldest incorporated boarding school in America, founded in 1778.

45. Claude Gibson to Tobias Gibson, Sept. 25, 1854, Gibson and Humphreys Family Papers.

46. Today the school is known as Jena University. According to its Web site, it was founded in 1558.

47. McKinley's journal was described by Scott Mitchell of Sturgis, Kentucky, in a June 26, 2005, e-mail to Gibson family genealogist William La-

Bach. Mitchell writes: "My aunt found it in a house that had burned around 1920. Over the years, I somehow became the owner of it. I came across it once again this last week and decided to read it." Mitchell reports that the last entry in the journal is March 22, 1863, the date of the death of McKinley's brother Claude. Mitchell offered to give LaBach the journal "to pass on in your family," but the journal was never sent to LaBach. The author has been unable to contact Mitchell.

48. Report of Brig. Gen. Randall Lee Gibson, C.S. Army, commanding Gibson's Brigade, *OR*, I, XXXVIII, 3: 854–856.

49. McKinley wears a uniform with a first lieutenant's collar markings, but his file does not record that he served at this rank. McKinley Gibson military service record, NARS; Dorman, *The Prestons of Smithfield and Greenfield in Virginia*, p. 253.

50. Gibson and Humphreys Family Papers; McBride and McLaurin, *Randall Lee Gibson of Louisiana*, pp. 116, 179.

51. Report of Col. Randall L. Gibson, Thirteenth Louisiana Infantry, commanding First Brigade. *OR*, I, X, 1: 479–480.

52. *OR*, I, XXX, 2: 219; I, XXXVIII, 3: 856; I, XLV, 1: 704; I, XLIX, 1: 318.

53. Reports of Capt. W. Irving Hodgson, Fifth Company, Washington Artillery. *OR*, I, X, 1: 513–514.

54. Hughes, *Pride of the Confederate Artillery*, p. 338.

55. Capt. Hodgson issued a supplementary report containing commendations for twenty-six enlisted men, on April 11, 1862, two days after his original report was written. The following day, he requested that the supplementary report be erased from the record because of the gallant behavior of so many in the rank and file. In the end, both reports and the retraction request were published. *OR*, I, X, 1: 514–515.

56. Hughes, *Pride of the Confederate Artillery*, p. 338.

57. Ibid.

58. Washington L. Watkins military service record, NARS; Reports of Col. Edward Daniels, First Wisconsin Cavalry, and Brig. Gen. M. Jeff Thompson, Confederate States Army. *OR*, I, XII: 67–68.

59. Greer W. Davis to Gov. Hamilton R. Gamble, May 29, 1862. Washington L. Watkins military service record, NARS.

60. Watkins believed that the role of the guard was to keep peace in the state by protecting both Northern and Southern sympathizers (See *OR*, II, I: 154), but it supported the Confederacy after political and military events plunged the state into war. A series of communications in the *Official Records* documents Nathaniel Watkins's negotiations with the federal government for a pardon, which he eventually received.

61. Richard James "Dick" Watkins signed the oath of allegiance to the United States before January 1862. It is likely that he served in the Missouri State Guard. John Clay Watkins did not serve in the military during the war. William B. Watkins served in the Confederate First and Fourth

Consolidated Missouri Infantry. He was captured, or deserted, during the Vicksburg Campaign and signed the oath of allegiance in 1863. Greer W. Davis to Gov. Hamilton R. Gamble, May 29, 1862. Washington L. Watkins military service record, NARS; William B. Watkins military service record, NARS; Col. Leonard F. Ross to Brig. Gen. Nathaniel W. Watkins, Jan. 30, 1862. *OR*, II, I: 163.

62. Washington L. Watkins military service record, NARS.

63. The two Virginia infantry regiments were the Fifth and the Twenty-seventh. Jones, *Lee's Tigers*, pp. 86–87; Report of Maj. Gen. Thomas J. "Stonewall" Jackson. *OR*, I, XII, 1: 712–715; Reminiscence of Pvt. Bernard H. "Barney" Collins, Company H, Seventh Louisiana Infantry, undated, Louisiana State University Special Collections.

64. This report was originally published in the *Lynchburg Virginian* and is described as an eyewitness account by Capt. Daniel A. Wilson of Lynchburg. *New Orleans Bee*, July 4, 1862.

65. Count Marie Joseph Gabriel St. Xavier de Choiseul left the South and returned to France to escape an anticipated Union blockade, according to one account. A second account notes that he left after Charles died. Leeming Grimshawe, "DeChoiseul Family Were a Part of the Old South." *The (Hendersonville, N.C.) Times-News* (Oct. 13, 1965); Arthur, *Western North Carolina: A History*, chap. 21; Patton, *A Condensed History of Flat Rock*, pp. 22-27.

66. Grimshawe, "DeChoiseul Family" (see n. 65); Patton, *The Story of Henderson County*, p. 120.

67. Miceli, *The Pickwick Club of New Orleans*, p. 129.

68. *The (New Orleans, La.) Delta*, Feb. 14, 1861.

69. Report of Brig. Gen. P. G. T. Beauregard, commanding the Confederate Army of the Potomac. *OR*, I, II: 445.

70. Maj. Roberdeau Wheat was wounded in the Battle of First Manassas. De Choiseul's letters in the Historic New Orleans Collection include lively anecdotes related to his stint as commander of the battalion.

71. Charles de Choiseul to Emma Walton, Jan. 1862, Walton-Glenny Family Papers.

72. Mary Boykin Chesnut includes a reference to de Choiseul on pages 321–322 of the version of her writings originally published as *A Diary of Dixie*. The passage is included in the August 19, 1864, entry, and reads: "A Wayside incident. A pine box, covered with flowers, was carefully put upon the train by some gentlemen. Isabella asked whose remains were in the box. Dr. Gibbes replied: 'In that box lies the body of a young man whose family antedates the Bourbons of France. He was the last Count de Choiseul, and he has died for the South.' Let his memory be held in perpetual remembrance by all who love the South!" This entry is problematic on several accounts, most notably the date (more than two years after his death). The author has not been able to reconcile the issues with this reference, and

therefore has not added it to de Choiseul's profile. The passage is absent in the Pulitzer Prize–winning 1981 version published as *Mary Chesnut's Civil War*. Editor C. Vann Woodward does not explain why this passage was deleted. However, the front matter includes a detailed explanation of the history of Chesnut's writings and the editorial challenges associated with publishing a version of the diary that would reflect the author's intent.

73. According to 1860 U.S. Slave Schedule, William R. Boggs owned twenty-three slaves.

74. *CV* (1922): p. 107.

75. Sickles, "The Second Missouri Cavalry C.S.A.," pp. 18–20.

76. David C. Boggs military service record, NARS.

77. *CV* (1922): p. 107.

78. Report of Col. William Barksdale, Thirteenth Mississippi Infantry, commanding Third Brigade, Magruder's Division. *OR*, I, XI, 2: 750.

79. Pvt. Frank Hume served with Reading in the "Southrons."

80. Transcript provided by historian Jeff T. Giambrone of Clinton, Mississippi. Booth, *Private Memoranda*, vol. 3, p. 10.

81. Abram Beach Reading non-graduate card, Seeley G. Mudd Manuscript Library.

82. Daniel and Gunter, *Confederate Cannon Foundries*, pp. 52–53.

83. Abram Beach Reading military service record, NARS.

84. Frank Hume military service records, NARS; 1860 U.S. Census.

85. According to a Guadalupe County historical marker erected in 1936 and *The Handbook of Texas Online*, Nathaniel Benton was also born in Tennessee. He arrived in Texas in 1835, joined the army, and later served as a Texas Ranger. After the start of the Civil War he organized Company D of the Fourth Texas Infantry. Benton did not accompany the regiment to Virginia. He stayed behind and raised Company B of the Thirty-sixth (initially the Thirty-second) Cavalry and became its lieutenant colonel. He was a brother-in-law of generals Ben and Henry E. McCulloch.

86. *The Seguin Enterprise*, Feb. 4, 1904.

87. Harris's father, a Tennessee native, served as a private in the First Tennessee Mounted Infantry during the Cherokee Wars and, in 1836, went to Texas with the regiment to protect the Sabine frontier. White, *Index to Volunteer Soldiers in Indian Wars and Disturbances, 1815–1858*, pp. 595–596.

88. Sowell, *Early Settlers and Indian Fighters of Southwest Texas*, vol. 2, p. 527.

89. Etlinger, *Sweetest You Can Find*, p. 270.

90. "Autobiography of Lt. J. Wes Harris," dated Jan. 21, 1917, provided by Martin Callahan of San Antonio, Texas.

91. John W. Harris death certificate, Texas Bureau of Vital Statistics.

92. *The Seguin Enterprise*, Dec. 1, 1922.

93. Maj. Baxter Smith joined Forrest's command with two companies

of C. C. Spiller's Cavalry Battalion shortly before this raid. He later became colonel of the Eighth (also known as the Fourth) Tennessee Cavalry. He related this anecdote during a memorial tribute to Brown. In 1897, Smith, in describing a later incident, involving a visit to severely wounded Col. James E. Saunders, notes that Brown was a member of Saunders's staff. The author has been unable to verify this staff affiliation. *The (Nashville, Tenn.) Daily American,* June 1, 1878; *CV* (1897): p. 121.

94. *The (Nashville, Tenn.) Daily American,* June 1, 1878.

95. Ibid.

96. Trim Brown is mentioned as a member of Edmund D. Baxter's Tennessee Light Artillery and Capt. Benjamin F. White Jr.'s Horse Artillery Battery. Edmund Baxter was the cousin of Maj. Baxter Smith. James T. Brown military service records, NARS; Captain E. D. Baxter SCV Camp 2034, *A Biography of Edmund Dillahunty Baxter* (Web site).

97. *The (Nashville, Tenn.) Daily American,* June 1, 1878.

98. Report of Brig. Gen. John C. Brown, commanding brigade. *OR,* I, XXX, 2: 373; Report of Brig. Gen. John C. Brown, commanding brigade and Stevenson's Division. *OR,* I, XXXI, 2: 727.

99. *The (Nashville, Tenn.) Daily American,* June 1, 1878.

100. Ibid., June 2, 1878.

101. 1st Lt. John R. Ellis to Col. Augustus J. Lythgoe, Aug. 11, 1862. John R. Ellis military service record, NARS.

102. 1860 U.S. Census and Slave Schedules.

103. Beck, *Third Alabama!,* p. 56.

104. Robert M. Jones military service record, NARS.

105. Report of Maj. Gen. Daniel H. Hill, commanding division. *OR,* I, XIX, 1: 1018–1030; Report of Brig. Gen. Robert E. Rodes, commanding brigade. *OR,* I, XIX, 1: 1033–1039.

106. Also known as Waller's Battalion, the Quartermaster Battalion is formally designated the Second Battalion Virginia Infantry Local Defense Troops. Robert M. Jones military service record, NARS.

107. Robert M. Jones Confederate military record, State of Alabama Department of Archives and History.

108. Thomas, *History of the Doles-Cook Brigade,* pp. 69–70; Report of Maj. Gen. Daniel H. Hill, commanding division. *OR,* I, XIX, 1: 1028–1029.

109. Thomas, *History of the Doles-Cook Brigade,* pp. 82–83.

110. In one entry, Young notes an exchange with slave traders: "Agreed with them *entirely,* that the negroes would be much better off in this country, & don't see what right Uncle Sam has to send them away." The ship's captain was named Procter, a Massachusetts resident, whom Young was frequently at odds with during the voyage. Dr. William Proby Young Diary. Virginia Historical Society, Richmond, Virginia.

111. Thomas, *History of the Doles-Cook Brigade,* pp. 82–83; William Proby Young Jr. military service record, NARS.

112. Thomas, *History of the Doles-Cook Brigade,* pp. 82–83; "Paroles of the Army of Northern Virginia." *SHSP* 15 (1887): p. 246.

113. 1870, 1880, 1900, and 1910 U.S. Censuses.

114. Thomas, *History of the Doles-Cook Brigade,* pp. 82–83.

115. William W. Helm military service record, NARS; list of blockade runners and other naval captures imprisoned in Fort Warren and turned over to the War Department for exchange, Mar. 23, 1865. *OR,* II, VIII: 407; list of vessels captured in the vicinity of Mobile, Alabama, issued by Capt. John R. Goldsborough, commanding West Gulf Blockading Squadron. *Official Records of the Union and Confederate Navies,* I, XX: 278; Naval Historical Center, Glasgow, *Dictionary of American Fighting Ships* (http://www.history.navy.mil/danfs/g5/glasgow.htm).

116. Two images of Helm have come to the author's attention. One is published in Volume 7 of Francis Trevelyan Miller's landmark *Photographic History of the Civil War.* Captioned "Comfortable Confederates in Fort Warren—1864," it identifies him as "W.W. Helm." Another image of him appears on the Web page "Confederate Prisoners held at Fort Warren in Boston" (http://www.geocities.com/coh41/FtWarren.html). It is a *carte de visite* identified as "W.W. Helms CSN."

117. William W. Helm military service record, NARS.

118. 1880 U.S. Census; 1886, 1887, 1890 Louisville, Kentucky, city directories.

119. General Order 122, orders and circulars issued by the Army of the Potomac and the Army and Department of Northern Virginia C.S.A., 1861–1866, NARS.

120. Pvt. Samuel P. Alexander was captured at Woodstock, Virginia, on June 2, 1862, sent to Fort Delaware, and paroled about two months later. He enlisted in the Forty-third Battalion Virginia Cavalry, also known as "Mosby's Rangers." He gained his parole at Lynchburg in May 1865.

121. Report of Capt. John D. Alexander, commanding Campbell Rangers. *OR,* I, II: 564–565.

122. General Order 122, orders and circulars issued by the Army of the Potomac and the Army and Department of Northern Virginia C.S.A., 1861–1866, NARS.

123. Ibid.

124. Driver, *2nd Virginia Cavalry,* p. 191.

125. James H. Polk to George W. Polk, Nov. 28, 1862, George Washington Polk Papers.

126. George W. Polk to James H. Polk, Aug. 9, 1859, ibid.

127. Polk first served in the Second Battalion Tennessee Cavalry. It merged with another battalion in May 1862 and formed the Sixth Tennessee Cavalry, also known as the First and Second Tennessee Cavalry. George Washington Polk Papers, University of the South; James H. Polk military service record, NARS.

128. Skedaddle may have become part of the Union cavalry. Polk, *Polk's Folly*, p. 280.

129. James H. Polk to George W. Polk, Apr. 22, 1864, George Washington Polk Papers.

130. Maj. John Ogden Murray, writing in 1905, is credited with coining the phrase "The Immortal Six Hundred." Murray, *The Immortal Six Hundred*, p. 11.

131. Polk, *Polk's Folly*, p. 281.

132. Ibid., pp. 309–310.

133. Ibid.

134. Ibid., xxvi, 332–337.

135. John A. Wyeth, "Trials with Gen. John H. Morgan" *CV* (1911): p. 119.

136. Report of Col. Robert P. Trabue, Fourth Kentucky Infantry, commanding First (Kentucky) Brigade. *OR*, I, X, 1: 620.

137. Maj. Gen. Ormsby McKnight Mitchel's son, Edward (or Edwin) M. Mitchel, served as a quartermaster with the Fourth Ohio Cavalry. Johnson, *The Twentieth Century Biographical Dictionary of Notable Americans*, vol. 7, p. 398.

138. Ramage, *Rebel Raider*, pp. 164–165; Brown, *The Bold Cavaliers*, pp. 23–24.

139. Stanton, *Bluegrass Pioneers*, pp. 157–158.

140. Charlton Morgan served as secretary to Ambrose Dudley Mann (1801–1889), who, with William L. Yancey and Pierre A. Rost, formed the delegation of Confederate commissioners.

141. Hunt-Morgan-Hill Family Collection, Eleanor S. Brockenbrough Library, Museum of the Confederacy.

142. Stanton, *Bluegrass Pioneers*, pp. 157–158.

143. Ibid.

144. Stuart, "Operation Sanders"; *New York Times*, April 19, 1863; Anna J. Sanders Journal, Oct. 20, 1864, George N. Sanders Papers.

145. *New York Times*, Jan. 21, 1863.

146. This profile appeared after his first capture. *New York Times*, Nov. 13, 1862.

147. The Free Academy was founded in 1847. Today it is known as the City College of New York (CCNY).

148. *New York Times*, Nov. 13, 1862.; Stuart, "Operation Sanders."

149. Harris had almost certainly been responsible for Sanders's capture on Dividing Creek, and he was plotting to thwart his plans again. Ibid.

150. Capt. Sylvanus W. Godon, U.S. Navy, commanding U.S.S. *Powhatan*, *Official Records of the Union and Confederate Navies*, 1, XIII: 497.

151. Sanders never received this letter. His mother sent the letters to New York Gov. Horatio Seymour, and he forwarded them to the U.S. War Department. Reid Sanders military service record, NARS.

152. Alexander, "How We Escaped from Fort Warren."

153. Maj. Stephen Cabot, commanding Fort Warren, to Anna J. Sanders, Sept. 8, 1864, George N. Sanders Papers.

154. The friend is Samuel Pickens, who hailed from one of Alabama's wealthiest slaveholding families. Two entries from his journal refer to David as "Davy." Hubbs, *Guarding Greensboro*, p. 264.; Hubbs, *Voices of Company D*, pp. xv–xvi, 144, 148, 186, 195.

155. Dr. Augustus Barnum. *The Selma Times-Journal,* July 24, 2005. Hubbs, *Guarding Greensboro*, p. 248.

156. The *Register of Candidates for Admission to the USNA;* U.S. Secretary of the Navy Isaac Toucey to David Barnum, Apr. 12, 1860; Superintendent George S. Blake to Secretary of the Navy Isaac Toucey, Sept. 27, 1860. William W. Jeffries Memorial Archives.

157. Hubbs, *Guarding Greensboro*, p. 248.

158. Hubbs, *Voices of Company D*, pp. 95, 394.

159. *Greensboro Watchman*, Mar. 29, 1900.

160. *Greensboro Record,* Dec. 17, 1903.

161. Hubbs, *Voices from Company D*, pp. 159, 183.

162. His captain was Jonathan W. Williams. Ibid., pp. 424–425; *Greensboro Record,* Dec. 17, 1903.

163. Built in 1841 under the supervision of Commo. Matthew Perry, the *Mississippi* served as his flagship during the Mexican War. In 1852, she was part of Perry's fleet that sailed to Japan on an historic trade mission. The *Mississippi* returned to America in 1860 and was assigned to blockade duty off Key West, Florida. In April 1862 she joined Flag Officer David Farragut's fleet at New Orleans. Paine, *Ships of the World,* p. 338.

164. "The fleet consisted of fourteen vessels, steam frigates, sloop-of-war, gunboats, and mortar-boats, and all except the mortar-boats came within range." Report of Maj. Gen. Franklin Gardner, commander of C.S. forces at Port Hudson. *OR,* I, XV: 274.

165. The private was Marcus A. Sanford of Company A. Ramsey, *David Wardlaw Ramsey in the War Between the States*, pp. 9–10.

166. Ibid.

167. Capt. David Ramsey to Rev. Abiezer C. Ramsey, dated Apr. 19, 1862, from Camp Chase near Columbus, Ohio. This letter was part of a group of letters written by Confederate prisoners that were never sent. The cache of letters that included this one was discovered in 1929; Ohio state officials turned them over to a Confederate veterans' group. A list of the letters was published in a newspaper, and the article was brought to the attention of the late Capt. Ramsey's son Hawthorne, who then came into possession of it. Ibid., Exhibit 2.

168. Ramsey, *David Wardlaw Ramsey in the War Between the States*, p. 12.

169. The University of Louisiana is known today as Tulane University.

170. 1870 U.S. census.

171. Herschel V. Johnson to James A. Seddon, Apr. 28, 1863, James J. McKinley military service record, NARS.

172. In his *carte de visite* photograph, McKinley wears an officer's double-breasted uniform coat.

173. Forrest wrote the letter that includes this quote after learning that Gen. Braxton Bragg had disapproved Rawle's nomination "for reasons unknown to me." He requested that the nomination be reconsidered. Rawle remained on Forrest's staff during this time. Brig. Gen. Nathan Bedford Forrest to Secretary of War James A. Seddon, Aug. 18, 1863. John Rawle military service record, NARS.

174. Report of Brig. Gen. Nathan B. Forrest. *OR*, I, XXX, 2: 525.

175. Sickles, "Southern Soldiers."

176. Chapter 32, "Of the Permanence of the Union," discusses "the principles of [the Constitution's] adhesion, and to the provisions it contains for its own duration and extension." Some sources suggest that Robert E. Lee resigned from the U.S. Army due in part to this book, which influenced him as a West Point cadet. Historians, notably Freeman, have challenged this claim.

177. John Rawle military service record, NARS.

178. Stanton Hall still stands.

179. *CV* (1909): p. 329.

180. Confederate forces turned back the Union navy. The Yankee ships resumed firing after dark, enabling the troop transports to successfully run the batteries and land south of Grand Gulf and forcing the Confederates to evacuate their defenses.

181. *SHSP* 22 (1894): p. 175.

182. His father, John Wesley Beauchamp, also graduated from the University of Nashville.

183. John A. Beauchamp military service record, NARS.

184. Commanded by Maj. Robert Martin, it was composed of independent batteries from various states.

185. *CV* (1910): p. 437.

186. Ibid.

187. The soldier who lost control of his horse was Wiley Chandler Howard. He served as a lieutenant in Company C of Cobb Legion Cavalry. Howard, *Sketch of Cobb Legion Cavalry*, pp. 6–7.

188. Ibid., pp. 3, 11.

189. Ibid., p. 11.

190. McCash, *Thomas R. R. Cobb, The Making of a Southern Nationalist*, pp. 311–312.

191. Howard, *Sketch of Cobb Legion Cavalry*, pp. 10–11.

192. Ibid., pp. 9–10.

193. Pvt. John A. Wright served in Company D of the 140th Pennsylvania Infantry. He survived the war.

194. Stegeman, *These Men She Gave*, p. 98.

195. Goldsborough, *The Maryland Line in the Confederate Army*, p. 96.

196. The story was somewhat exaggerated. Dr. Charles Edward Goldsborough was likely captured by others and processed at Star Fort, which had been turned into a receiving station for federal prisoners. There he probably met William, who had been assigned as provost guard. A sketch of Charles's life claims that he was "captured on the field at Carter's Woods, by his brother, William," on June 15. Carter's Woods was the wooded area near railroad tracks at Stephenson's Depot, located four miles north and east of Star Fort. *History of Cumberland and Adams Counties, Pennsylvania*, pp. 508–509.

197. The open field was later named for the lieutenant colonel in command of federal forces on this sector of the battlefield, Ario Pardee Jr. Personal communication from Ed Bearss to the author, Feb. 6, 2007; Report of Lt. Col. Ario Pardee Jr., 147th Pennsylvania Infantry, *OR*, I, XXVII, 1: 845–846; Goldsborough, *The Maryland Line in the Confederate Army*, pp. 106–109.

198. Scharf, *History of Western Maryland*, vol. 1, p. 332.

199. This was his second injury of the war. At the Battle of Second Manassas, acting as an aide to his cousin, Col. Bradley T. Johnson, he was wounded in the fighting at the Railroad Cut; he was serving temporarily as adjutant of the Forty-eighth Virginia Infantry while between assignments: the First Maryland Infantry, in which he had succeeded Johnson as captain of Company A, had ended their term of enlistment, and the Second Maryland Infantry had not yet formed. Report of Col. Bradley T. Johnson, brigade commander, *OR*, 1, XII, 2: 666.; William W. Goldsborough military service record, NARS.

200. The other officers wounded and carried to the nearby house with Goldsborough were Lt. Col. James R. Herbert and lieutenants Andrew C. Trippe and Joseph W. Barber. Barber did not survive. Spencer, *Genealogical and Memorial Encyclopedia of the State of Maryland*, p. 55.

201. The sketch of Charles's life in the *History of Cumberland and Adams Counties* notes that the brothers reunited at Fort Delaware. Charles's military service record makes no mention of his presence there. The author believes the former account inaccurate. *History of Cumberland and Adams Counties, Pennsylvania*, pp. 508–509; Charles E. Goldsborough military service record, NARS.

202. Joslyn, *Biographical Roster of the Immortal 600*, p. 117.

203. Isabella Buchanan Edmondson's diary entry is dated July 4, 1863, but was likely written at a later date. Galbraith and Galbraith, *A Lost Heroine of the Confederacy*, p. 19.

204. Dr. Simon Gratz Moses of Philadelphia graduated from the University of Pennsylvania in 1835 and opened a private practice in Bordentown, New Jersey. Gratz Moses was born there in 1839—the same year the family went to Europe, where Dr. Moses served as private physician to Joseph Bonaparte, the eldest brother of Napoleon (Joseph had lived in Bordentown for years before his return to France). The Moses family returned to America in 1840, and they settled in St. Louis the following year. Hyde and Conard, *Encyclopedia of the History of St. Louis,* Vol. 3, pp. 1574–1575; Soule, "Dr. S. Gratz Moses."

205. The brother was John A. Moses. The author located one Confederate soldier with this name. He served as a private in Company D of the Second Kentucky Cavalry. Their father returned to St. Louis after his exile and resumed his medical practice there.

206. Gratz A. Moses military service record, NARS.

207. Galbraith and Galbraith, *A Lost Heroine of the Confederacy,* p. 29.

208. Ibid., p. xxiv.

209. Ibid., pp. xxiv–xxviii.

210. Ibid., p. xxxi.

211. The author found two references to Wilson's nickname, "Mike." *CV* (1914): p. 431; (1918): p. 503.

212. Micajah R. Wilson military service record, NARS.

213. 1860 U.S. Census.

214. Micajah R. Wilson military service record, NARS.

215. The Eighth was also known as the First Battalion, Second Battalion, and Jones's Battalion (after its commander, Lt. Col. Bart. Jones).

216. Wilson was one of six officers included in this notation. Report of Brig. Gen. William L. Cabell, C.S. army, commanding Cabell's Brigade. *OR,* I, XVII, 1: 403.

217. Hewitt, *Port Hudson, Confederate Bastion on the Mississippi,* pp. 20, 132.

218. Micajah R. Wilson to President Andrew Johnson, June 17, 1865. U.S. Civil War Manuscripts Collection, Rare Book and Manuscript Library, Columbia University.

219. 1880 U.S. Census.

220. Emma French Wilson pension file, Louisiana State Archives.

221. Union Brig. Gen. George L. Andrews refused Gen. Gardner's sword. Association of the Defenders of Port Hudson, "Fortification and Siege of Port Hudson." *SHSP* 14 (1886): p. 344.

222. The Georgia Military Institute was established in Marietta in 1851. Union forces burned it in November 1864. The Georgia legislature made several unsuccessful attempts to reestablish the school after the war.

223. *Biographical and Historical Memoirs of Louisiana,* vol. 1, p. 533.

224. The "Columbus Riflemen," also known as the "Columbus Rifles," became Company K of the Fourteenth Mississippi Infantry.

225. Federal authorities transferred Lanier from Johnson's Island to Point Lookout in March 1865, and the following month to Fort Delaware, where he signed the oath. John S. Lanier military service record, NARS.

226. *Biographical and Historical Memoirs of Louisiana*, vol. 1, p. 533.

227. The officer, John Robert Boyles, served in the Twelfth South Carolina Infantry. After the war, he wrote "Reminiscences of the Civil War," which is part of the collection of the State Archives of South Carolina. Sayers, *Wounded at Gettysburg* (Web site); Mattie B. Boyles pension record, South Carolina Department of Archives and History.

228. Report of Col. J. Foster Marshall, Orr's Rifles, *OR*, I, XI, 2: 876.

229. Evins, *The Evins Family*, p. 8.

230. *Carolina (Spartanburg, South Carolina) Spartan*, Nov. 28, 1872.

231. Gregg's South Carolina Brigade.

232. Studnicki, "Perry's Brigade."

233. Edgar Haskell Raysor died at Antietam. John Michael Raysor suffered a wound that shattered his right arm and he left the regiment in August 1863. Alfred Raysor surrendered with George in 1865.

234. Capt. William J. Bailey died in a Union prison. Pasco, "Jefferson County, Florida, 1827–1910, Part II."

235. Report of Col. David Lang, Eighth Florida Infantry, commanding Perry's Brigade. *OR*, I, XXVII, 2: 631–632.

236. The casualty rate is 65 percent. By comparison, the Union's famed Iron Brigade suffered a 63 percent rate at Gettysburg. Studnicki, "Perry's Brigade."

237. George D. Raysor military service record, NARS.

238. Huxford, *The History of Brooks County Georgia*, pp. 156, 193.

239. Divine, *8th Virginia Infantry*, p. 21.

240. Janney and Janney, *Ye Meetg Hous Smal*, pp. 60–64.

241. Report of Col. Wheelock G. Veazy, Sixteenth Vermont Infantry, who received the Medal of Honor for his actions at Gettysburg on July 3, 1863. *OR*, I, XXVII, 1: 1042.

242. Kirkbride Taylor military service record, NARS.

243. *Hampshire (Romney, West Virginia) Review*, Oct. 15, 1913.

244. "Prison Life at Fort McHenry," *SHSP* 8 (1880): pp. 77, 81.

245. Ibid., p. 77.

246. J. William Jones, "Rev. T. D. Witherspoon, D.D." *CV* (1899): p. 178.

247. Sanders, *History of the Louisville Presbyterian Theological Seminary*, p. 39.

248. Thomas Dwight Witherspoon military service record, NARS; Stubbs, *Duty, Honor, Valor*, p. 813.

249. J. William Jones, "Rev. T. D. Witherspoon, D.D." *CV* (1899): p. 178.

250. Edwin Hugh Miller served as a commissary sergeant in the Forty-second Infantry. At Gettysburg, he allowed himself to be captured so that he could search for his grievously wounded father. After he accompanied

his father's body to Richmond via Baltimore, he returned to his home in Mississippi and became captain of a cavalry company.

251. "Prison Life at Fort McHenry," *SHSP* 8 (1880): p. 81.

252. This undated text may have been originally written for Witherspoon's "Prison Life at Fort McHenry," but it was not included in the final three-part article. Thomas Dwight Witherspoon Papers.

253. J. William Jones, "Rev. T. D. Witherspoon, D.D." *CV* (1899): p. 178.

254. Caldwell, *The History of a Brigade of South Carolinians,* pp. 11–22.

255. Report of Brig. Gen. Hugh J. Kilpatrick, Third Division, Cavalry Corps, *OR,* I, XXVII, 1: 990.; Report of Maj. Gen. Henry Heth, commanding Heth's and Pender's divisions, *OR,* I, XXVII, 2: 641–642.; Boatner, *Civil War Dictionary,* pp. 273–274.

256. Caldwell, *History of a Brigade of South Carolinians,* p. 150.

257. C. C. Featherstone to a cousin, 1935. Transcription of the letter provided by Joseph E. Major of Greenville, South Carolina.

258. Transcription from Andrews's *Condensed History of the 3rd Georgia Volunteer Infantry* published on the Company "G," Third Regiment Georgia Volunteer Infantry Web site.

259. Transcription from Folsom's *Heroes and Martyrs of Georgia* published on the Company "G," 3rd Regiment Georgia Volunteer Infantry Web site.

260. Genealogical research notes compiled by Janice Parkison Rodriguez of Johnstown, Pennsylvania, and posted on the Web site RootsWeb.com on July 1, 2002.

261. Ed Bearss, personal communication to the author, Feb. 6, 2007. Report of Brig. Gen. Ambrose R. Wright, C.S. Army, commanding brigade, *OR* I, XXVII, 2: 622–625.

262. Letter from an Augusta-based assistant surgeon dated Oct. 22, 1863. Surgeon's report. John L. Ells military service record, NARA.

263. *The (Macon) Georgia Weekly Telegraph,* Aug. 14, 1868.

264. Ells is listed as a Baltimore news reporter in the 1880 U.S. Census. His brother, James Nathan Ells, edited the *Southern Field and Fireside,* an Augusta literary magazine.

265. *CV* (1902): pp. 561–562.

266. Perrin, *History of Fayette County, Kentucky,* pp. 585–586; *CV* (1902): pp. 561–562.

267. *The (Lexington, Kentucky) Morning Herald,* Dec. 5, 1902.

268. Joslyn, *Biographical Roster of the Immortal 600,* pp. 59–60; *CV* (1902): pp. 561–562.

269. Thomas B. Webber to his parents, Aug. 22, 1862, and June 15, 1864. Civil War Times Illustrated Collection, U.S. Army Military History Institute; Duke, *History of Morgan's Cavalry,* p. 454.

270. Duke, *History of Morgan's Cavalry,* p. 454.

271. Ibid.

272. Quotes from the January 8 and 11 entries in Webber's 1861 diary, which is part of the Rare Book, Manuscript, and Special Collections Library of Duke University. Power, *The 1861 Diary of Major Thomas B Webber*, pages unnumbered.

273. He was later reported as having deserted, although no formal charges appear on his record. Thomas B. Webber military service record, NARS.

274. Thomas B. Webber to Lt. Gen. John C. Pemberton, Nov. 4, 1862. Thomas B. Webber military service record, NARS.

275. Duke, *History of Morgan's Cavalry*, pp. 404, 454.

276. Webber's letter made its way to the War Department in Washington, D.C. On October 10, 1863, he was placed into solitary confinement at Ohio State Penitentiary. He protested his treatment and defended his statement as being "in favor of executing the statutes of the Southern States as provided for negroes in insurrection." Ibid., pp. 476–477; *OR*, II, VI: 408–409.

277. Affidavit of Lee Webber, June 30, 1909, transcribed from the Shelby County, Tennessee, courthouse records; Lee Webber Tennessee Confederate Pension Applications: Soldiers and Widows, Tennessee State Library and Archives.

278. Joslyn, *Immortal Captives*, pp. 17–22.

279. Lee Webber Tennessee Confederate Pension Applications: Soldiers and Widows, Tennessee State Library and Archives.

280. 1870 U.S. Federal Census Mortality Schedule for Missisippi.

281. 1860 U.S. Census; "John M. Coleman" *CV* (1924): p. 476.

282. John M. Coleman military service record, NARS.

283. "John M. Coleman" *CV* (1924): p. 476; "A Correction" *CV* (1925): p. 107; *The (Louisville, Kentucky) Courier-Journal*, Nov. 15, 1924.

284. John M. King military service record, NARS.

285. Report of Col. Randall Lee Gibson, commanding Adams's Brigade. *OR*, I, XX, 1: 797–799.

286. John M. King military service record, NARS.

287. The author dates this image between January and September 1863 —the period after his wounding and before his amputation.

288. Hughes, *Pride of the Confederate Artillery*, pp. 124–125, 287–288.

289. Ibid.; Felix Arroyo military service record, NARS.

290. Hughes, *Pride of the Confederate Artillery*, p. 160.

291. Ibid., pp. 281, 287–288; Leontine Arroyo pension file, Louisiana State Archives.

292. Report of Col. John S. Fulton, Forty-fourth Tennessee Infantry, commanding Johnson's Brigade. *OR*, I, XXX, 2: 476.

293. Report of Col. Richard H. Keeble, Twenty-third Tennessee Infantry. *OR*, I, XXX, 2: 486–487.

294. Report of Col. John S. Fulton, Forty-fourth Tennessee Infantry, commanding Johnson's Brigade. *OR*, I, XXX, 2: 476–477; Report of Col. Richard H. Keeble, Twenty-third Tennessee Infantry. *OR*, I, XXX, 2: 487.

295. Beglan, *A Family and Its Heritage*, p. C5-28.

296. *CV* (1926): p. 27.

297. Hugh G. Gwyn to Mrs. Johnston, Aug. 7, 1865. Eleanor S. Brockenbrough Library, Museum of the Confederacy.

298. *CV* (1906): pp. 118–119; Hugh G. Gwyn military service record, NARS; Connelley, *History of Kentucky*, vol. 2, p. 1148.

299. Duke, *History of Morgan's Cavalry*, p. 574.

300. This letter also contains a reference to having had his picture taken in a new Confederate uniform at Augusta. The portrait accompanying this profile may be from that sitting. Hugh G. Gwyn to friends in direct care of James Geddes, Aug. 7, 1865. Eleanor S. Brockenbrough Library, Museum of the Confederacy.

301. *CV* (1906): pp. 118–119.

302. Hugh G. Gwyn death certificate, Department of Vital Records, San Diego County, California.

303. *CV* (1926): p. 88.

304. *Chevaux de frise* were used in a defensive structure placed in front of earthworks. According to the Petersburg National Battlefield Pictionary on the Internet, "they were logs that measured about 12 feet long and 10 inches thick, drilled through every foot at right angles for sharpened stakes which projected three feet" and were "most common among the Confederate fortifications."

305. William Porcher Miles to Confederate secretary of war LeRoy P. Walker, Mar. 28, 1861. Francis H. Harleston military service record, NARS.

306. Report of Lt. Col. Roswell S. Ripley, South Carolina Army, commanding artillery. *OR*, I, I: 40.

307. "Frank H. Harleston—A Hero of Fort Sumter." *SHSP* 10 (1882): p. 311.

308. Report of Col. Alfred Rhett, First South Carolina Artillery. *OR*, I, XXVIII, 1: 613; "Frank H. Harleston." *SHSP* 10 (1882): p. 314.

309. Rhett, "Frank H. Harleston," *SHSP* 10 (1882): pp. 318–319.

310. The officer was engineer John Johnson. Ibid., pp. 319–320.

311. Special Orders No. 282, issued by the command of Gen. P. G. T. Beauregard. *OR*, I, XXVII, 2: 577.

312. Brig. Gen. Alpheus S. Williams to Col. Samuel Ross, commanding Twentieth Connecticut Infantry, *OR*, 1, XXXI, 3: 285.

313. *Florence (Alabama) Times*, May 30, 1896.

314. Joslyn, *Biographical Roster of the Immortal Six Hundred*, p. 28.

315. James Jackson Andrews military service record, NARS.

316. *Florence (Alabama) Times*, May 30, 1896.

317. The local farmer was J. O. Thomas. "Yankee Gunboat 'Smith Briggs.'" *SHSP* 34 (1906): pp. 162–169.

318. Ibid., pp. 164–165.

319. The Union leader, Capt. John C. Lee of the Ninety-ninth New York Infantry, reported the strength of Sturdivant's force to be an infantry regiment, a cavalry regiment, and an artillery battery. Report of Lt. Cmdr. James H. Gillis, commanding the *Commodore Morris, Official Records of the Union and Confederate Navies,* 1, IX: 429–430.

320. "Yankee Gunboat 'Smith Briggs.'" *SHSP* 34 (1906): p. 166; Report of Pilot Henry Stevens, U.S. flagship *Minnesota, Official Records of the Union and Confederate Navies,* 1, IX: 433–434; Report of Major and Signal Officer James F. Milligan, Department of North Carolina. *OR,* I, LI, 2: 849–850; Corell, *History of the Naval Brigade,* pp. 9, 14, 16.

321. Report of Brig. Gen. Charles K. Graham, U.S. Army, commanding Naval Brigade. *OR,* I, XXXIII: 103–106.

322. "Yankee Gunboat 'Smith Briggs.'" *SHSP* 34 (1906): p. 168.

323. *The (Richmond, Virginia) Daily Dispatch,* Aug. 10, 1869.

324. Nathaniel A. Sturdivant military service record, NARS; Report of Brig. Gen. William N. Pendleton, C.S. Army, Chief of Artillery, Army of Northern Virginia. *OR,* I, XL, 1: 757; Davis, *Death in the Trenches,* pp. 46–47.

325. *The (Richmond, Virginia) Daily Dispatch,* Aug. 10, 1869.

326. Ibid.

327. Andrew H. Ramsay military service record, NARS.

328. Ibid.

329. Trimpi, *Crimson Confederates,* pp. 888–889.

330. This unit is also known as Capt. Green's Company. Ibid.

331. Report of Brig. Gen. Randall L. Gibson, commanding forces on Eastern Shore of Mobile Bay. *OR,* I, XLIX, 1: 318.

332. He had two younger sisters, one of whom was Catherine Priestley Richardson. She married John W. Labouisse, who also served in the Thirteenth Louisiana Infantry and is profiled in this volume. The *cartes de visite* of both soldiers came from the same photograph album.

333. Mary E. Scudday Confederate Pension Application, State of Louisiana, Division of Archives, Records Management and History; 1880 U.S. Census; *The (New Orleans, Louisiana) Daily Picayune,* Dec. 8, 1896.

334. "The Battle of the Wilderness." *SHSP* 20 (1892): pp. 81–83; Henderson, *12th Virginia Infantry,* pp. 64–69.

335. Adjutant Hugh Ritchie Smith surrendered with William at Appomattox Court House. James Smith left the Twelfth with a medical discharge. Henderson, *12th Virginia Infantry,* p. 156.

336. William C. Smith military service record, NARS.

337. "Battle of the Wilderness." *SHSP* 20 (1892): pp. 81–83.

338. Ibid.

339. *SHSP* 31 (1903): p. 271; *SHSP* 15 (1887): p. 350.

340. Henderson, *12th Virginia Infantry*, p. 157.

341. William C. Smith military service record, NARS; Rachel J. Smith pension record, NARS.

342. *Nashville (Tennessee) Banner*, Apr. 19, 1899.

343. The writer, Sgt. Maj. Robert R. Hemphill, served in Company G. *CV* (1900): pp. 282–283.

344. William M. Whistler to Walter H. Taylor, Nov. 6, 1861. William M. Whistler military service record, NARS.

345. Anna Matilda Whistler to James Abbott McNeill Whistler, July 11, 1861. William M. Whistler military service record, NARS.

346. During his stay in Richmond, he served at Jackson General Hospital and Howard's Grove Hospital. William M. Whistler military service record, NARS.

347. *CV* (1900): pp. 282–283.

348. Ibid.

349. Ibid.; The Correspondence of James McNeill Whistler, 1855–1903, online edition, Centre for Whistler Studies, University of Glasgow, Scotland.

350. Caldwell, *History of a Brigade of South Carolinians*, pp. 188–189; Report of Brig. Gen. Samuel McGowan, commanding brigade, *OR*, I, XXXVI, 1: 1093–1094.

351. Robert Fullerton to Cordelia Fullerton, Feb. 25, 1878, Collection of Jerry Hunt of Cordele, Georgia.

352. Sen. James L. Orr to Secretary of the Treasury Christopher G. Memminger, Mar. 10, 1863, George W. Fullerton military service record, NARS.

353. Ibid.

354. Caldwell, *History of a Brigade of South Carolinians*, p. 195; Report of Brig. Gen. Samuel McGowan, commanding brigade, *OR*, I, XXXVI, 1: 1093–1094.

355. A worm fence, also known as a Virginia or Virginia rail fence, is constructed of supporting rails that cross each other at an angle, causing the fence to proceed in a zigzag pattern.

356. Account by cadet Nelson Berkeley Noland. Turner, *New Market Campaign*, pp. 148–149.

357. Today the college is known as Georgetown University.

358. Samuel S. Shriver military service record, NARS; Couper, *V.M.I. New Market Cadets*, p. 185; undated letter written after 1900 by a member of the Shriver family, Virginia Military Institute Archives, Lexington, Virginia; 1880 U.S. Census; Burig, *Shriver Family*, p. 1.

359. Turner, *New Market Campaign*, p. 81.

360. Undated letter written after 1900 by a Shriver family member, Virginia Military Institute Archives.

361. The letter mentioned above states that Shriver served as an arms inspector in the Ordnance Department in Richmond after he recovered from his wounds. This information is not in his military service file.

362. The Eighth was also known as the Foreign Battalion, Second Foreign Battalion, and the Second Foreign Legion. Special Orders No. 73, Adjutant and Inspector General's Office, Richmond. *OR*, IV, III: 1176; McMurry, *Virginia Military Institute Alumni in the Civil War*, p. 204.

363. Daniel McElheran Shriver organized and served as captain of the "Shriver Grays," which became Company G of the Twenty-seventh Virginia Infantry. He left the army as a lieutenant colonel to join the Virginia General Assembly and died in July 1865. Burig, *Shriver Family*, pp. 4–5.

364. The other Ranger, John Stevens "Stenny" Mason served as a private in the Seventeenth Virginia Infantry before joining Mosby. After the war he served in the Virginia legislature. He was a grandson of U.S. statesman George Mason. Keen and Mewborn, *43rd Battalion Virginia Cavalry*, p. 345.

365. No date is given for Lee's release from Old Capitol Prison. List of persons received at the Old Capitol Prison other than prisoners of war since Mar. 1, 1861. *OR*, I, II, 2: 237.

366. Lee, *Lee of Virginia*, p. 509; Julian P. Lee military service record, NARS.

367. "Diary of Captain Robert E. Park, Twelfth Alabama Regiment." *SHSP* 8 (1877): pp. 252–254.

368. Lee, *Lee of Virginia*, p. 509; 1870, 1880, 1900 U.S. Census data.

369. *CV* (1910): p. 392; Hughes, *Pride of the Confederate Artillery*, p. 192.

370. Bardstown was home to the St. Joseph College and Seminary, which closed during the war.

371. Villeneuve François "Fatty" Allain was about five years older than Alex. He survived the war. Hughes, *Pride of the Confederate Artillery*, p. 286.

372. *CV* (1910): p. 392.

373. Allain, *Diary of Alexander Pierre Allain*, pp. 7, 28–29.

374. *CV* (1910): p. 392; Hughes, *The Pride of the Confederate Artillery*, p. 192.

375. Allain, *Diary of Alexander Pierre Allain*, p. 36.

376. *CV* (1910): p. 392.

377. Ibid., Jeanne Georgie Proctor Allain pension file, Louisiana State Archives.

378. This story is part of an oral history passed by Smith to his family and their descendants. William Alden Turner of La Plata, Maryland, told this version to the author during telephone conversations on August 25 and October 14, 2006. Turner is in possession of the silver goblets, which were

passed to him by his third cousin, Virginia Marting, one of Smith's grand-daughters and a South African national.

379. Schneck, *Burning of Chambersburg*, pp. 19–21.

380. Frederick W. Smith to President Jefferson Davis, Aug. 9, 1861. Frederick W. Smith military service record, NARS.

381. Stiles, *Four Years Under Marse Robert*, p. 202.

382. Krick, *Staff Officers in Gray*, p. 269.

383. Brig. Gen. Smith was elected governor before the Battle of Gettysburg. He commanded a brigade under Maj. Gen. Jubal Early. On the first day of fighting, Gen. Smith declined to comply with Early's orders to advance, explaining that he believed enemy troops were heading towards their position from the east. Smith's assessment was incorrect, and the impact of his refusal to execute Early's request is the subject of debate among historians. Smith was promoted to major general before leaving the army.

384. Brig. Gen. Gabriel C. Wharton to Secretary of War James A. Seddon, Jan. 30, 1865. Frederick W. Smith military service record, NARS.

385. Krick, *Staff Officers in Gray*, p. 269.

386. In 1860, he owned seventeen slaves. 1860 U.S. Slave Schedule; 1860 U.S. Census.

387. William C. Wimberly military service record, NARS.

388. Wimberly served as major of the Sixty-fifth Militia Battalion, first lieutenant and captain in the Fifth Infantry (State Guards), captain of Company K of the Ninth Militia Infantry, and captain of Company F of the Third Militia Infantry. William C. Wimberly military service record, Georgia Archives.

389. Thomas, *History of the Doles-Cook Brigade*, p. 97; William C. Wimberly to Gen. Henry C. Wayne, Aug. 6, 1864. William C. Wimberly military service record, Georgia Archives.

390. *Macon (Georgia) Daily Telegraph*, Nov. 24, 1864.

391. Caldwell, *History of a Brigade of South Carolinians*, pp. 222–226; Report of Lt. William N. Dennison, Battery A, Second U.S. Artillery, *OR*, I, XL, 1: 652–653; *New York Herald*, July 31, 1864.

392. One of the other delegates was Samuel McGowan, who would be Harper's lieutenant colonel, and later became colonel and commander of the all-South Carolina brigade that bears his name. House Research Committee, *Biographical Directory of the South Carolina House of Representatives*, vol. 1, pp. 378, 382.

393. Report of Col. James Jones, commanding Fourteenth South Carolina Infantry, *OR*, I, VI: 69–71.

394. Report of Col. Samuel McGowan, commanding Fourteenth South Carolina Infantry, *OR*, I, XI, 2: 868–871.

395. Henry Holcombe Harper military service record, NARS.

396. Several sources note that Harper was imprisoned at Fortress Mon-

roe. The original reference is in a questionnaire filled out by his son, James C. Harper, M.D. Maj. Harper's military service record does not mention his having been imprisoned there. It does include a record of his transfer from the Old Capitol Prison to Fort Delaware. He may have had this photograph taken by Baltimore's Bendann Brothers during this trip. Dr. Harper also notes that his father was wounded four times in battle. Other sources record only his wounding at Glendale (Frayser's Farm). Krick, *Lee's Colonels*, p. 164; Wallace, *History of South Carolina*, vol. 4, p. 903.

397. House Research Committee, *Biographical Directory of the South Carolina House of Representatives*, vol. 1, p. 429.

398. Pippinger, *Georgetown Courier Marriage and Death Notices*, p. 112; Williams Folder, Local Genealogy Collection, Peabody Room, Georgetown Branch Library, Washington, D.C.

399. Lloyd A. Williams served in the U.S. navy from 1852 to 1862. He served as chief engineer aboard the frigate *Colorado* during his last assignment. *The (Washington, D.C.) Evening Star*, Dec. 29, 1873.

400. This *carte de visite* is a copy of an ambrotype taken in 1863. Hartzler, *A Band of Brothers*, p. 3.

401. "Paroles of the Army of Northern Virginia." *SHSP* 15 (1887): p. 383; Bodisco B. Williams military service record, NARS.

402. 1870 U.S. Census.

403. *The Georgetown Courier* reported "erysipelas in the head" as Lloyd's cause of death. *The Evening Star* attributed his death to pneumonia. Pippinger, *The Georgetown Courier Marriage and Death Notices*, p. 112; *The (Washington, D.C.) Evening Star*, Dec. 23, 1873.

404. Watts, *The Babe of the Company*, pp. 12–14.

405. Ibid. Federal authorities later discovered McMurtry's true identity and banished the hostess, a Miss Saunders, from the state.

406. This story is part of a larger account of the Fayette Raid published in the 1870s by John N. Edwards, who romanticized James's activities. Numerous inconsistencies have been found in his writings, including his account of the events at Fayette. The author has found no evidence to dispute that McMurtry was wounded in the attack, or that he and James were friends. Edwards, *Noted Guerrillas*, pp. 291–292; Buel, *Border Outlaws*, pp. 300–301; *Wichita (Wichita Falls, Texas) Daily Times*, June 23, 1908.

407. The *carte de visite* portrait pictures McMurtry with another guerrilla named William "Bill" Hulse. Edwards, *Noted Guerrillas*, pp. 148–149.

408. *Wichita (Wichita Falls, Texas) Daily Times*, June 23, 1908.

409. Ibid.

410. The Kentucky "Orphan" Brigade included the Second, Fourth, Fifth, Sixth, and Ninth Kentucky infantries and Cobb's Artillery Company. According to the Web site "The First Kentucky Brigade, CSA" (http://www .rootsweb.com/~orphanhm), the soldiers of the brigade "were 'orphaned'

from their home state, because the state government remained loyal to the Union, and for most of the war, Kentucky was behind enemy lines."

411. Davis, *Orphan Brigade*, p. 190.

412. Report of Lt. Col. John C. Wickliffe, Ninth Kentucky Infantry. *OR,* I, XXX, 2: 214.

413. John T. Smarr military service record, NARS.

414. The 1880 U.S. census for Scott County, Kentucky, reports him as single. However, one genealogical record notes that he wed Fannie Lowery. The 1880 census lists a servant named Fanny Coleman as a member of the same household to which Smarr belonged.

415. Towner, *Our County and Its People*, p. 273.

416. In May 1862, Thomas's Company A was divided into new companies, designated A and B. Thomas became part of Company B, the "St. James Mounted Riflemen," which became an independent organization also known by the name of its commander, Capt. Louis Augustus Whilden. Company B then joined the Fifth South Carolina Cavalry as Company E. Knudsen, "History of the Fifth South Carolina Cavalry," Web site; *Military Images* (Mar.–Apr. 1999): pp. 4–5.

417. Named for Brig. Gen. Matthew Calbraith Butler, the brigade included the Fourth, Fifth, and Sixth cavalry regiments.

418. From an article transcribed by Bryce Suderow and posted on the Civil War Discussion Forum Web site on Sept. 15, 2003. *Charleston (South Carolina) Daily Courier,* Aug. 24, 1864.

419. From a November 1897 *Macon (Georgia) Telegraph* article reprinted in the brigade history. Brooks, *Butler and His Cavalry,* pp. 350–351.

420. Report of Maj. Gen. Robert Ransom Jr., C.S.A., *OR,* I, XXXVI, 2: 212.

421. Philip E. Thomas military service record; Woodlawn Cemetery memorial marker.

422. On October 9, 1864, the Twenty-fifth and other cavalrymen were defeated at Tom's Brook. The battle is also known as the "Woodstock Races," a reference to the hasty retreat of the Confederate troopers. Lambert, *25th Virginia Cavalry,* pp. 83–84.

423. Ibid., pp. 131–132; L. Wilber Reid military service record, NARS.

424. L. Wilber Reid to Maj. John T. L. Preston, Sept. 15, 1858, James H. Reid to Maj. John T. L. Preston, Sept. 19, 1858, Virginia Military Institute Archives.

425. These regiments were organized as the First and Second Kanawha Infantries. Reid also recruited men for the Third Kanawha Infantry, but it disbanded and its companies were distributed to the other two regiments. Personal communication from Steve Teeft, historian of the Thirty-sixth Virginia Infantry, Nov. 8, 2006.

426. Reid was commanding the Fiftieth Virginia Infantry, a tempo-

rary assignment, when he received this wound. L. Wilber Reid to Gen. Samuel Cooper, Mar. 16, 1865. L. Wilber Reid military service record, NARS.

427. James H. Reid to W. P. Conray, Oct. 6, 1864. L. Wilber Reid military service record, NARS; Report of Col. John McCausland, Thirty-sixth Virginia Infantry, *OR*, I, VII: 278.

428. The captain, Benjamin R. Linkous, had fought in the Mexican War and served as doorkeeper of the Virginia Secession Convention in early 1861. He survived the war. *Beckley (West Virginia) Post-Herald*, Aug. 26, 1950; Krick, *Lee's Colonels*, p. 220.

429. Reid declined a commission in the Seventeenth Virginia Cavalry to join the Twenty-seventh Virginia Cavalry Battalion. Personal communication from Steve Teeft, historian of the Thirty-sixth Virginia Infantry, Nov. 9, 2006.

430. General Orders No. 14, issued by Adjutant and Inspector General Samuel Cooper on March 23, 1865. *OR*, IV, III: 1161–1162.

431. Capt. John Hansen McNeill was gunned down during a charge at Mt. Jackson, Virginia, on October 3, 1864. Most reports claim he was a victim of an accidental shooting. One report states that a disgruntled ranger bent on revenge shot him. Another claims that a captured and supposedly disarmed federal soldier, left unattended, shot him with a concealed pistol. McNeill died November 10, 1864.

432. Evans, *Confederate Military History Extended Edition*, vol. 3, pp. 116–125.

433. Bright, "The McNeill Rangers."

434. The Cumberland native was Sgt. John B. Fay. *CV* (1910): p. 410.

435. Ibid., pp. 410–411.

436. Sources estimate the number of Rangers Jesse took on this mission at between 30 and 150. The author used the number given by McNeill in his *Confederate Veteran* account. *CV* (1906): pp. 410–413.

437. *CV* (1910): p. 411; Report of Major and Assistant Adjutant General Robert P. Kennedy. *OR*, I, XLVI, 1: 469–470.

438. Capt. Thayer Melvin served as assistant adjutant general under Maj. Gen. Kelley. Cranmer, *History of Wheeling City and Ohio County, West Virginia*, pp. 716–717.

439. Bright, "The McNeill Rangers."

440. Several sources state that Hayes and McKinley quartered at the same hotels as the generals. McKinley did reside at Kelley's hotel. Hayes did not stay in either. According to his diary, "the fact was I had received an order to get quarters in town and was in town that night at General [Isaac H.] Duval's headquarters. But he, having left as everybody knew a week before, his quarters were not searched. A narrow chance for me." Armstrong, *Major McKinley*, p. 95; Williams, *Diary and Letters of Rutherford B. Hayes*, vol. 2, p. 560.

441. Duffey, *McNeill's Last Charge*, p. 17.

442. *CV* (1910): p. 413.

443. *Champaign County (Illinois) News,* Mar. 5, 1912.

444. Custer was not directly responsible for the executions of the Rangers, but Mosby held him accountable. The killings stopped after Mosby's retaliatory executions.

445. Sources vary on the number of Union men involved.

446. Williamson, *Mosby's Rangers,* pp. 291–292.

447. Ibid.

448. Scott, *Partisan Life with Col. John S. Mosby,* pp. 359–360; Williamson, *Mosby's Rangers,* pp. 292–293; Wert, "The Gray Ghosts' Death Lottery," pp. 32–38.

449. John N. Murphy military service record, NARS.

450. The exact date of Murphy's enlistment in Mosby's Rangers is unknown. Sources generally agree he joined in the fall of 1864. Ibid.; Wert, *Mosby's Rangers,* p. 258.

451. The other officer was Capt. Thomas W. T. Richards. Keen and Mewborn, *43rd Battalion Virginia Cavalry Mosby's Command,* p. 352.

452. From the May 3, 1862, edition of the *Macon Daily Telegraph.* Iobst, *Civil War Macon,* p. 126.

453. *Macon (Georgia) Daily Telegraph,* Dec. 26, 1864.

454. The South Carolina Military Academy is known today as The Citadel.

455. Albert Heyward's younger brothers, James and Julius, were also listed on Company A's roll. Baker, *Cadets in Gray,* pp. 68, 206.

456. Albert R. Heyward military service record, NARS.

457. Baker, *Cadets in Gray,* pp. 136–140.

458. Report of Maj. Gen. Samuel Jones, commanding the District of South Carolina. *OR,* I, XLIV: 445.

459. Baker, *Cadets in Gray,* pp. 147–149.

460. *The (Columbia, South Carolina) State,* Nov. 25, 1910.

461. Bryan W. Cobb military service record, NARS; Bryan W. Cobb disability pension record, North Carolina State Archives.

462. *Goldsboro (North Carolina) Daily Argus,* Mar. 24, 1906.

463. Wayne County Historical Association, *The Heritage of Wayne County, North Carolina, 1982,* p. 189.; Lane, "For My Children" Web site.

464. The *Carolina Messenger* was a semiweekly newspaper published from 1869 to 1877. Its name was changed to the *Goldsboro Messenger* on March 26, 1877.

465. Nathaniel B. Logan military service record, NARS; Robertson, *4th Virginia Infantry,* p. 34.

466. Washington College is known today as Washington and Lee University.

467. Bean, *The Liberty Hall Volunteers,* pp. viii–ix; Turner, *Ted Barclay, Liberty Hall Volunteers,* p. 146.

468. Nathaniel B. Logan military service record, NARS.

469. Ibid.

470. Report of Maj. Gen. Fitzhugh Lee, commanding C.S. Army Cavalry Corps. *OR*, I, XLVI, 1: 1303; Fitzhugh Lee to John Esten Cooke, Mar. 21, 1868. John Esten Cooke Correspondence.

471. Maj. Briscoe G. Baldwin to Brig. Gen. Fitzhugh Lee, Oct. 26, 1862. Charles F. E. Minnegerode Jr. military service record, NARS.

472. Ibid.

473. Rev. Charles Frederick Ernest Minnegerode Sr. presided over the pulpit of St. Paul's Protestant Episcopal Church in Richmond, Virginia, for many years. Several sources credit him as the first person to introduce the Christmas tree to Williamsburg, Virginia, in 1842. *SHSP* 29 (1901): pp. 154–166.

474. Rev. Charles F. E. Minnegerode Sr. to Secretary of War George W. Randolph, Nov. 1, 1862. Charles F. E. Minnegerode Jr. military service record, NARS.

475. Minnegerode participated in the March 1863 Battle of Kelly's Ford, noted for the death of Maj. John Pelham. One account states that it was Minnegerode and another officer who removed Pelham's body from the battlefield. Douglas Southall Freeman noted, "It is quite impossible to reconcile the various accounts of the fall of Pelham and of the removal of his body." Freeman, *Lee's Lieutenants*, vol. 2, p. 464n.

476. Report of Maj. Gen. Fitzhugh Lee, commanding C.S. Army Cavalry Corps. *OR*, I, XLVI, 1: 1303.

477. According to Union Maj. Gen. John Gibbon, Lee learned Minnegerode's fate on April 12, 1865. Gibbon, who had taught Lee at West Point, noted: "Early on the 9th, seeing that surrender was inevitable [Lee] had, with his cavalry force, made his escape and proceeded towards Lynchburg, but soon after becoming convinced that the war was practically ended he had ridden to Farmville and reported to Gen. [George G.] Meade. There he was advised to return to Appomattox and be paroled. This he accordingly did, being anxious, besides, to learn the fate of a favorite staff officer (Charles Minnegerode) who had been badly wounded in the last battle." Longacre's *Fitz Lee* asserts that the general visited Minnegerode at the young officer's home in Farmville before returning to Appomattox. Gibbon, *Personal Recollections of the Civil War*, p. 340; Longacre, *Fitz Lee*, pp. 188–189.

478. *SHSP* 9 (1881): pp. 212–218.

479. Jefferson Davis to Charles F. E. Minnegerode Jr., undated. Davis Family Collection.

480. *Alexandria (Virginia) Gazette*, Jan. 26, 1888.

481. *The Norfolk (Virginia) Landmark*, Feb. 9, 1894.

482. Richmond College is today known as the University of Richmond.

483. Report of Capt. William J. Dance, commanding First Virginia Ar-

tillery. *OR*, I, XXVII, 2: 605.; Daniel, *Richmond Howitzers in the War,* pp. 91–93.

484. The First Virginia Artillery formed in September or October 1861. In September 1864 its designation changed to the First Battalion Virginia Light Artillery after all but three of its companies disbanded or mustered out of the service. The battalion dissolved in January 1865, and Smith's company lived on as the Third Richmond Howitzers. Oscar V. Smith military service record, NARS.

485. *The Norfolk (Virginia) Landmark,* Feb. 8, 1894.

486. One of the pallbearers, Richard Curzon Hoffman, is also profiled in this volume. Ibid., Feb. 10, 1894.

487. Ibid., Feb. 9, 1894.

488. Alexander T. Bell military service record, NARS.

489. Bridges, *Fighting with Jeb Stuart,* p. 283.

490. H. H. Matthews, "Dr. A.T. Bell," *CV* (1913): p. 241.

491. Bell "transferred to Moorman's Lynchburg Battery of the Stuart Horse Artillery. A few months after his transfer the batteries of the Horse Artillery were divided into battalions, commanded by Majs. R. P. Chew and James Breathed. Moorman's Battery, to which he was attached, became a part of Breathed's Battalion." Ibid.

492. Ibid.

493. Ibid.

494. Hughes, *Pride of the Confederate Artillery,* pp. 275–276.

495. Ibid., p. 299; James Clarke Jr. military service record, NARS.

496. Hughes, *The Pride of the Confederate Artillery,* pp. 275–276.

497. 1870, 1880 U.S. Census.

498. Emma W. Clarke, pension file, Louisiana State Archives.

499. *The (New Orleans, Louisiana) Daily Picayune,* Dec. 8, 1896.

500. Jones, *Lee's Tigers,* pp. 250–251.

501. *The (New Orleans, Louisiana) Daily Picayune,* Dec. 8, 1896.

502. John W. Labouisse military service record, NARS.

503. Labouisse served on the staff of Brig. Gen. Daniel W. Adams. Adams suffered a wound during the battle, and command of the brigade devolved upon Col. Gibson. *OR*, I, XXX, 2: 216–219.

504. He served on the staff of Col. J. Warren Grigsby, then Brig. Gen. John S. Williams, who commanded Grigsby's brigade during the Atlanta Campaign, before joining Wheeler's staff. John W. Labouisse military service record, NARS.

505. Ibid.

506. *The (New Orleans, Louisiana) Daily Picayune,* Dec. 8, 1896.

507. Ibid.

508. Duke, *A History of Morgan's Cavalry,* pp. 572–577.

509. William C. Curd military service record, NARS.

510. *Glasgow (Kentucky) Weekly Times*, Feb. 17, 1897; 1850 U.S. Census.

511. William C. Curd military service record, NARS.

512. U.S. Government, *Journal of the House of Representatives of the United States, Thirty-Ninth Congress*, p. 172.

513. *(Marshall) Texas Republican*, Feb. 16, 1867, transcribed by Vicki Betts, University of Texas at Tyler.

514. According to the *Handbook of Texas Online*, he left Howard College in Marion, Alabama, (today Samford University in Birmingham) and enlisted as a private in the First Regiment, Texas Mounted Rifles. He was discharged in September 1846, one week before his regiment fought in the Battle of Monterrey.

515. Chilton introduced "a resolution recommending a thorough canvassing of the constitutional rights of Congress in regard to slavery" in response to a circular that questioned the authority of Congress to legislate on reopening the slave trade. Barker, "The African Slave Trade in Texas."

516. *Austin (Texas) State Gazette*, Mar. 23, 1861, transcribed by Vicki Betts, University of Texas at Tyler.

517. *Dallas (Texas) Herald*, June 19, 1861, transcribed by Vicki Betts, University of Texas at Tyler.

518. George W. Chilton to Maj. Gen. John B. Magruder, Jan. 11, 1864. George W. Chilton military service record, NARS.

519. Report of Col. James McIntosh, Second Arkansas Mounted Rifles, commanding division. *OR*, I, VIII: 23; Sparks, *The War Between the States, as I Saw It*, p. 485.

520. Betts, "Private and Amateur Hangings"; *Tyler (Texas) Reporter*, Apr. 16, 1863, transcribed by Vicki Betts, University of Texas at Tyler.

521. He was absent from the army for health reasons in early 1865. During his convalescence, he edited a newspaper called the *Confederate Journal. Dallas (Texas) Herald*, Jan. 26, 1865, transcribed by Vicki Betts, University of Texas at Tyler; George W. Chilton military service record, NARS.

522. Betts, "Private and Amateur Hangings."

523. British military observer Lt. Col. Arthur Fremantle saw Montgomery's corpse, with head and arms intact, a few weeks after the hanging. Lord, *The Fremantle Diary*, pp. 7–8.

524. *CV* (1920): p. 244.

525. Ibid.; *CV* (1917): p. 194.

526. Beall's company affiliated with several organizations during the war, including the Seventeenth Battalion (Sanders's) Tennessee Cavalry and Twelfth Battalion Mississippi Cavalry, also known as the Twelfth Partisan Rangers Battalion. In January 1865, the battalion was increased to regiment size and designated the Tenth Mississippi Cavalry.

527. He fought with Maj. Edward J. Sanders's Seventeenth Battalion Tennessee Cavalry.

528. Frederick Beall military service record, NARS; *CV* (1924): p. 45.

529. His *carte de visite* suggests that he might not have gone directly home. The photographer may be the same James Inglis who operated in Quebec, Canada, in the 1880s and 1890s. *CV* (1924): p. 45.

530. 1870, 1880, 1900 U.S. census; *CV* (1923): p. 45; *The (Washington, D.C.) Evening Star*, Jan. 31, 1929; *The Washington Post*, Feb. 1, 1929.

531. The remains of 409 Confederate veterans are interred in Arlington. Congress authorized the construction of a Confederate memorial in 1906, and it was dedicated in 1914. Bigler, *In Honored Glory*, pp. 37–38.

References

Books and Unpublished Manuscripts

Adkins-Rochette, Patricia. *Bourland in North Texas and Indian Territory during the Civil War: Fort Cobb, Fort Arbuckle & the Wichita Mountains.* Duncan, Okla.: BourlandCivilWar.com, 2006.

Alexander, John H. *Mosby's Men.* New York: Neale Publishing Co., 1907.

Alexander, Ted. *Southern Revenge! Civil War History of Chambersburg, Pennsylvania.* Shippensburg, Pa.: White Mane Publishing Co., 1989.

Allain, Raymond E., Sr. *Diary of Alexander Pierre Allain (March 25, 1844–May 29, 1910).* Publisher unknown, 2002.

Andrews, Charles H. *Condensed History of the 3rd Georgia Volunteer Infantry.* Georgia Archives, about 1885.

Armstrong, William H. *Major McKinley: William McKinley & The Civil War.* Kent, Ohio: Kent State University Press, 2000.

Arthur, John P. *Western North Carolina: A History.* Raleigh, N.C.: Edwards & Broughton Printing Co., 1914.

Avary, Myrta Lockett, and Isabella D. Martin. *A Diary from Dixie, as Written by Mary Boykin Chesnut.* Gloucester, Mass.: Peter Smith, 1961.

Baker, Gary R. *Cadets in Gray: The Story of the Cadets of the South Carolina Military Academy and the Cadet Rangers in the Civil War.* Columbia, S.C.: Palmetto Bookworks, 1989.

Bates, Samuel P. *Martial Deeds of Pennsylvania.* Philadelphia: T. H. Davis & Co., 1875.

Bean, William G. *The Liberty Hall Volunteers: Stonewall's College Boys.* Charlottesville: University Press of Virginia, 1964.

Beck, Brandon H. *Third Alabama! The Civil War Memoir of Brigadier General Cullen Andrews Battle, CSA.* Tuscaloosa: University of Alabama Press, 2002.

Beglan, Joseph F. *A Family and Its Heritage.* Baltimore, Md.: J. F. Beglan, 1988.

Bigler, Philip. *In Honored Glory: Arlington National Cemetery, the Final Post.* St. Petersburg, Fla.: Vandamere Press, 2005.

Biographical and Historical Memoirs of Louisiana, vol. 1. Chicago: Goodspeed Publishing Co., 1892.

Boatner, Mark. *The Civil War Dictionary.* New York: David McKay Co., 1962.

Booth, Roswell V. *Private Memoranda.* Vicksburg, Miss.: Old Court House Museum.

Bridges, David P. *Fighting with Jeb Stuart: Major James Breathed and the Confederate Horse Artillery.* Arlington, Va.: Breathed Bridges Best, Inc., 2006.

Brooks, Ulysses R. *Butler and His Cavalry in the War of Secession 1861–1865.* Columbia, S.C.: The State Co., 1909.

Brown, Dee A. *The Bold Cavaliers: Morgan's 2nd Kentucky Cavalry Raiders.* Philadelphia: J. B. Lippincott Co., 1959.

Brugger, Robert J. *The Presidents of the Maryland Club.* Baltimore, Md.: Maryland Club, 2007.

Buel, J. W. *The Border Outlaws.* Harrisburg, Pa.: National Historical Society, 1994.

Burig, Paul. *The Shriver Family.* Publisher unknown, ca. 1995.

Caldwell, James F. J. *The History of a Brigade of South Carolinians First Known as "Gregg's" and Subsequently as "McGowan's Brigade."* Dayton, Ohio: Morningside Press, 1992.

Carr, Lucien. *Missouri: A Bone of Contention.* Boston: Houghton, Mifflin and Co., 1888.

Carroll. John M. *Custer in the Civil War.* Mattituck, N.Y.: J. M. Carroll Co., 1977.

Connelley, William E. *History of Kentucky,* vol. 2. Chicago: American Historical Society, 1922.

Corell, Philip. *History of the Naval Brigade: 99th New York Volunteers Union Coast Guard, 1861–1865.* New York: Regimental Veteran Association of New York, 1905.

Couper, William. *The V.M.I. New Market Cadets: Biographical Sketches of All Members of the Virginia Military Institute Corps of Cadets Who Fought in the Battle of New Market.* Charlottesville, Va.: Michie Co., 1933.

Cranmer, Gibson L. *History of Wheeling City and Ohio County, West Virginia, and Representative Citizens.* Chicago: Biographical Publishing Co., 1902.

Cunningham, Sumner A. *Confederate Veteran Magazine.* Nashville, Tenn.: 1893–1932.

Daniel, Frederick S. *Richmond Howitzers in the War: Four Years Campaigning with the Army of Northern Virginia.* Richmond: publisher unknown, 1891.

Daniel, Larry J., and Riley W. Gunter. *Confederate Cannon Foundries.* Union City, Tenn.: Pioneer Press, 1977.

Daughters of the American Revolution. *History and Reminiscences of Dougherty County Georgia.* Albany, Ga.: Albany Herald, 1924.

Davis, William C. *Death in the Trenches: Grant at Petersburg.* Alexandria, Va.: Time-Life Books, 1986.

Davis, William C. *The Killing Ground: Wilderness to Cold Harbor.* Alexandria, Va.: Time-Life Books, 1986.

Davis, William C. *The Orphan Brigade: The Kentucky Confederates Who Couldn't Go Home.* Mechanicsburg, Pa.: Stackpole Books, 1993.

Divine, John E. *8th Virginia Infantry.* Lynchburg, Va.: H. E. Howard, 1983.

Dorman, John F. *The Prestons of Smithfield and Greenfield in Virginia: Descendants of John and Elizabeth (Patton) Preston through Five Generations.* Louisville, Ky.: The Filson Club, 1982.

Driver, Robert J., Jr. *2nd Virginia Cavalry.* Lynchburg, Va.: H. E. Howard, 1995.

Duffey, Jefferson W. *McNeill's Last Charge: An Account of a Daring Confederate in the Civil War.* Winchester, Va.: George F. Norton Publishing Co., 1912.

Duke, Basil W. *A History of Morgan's Cavalry.* Bloomington: Indiana University Press, 1960.

Edwards, John N. *Noted Guerrillas, or the Warfare of the Border.* Dayton, Ohio: Press of the Morningside Bookshop, 1976.

Etlinger, Josephine B. S. *Sweetest You Can Find: Life in Eastern Guadalupe County, Texas, 1851–1951.* San Antonio, Tex.: Watercress Press, 1987.

Evans, Clement A. *Confederate Military History Extended Edition,* vol. 3. Wilmington, N.C.: Broadfoot Publishing Co., 1987.

Evins, Joe L. *The Evins Family: A Genealogical Study.* Washington, D.C.: publisher unknown, 1987.

Folsom, James M. *Heroes and Martyrs of Georgia: Georgia's Record in the Revolution of 1861.* Macon, Ga.: Burke, Boykin & Co., 1864.

Fox, Jim J. *Memoirs of the War of Secession from the Original Manuscripts of Johnson Hagood, Brigadier-General, C.S.A.* Camden, S.C.: Jim Fox Books, 1997.

Fox, William F. *Regimental Losses in the American Civil War, 1861–1865.* Albany, N.Y., 1889.

Freeman, Douglas S. *Lee's Lieutenants,* vol. 2. New York: Charles Scribner's Sons, 1971.

Freeman, Douglas S. *R. E. Lee, A Biography.* New York: Charles Scribner's Sons, 1934.

Galbraith, Loretta, and William Galbraith. *A Lost Heroine of the Confederacy: The Diaries and Letters of Belle Edmondson.* Jackson: University Press of Mississippi, 1990.

Gibbon, John. *Personal Recollections of the Civil War.* Dayton, Ohio: Press of the Morningside Bookshop, 1988.

Goldsborough, William W. *The Maryland Line in the Confederate Army, 1861–1865.* Baltimore, Md.: Press of Guggenheimer, Weil & Co., 1900.

Griffith, Lucille. *Yours Till Death: Civil War Letters of John W. Cotton.* University: University of Alabama Press, 1951.

Hartzler, Daniel D. *A Band of Brothers: Photographic Epilogue to Marylanders in the Confederacy.* Westminster, Md.: Willow Bend Books, 2005.

Hartzler, Daniel D. *Marylanders in the Confederacy.* Westminster, Md.: Willow Bend Books, 2001.

Henderson, William D. *12th Virginia Infantry.* Lynchburg, Va.: H. E. Howard, Inc., 1984.

Hewitt, Lawrence L. *Port Hudson, Confederate Bastion on the Mississippi.* Baton Rouge: Louisiana State University Press, 1987.

History of Cumberland and Adams Counties, Pennsylvania. Chicago: Warner, Beers & Co., 1886.

Hodge, Frederick A. *The Plea and the Pioneers in Virginia: A History of the Rise and Early Progress of the Disciples of Christ in Virginia.* Richmond, Va.: Everett Waddey Co., 1905.

House Research Committee. *Biographical Directory of the South Carolina House of Representatives,* vol. 1. Columbia: University of South Carolina Press, 1974.

Howard, Wiley C. *Sketch of Cobb Legion Cavalry and Some Incidents and Scenes Remembered.* Atlanta, Ga.: United Confederate Veterans, 1901.

Hubbs, G. Ward. *Guarding Greensboro: A Confederate Company in the Making of a Southern Community.* Athens: University of Georgia Press, 2003.

Hubbs, G. Ward. *Voices from Company D: Diaries by the Greensboro Guards, Fifth Alabama Infantry Regiment, Army of Northern Virginia.* Athens: University of Georgia Press, 2003.

Hughes, Nathaniel C., Jr. *The Pride of the Confederate Artillery: The*

Washington Artillery in the Army of Tennessee. Baton Rouge: Louisiana State University Press, 1997.

Huxford, Folks. *The History of Brooks County Georgia, 1858–1948.* Spartanburg, S.C.: Reprint Co., 2004.

Hyde, William, and Howard L. Conard. *Encyclopedia of the History of St. Louis: A Compendium of History and Biography for Ready Reference,* vol. 3. New York: Haldeman, Conard & Co., 1899.

Iobst, Richard W. *Civil War Macon: The History of a Confederate City.* Macon, Ga.: Mercer University Press, 1999.

Janney, Werner, and Asa Moore Janney. *Ye Meetg Hous Smal: A Short Account of FRIENDS in Loudoun County, Virginia, 1732–1980.* Lincoln, Va.: publisher unknown, 1980.

Johnson, Rossiter. *The Twentieth Century Biographical Dictionary of Notable Americans,* vol. 7. Boston: The Biographical Society, 1904.

Jones, J. William. *Southern Historical Society Papers.* Richmond, Va.: Richmond Historical Society, 1876–1959.

Jones, Terry L. *Lee's Tigers: The Louisiana Infantry in the Army of Northern Virginia.* Baton Rouge: Louisiana State University Press, 1987.

Joslyn, Mauriel P. *The Biographical Roster of the Immortal 600.* Shippensburg, Pa.: White Mane Publishing Co., 1992.

Joslyn, Mauriel P. *Immortal Captives: The Story of 600 Confederate Officers and the United States Prisoner of War Policy.* Shippensburg, Pa.: White Mane Publishing Co., 1996.

Keen, Hugh C., and Horace Mewborn. *43rd Battalion Virginia Cavalry Mosby's Command.* Lynchburg, Va.: H. E. Howard, Inc., 1993.

Kennedy, Joseph C. G. *Population of the United States in 1860; Compiled From the Original Returns of the Eighth Census.* Washington, D.C.: Government Printing Office, 1864.

Krick, Robert E. L. *Staff Officers in Gray: A Biographical Register of the Staff Officers in the Army of Northern Virginia.* Chapel Hill: University of North Carolina Press, 2003.

Krick, Robert K. *Lee's Colonels: A Biographical Register of the Field Officers of the Army of Northern Virginia.* Dayton, Ohio: Press of Morningside Bookshop, 1979.

Lambert, Dobbie E. *25th Virginia Cavalry.* Lynchburg, Va.: H. E. Howard, Inc., 1994.

Lee, Edmund J. *Lee of Virginia, 1642–1892: Biographical and Genealogical Sketches of the Descendants of Colonel Richard Lee.* Baltimore, Md.: Genealogical Publishing Co., 2003.

Longacre, Edward G. *Fitz Lee: A Military Biography of Major General*

Fitzhugh Lee, C.S.A. Cambridge, Mass.: Da Capo Press, 2005.

Lord, Walter. *The Fremantle Diary: Being the Journal of Lieutenant Colonel James Arthur Lyon Fremantle, Coldstream Guards, on his Three Months in the Southern States.* Boston: Little, Brown and Co., 1954.

Mackall, S. Somervell. *Early Days of Washington.* Washington, D.C.: Neale Co., 1899.

Marquis Publications. *Who Was Who in America,* vol. 1, *1897–1942.* Chicago: A. N. Marquis Co., 1968.

McBride, Mary Gorton, and Ann Mathison McLaurin. *Randall Lee Gibson of Louisiana: Confederate General and New South Reformer.* Baton Rouge: Louisiana State University Press, 2007.

McCash, William B. *Thomas R. R. Cobb: The Making of a Southern Nationalist.* Macon, Ga.: Mercer University Press, 1983.

McMurry, Richard M. *Virginia Military Institute Alumni in the Civil War, In Bello Praesidium.* Lynchburg, Va.: H. E. Howard, Inc., 1999.

Miceli, Augusto P. *The Pickwick Club of New Orleans.* New Orleans, La.: Pickwick Press, 1964.

Miller, Francis T. *Photographic History of the Civil War,* 10 vols. New York: Review of Reviews Co., 1912.

Murray, John O. *The Immortal Six Hundred: A Story of Cruelty to Confederate Prisoners of War.* Winchester, Va.: Eddy Press, 1905.

Osborne, Charles C. *Jubal: The Life and Times of General Jubal A. Early, CSA, Defender of the Lost Cause.* Chapel Hill, N.C.: Algonquin Books, 1992.

Paine, Lincoln P. *Ships of the World: An Historical Encyclopedia.* Boston: Houghton Mifflin Co., 1997.

Patton, Sadie S. *A Condensed History of Flat Rock: (The Little Charleston of the Mountains).* Flat Rock, N.C.: Church Printing, 1961.

Patton, Sadie S. *The Story of Henderson County.* Asheville, N.C.: Miller Printing Co., 1947.

Perrin, William H. *History of Fayette County, Kentucky.* Easley, S.C.: Southern Historical Press, 1979.

Perrin, William H. *Kentucky: A History of the State.* Louisville, Ky.: F. A. Battey and Co., 1887.

Pfanz, Harry W. *Gettysburg—The First Day.* Chapel Hill: University of North Carolina Press, 2001.

Pippinger, Wesley E. *The Georgetown Courier Marriage and Death Notices: Georgetown, District of Columbia, November 18, 1865 to May 6, 1876.* Westminster, Md.: Willow Bend Books, 1998.

Polk, William R. *Polk's Folly: An American Family History.* New York: Doubleday, 2000.

Power, Jim. *The 1861 Diary of Major Thomas B Webber.* Publisher unknown, n.d.

Ramage, James A. *Rebel Raider: The Life of General John Hunt Morgan.* Lexington: University Press of Kentucky, 1986.

Ramsey, Joel W. *David Wardlaw Ramsey in the War Between the States.* Publisher unknown, n.d.

Rawle, William, L.L.D. *A View of the Constitution of the United States of America.* Philadelphia: Philip H. Nicklin, Law Bookseller, 1829.

Richardson, Robert. *Memoirs of Alexander Campbell,* vol. 1. Philadelphia: J. B. Lippincott & Co., 1868.

Riggs, Susan A. *21st Virginia Infantry.* Lynchburg, Va.: H. E. Howard, Inc., 1991.

Roberts, Barry, and Carl Moneyhon. *Portraits of Conflict: A Photographic History of Mississippi in the Civil War.* Fayetteville: University of Arkansas Press, 1993.

Robertson, James I. *4th Virginia Infantry.* Lynchburg, Va.: H. E. Howard, Inc., 1982.

Sanders, Robert S. *History of the Louisville Presbyterian Theological Seminary, 1853–1953.* Louisville, Ky.: Louisville Presbyterian Theological Seminary, 1953.

Schaff, Morris. *The Spirit of Old West Point, 1858–1862.* Boston: Houghton Mifflin and Co., 1908.

Scharf, J. Thomas. *History of Western Maryland,* vol. 1. Philadelphia: L. H. Everts, 1882.

Schneck, Benjamin S. *The Burning of Chambersburg.* Philadelphia: Lindsay & Blakiston, 1864.

Scott, John. *Partisan Life with Col. John S. Mosby.* New York: Harper & Brothers, Publishers, 1867.

Sifakis, Stewart. *Compendium of the Confederate Armies.* New York: Facts on File, 1988–1995.

Sowell, Andrew J. *Early Settlers and Indian Fighters of Southwest Texas: Facts Gathered from Survivors of Frontier Days,* vol. 2. New York: Argosy-Antiquarian, 1964.

Sparks, A.W. *The War Between the States, as I Saw It, Reminiscent, Historical and Personal.* Tyler, Tex.: Lee & Burnett, Printers, 1901.

Spencer, Richard H. *Genealogical and Memorial Encyclopedia of the State of Maryland: A Record of the Achievements of Her People in the Making of a Commonwealth and the Founding of a Nation.* New York: American Historical Society, 1919.

Stanton, Charles P. *Bluegrass Pioneers: A Chronicle of the Hunt and Morgan Families of Lexington, Kentucky, Including Their Antecedents and Descendants.* Brooklyn, N.Y.: C. P. Stanton, 1996.

Stegeman, John F. *These Men She Gave: Civil War Diary of Athens, Georgia.* Athens: University of Georgia Press, 1964.

Steiner, Bernard C. *Men of Mark in Maryland,* vol. 1. Baltimore, Md.: B. F. Johnson, Inc., 1907.

Stiles, Robert. *Four Years Under Marse Robert.* New York: Neale Publishing Co., 1904.

Stubbs, Steven H. *Duty-Honor-Valor: The Story of the Eleventh Mississippi Infantry Regiment.* Philadelphia, Miss.: Dancing Rabbit Press, 2000.

Thomas, Henry W. *History of the Doles-Cook Brigade, Army of Northern Virginia, C.S.A.* Dayton, Ohio: Morningside House, Inc., 1988.

Towner, Ausburn. *Our County and Its People: A History of the Valley and County of Chemung, from the Closing Years of the Eighteenth Century.* Syracuse, N.Y.: D. Mason & Co., 1892.

Trimpi, Helen P. *Crimson Confederates: Harvard Men Who Fought for the South.* Unpublished manuscript, n.d.

Turner, Charles W. *Ted Barclay, Liberty Hall Volunteers: Letters from the Stonewall Brigade.* Berryville, Va.: Rockbridge Publishing Co., 1992.

Turner, Edward R. *The New Market Campaign, May, 1864.* Richmond, Va.: Whittet & Shepperson, 1912.

U.S. Government. *Journal of the House of Representatives of the United States, Thirty-Ninth Congress.* Washington, D.C.: Government Printing Office, 1867.

U.S. Government. *The War of the Rebellion: A Compilation of the Official Records of the Union and Confederate Armies,* 128 vols. Washington, D.C., 1880–1901.

U.S. Naval War Records Office. *Official Records of the Union and Confederate Navies in the War of the Rebellion,* 30 vols. Washington, D.C., 1894–1922.

Wallace, David D. *The History of South Carolina,* vol. 4. New York: American Historical Society, 1935.

Watts, Hamp B. *The Babe of the Company: An Unfolded Leaf from the Forest of Never-to-be-Forgotten Tears.* Independence, Mo.: Two Trails Publishing, 2004.

Wayne County Historical Association, and Old Dobbs County Genealogical Society. *The Heritage of Wayne County, North Carolina, 1982.* Winston-Salem, N.C.: Hunter Publishing Co., n.d.

Wert, Jeffry D. *Custer: The Controversial Life of George Armstrong Custer.* New York: Simon & Schuster, 1996.

Wert, Jeffry D. *Mosby's Rangers.* New York: Simon and Schuster, 1990.

White, Virgil D. *Index to Volunteer Soldiers in Indian Wars and Disturbances, 1815–1858,* vol. 1. Waynesboro, Tenn.: National Historical Publishing Co., 1994.

Williams, Charles R. *The Diary and Letters of Rutherford B. Hayes, Nineteenth President of the United States.* Columbus: Ohio State Archeological and Historical Society, 1922.

Williamson, James J. *Mosby's Rangers: A Record of the Operations of the Forty-Third Battalion Virginia Cavalry.* New York: Ralph B. Kenyon, Publisher, 1896.

Woodward, C. Vann. *Mary Chesnut's Civil War.* New Haven, Conn.: Yale University Press, 1981.

Articles

Alexander, J. W., "How We Escaped from Fort Warren." *New England Magazine* (October 1892).

Baker, Russell P., "The Story and Legend of Doc Rayburn, The Scouter." *Arkansas History Commission and State Archives* (2005).

Baker, Russell P., "Yellow Doc, The Ranger: An Arkansas Legend." *The United Daughters of the Confederacy Magazine* (May 1986).

Barker, Eugene C., "The African Slave Trade in Texas." *Quarterly of the Texas State Historical Association* (October 1902).

Betts, Vicki, "Private and Amateur Hangings: The Lynching of W. W. Montgomery, March 15, 1863." *Southwestern Historical Quarterly* (October 1984).

Bright, Simeon Miller, "The McNeill Rangers: A Study in Confederate Guerrilla Warfare." *West Virginia History Magazine* (July 1951).

DeBow, James D. B., "Terrebonne Parish." *Commercial Review* (February 1850).

Edwards, Blanche W., "Doc Rayburn, A Daring Confederate Hero." U.S. Government Works Progress Administration (1938).

Hunsicker, Neva I., "Rayburn the Raider." *Arkansas Historical Quarterly* (Spring 1948).

Pasco, Samuel, "Jefferson County, Florida, 1827–1910, Part II." *Florida Historical Society* (January 1929).

Sickles, John, "Custer's Roommate at West Point: James P. Parker." *Military Images* (March–April 1999).

Sickles, John, "The Second Missouri Cavalry C.S.A." *Military Images* (March–April 2006).

Sickles, John, "Southern Soldiers." *Military Images* (November–December 1999).

Soule, Samuel D., M.D., "Dr. S. Gratz Moses." *St. Louis Metropolitan Medicine* (April 1980).

Stuart, Meriwether, "Operation Sanders." *Virginia Magazine* (April 1973).

Wert, Jeffry D., "The Gray Ghosts' Death Lottery." *Civil War Times* (May 2007).

Manuscript Collections

Applications for Pensions, North Carolina State Archives, Raleigh, N.C.

Census and slave schedule records, Bureau of the Census Records, U.S. National Archives and Records Administration, Washington, D.C.

Civil War Records—CSA, State of Alabama Department of Archives and History, Montgomery, Ala.

Civil War Times Illustrated Collection, U.S. Army Military History Institute, Carlisle Barracks, Pa.

Compiled Military Service Records, U.S. National Archives and Records Administration, Washington, D.C.

Confederate Pension Applications, South Carolina Department of Archives and History, Columbia, S.C.

Confederate Pension Records, Division of Archives, Records Management, and History, State of Louisiana Secretary of State, Baton Rouge, La.

The Correspondence of James McNeill Whistler, 1855–1903, Online edition, Centre for Whistler Studies, University of Glasgow, Scotland.

Department of Vital Records, San Diego County, Calif.

George N. Sanders Papers, Library of Congress, Washington, D.C.

George Washington Polk Papers, University of the South, Sewanee, Tenn.

Gibson and Humphreys Family Papers, Southern Historical Collection, University of North Carolina, Chapel Hill.

Gilder Lehrman Collection, Gilder Lehrman Institute of American History, New-York Historical Society, New York.

Hunt-Morgan-Hill Family Collection, Eleanor S. Brockenbrough Library, Museum of the Confederacy, Richmond, Va.

Jefferson Davis Family Collection, Eleanor S. Brockenbrough Library, Museum of the Confederacy, Richmond, Va.

John Esten Cooke Correspondence, William R. Perkins Library, Duke University, Durham, N.C.

Joseph E. Major Collection, Greenville, S.C.

Louisiana and Lower Mississippi Valley Collections, Louisiana State University Libraries Special Collections, Baton Rouge.

Manuscript Collections, Eleanor S. Brockenbrough Library, Museum of the Confederacy, Richmond, Va.

Manuscripts Collections, Virginia Historical Society, Richmond, Va.

Martin Callahan Collection, San Antonio, Tex.

Orders and circulars issued by the Army of the Potomac and the Army and Department of Northern Virginia C.S.A., 1861–1866, U.S. National Archives and Records Administration, Washington, D.C.

Seeley G. Mudd Manuscript Library, Princeton University, Princeton, N.J.

Tennessee Confederate Pension Applications: Soldiers and Widows, Tennessee State Library and Archives, Nashville.

Texas Department of State Health Services, Bureau of Vital Statistics, Austin.

Thomas Dwight Witherspoon Papers, William L. Clements Library, University of Michigan, Ann Arbor.

U.S. Civil War Manuscripts Collection, Rare Book and Manuscript Library, Columbia University, New York.

Virginia Military Institute Archives, Lexington.

Walton-Glenny Family Papers, Historic New Orleans Collection, New Orleans, La.

Williams Folder, Local Genealogy Collection, Peabody Room, Georgetown Branch Library, Washington, D.C.

William W. Jeffries Memorial Archives, Special Collections and Archives Division, United States Naval Academy, Annapolis, Md.

Newspapers

The Albany (Georgia) Patriot
Alexandria (Virginia) Gazette
Austin (Texas) State Gazette
Beckley (West Virginia) Post-Herald
Carolina (Spartanburg, South Carolina) Spartan
Champaign County (Illinois) News
Charleston (South Carolina) Daily Courier
The (Louisville, Kentucky) Courier-Journal
The (Nashville, Tennessee) Daily American
The (Richmond, Virginia) Daily Dispatch
The (New Orleans, Louisiana) Daily Picayune
Dallas (Texas) Herald
The (New Orleans, Louisiana) Delta

The (Washington, D.C.) Evening Star
Florence (Alabama) Times
The (Macon) Georgia Weekly Telegraph
Glasgow (Kentucky) Weekly Times
Goldsboro (North Carolina) Daily Argus
Greensboro (Alabama) Record
Greensboro (Alabama) Watchman
Hampshire (Romney, West Virginia) Review
Macon (Georgia) Daily Telegraph
The (Lexington, Kentucky) Morning Herald
Nashville (Tennessee) Banner
New Orleans (Louisiana) Bee
New York Herald
New York Times
The Norfolk (Virginia) Landmark
The Seguin (Texas) Enterprise
The Selma (Alabama) Times-Journal
The (Columbia, South Carolina) State
(Marshall) Texas Republican
The (Hendersonville, North Carolina) Times-News
Tyler (Texas) Reporter
The Washington Post
Wichita (Wichita Falls, Texas) Daily Times

World Wide Web Sites

Ancestry.com. "RootsWeb.com." 1998–2006. rootsweb.com.

Barner, Elizabeth Watkins. "Watkins Family History Society: Nathaniel Watkins." 2006. watkinsfhs.net/?Famous_Watkins_People:Nathaniel_Watkins.

Butler Center for Arkansas Studies at the Central Arkansas Library System. "The Encyclopedia of Arkansas History and Culture." 2006. encyclopediaofarkansas.net.

Captain E. D. Baxter SCV Camp 2034. "A Biography of Edmund Dillahunty Baxter." 2006. tennessee-scv.org/camp2034/history/e_d_baxter.htm.

Church of Jesus Christ of Latter-Day Saints. "FamilySearch." 1999–2005. familysearch.org.

"Co. 'G', 3rd Regiment Georgia Volunteer Infantry." 1997. 3gvi.org/ga3history.html.

Cornell University Library. "The Making of America Collection." 2007. cdl.library.cornell.edu/moa/browse.monographs/waro.html.

Friedrich-Schiller-University Jena. "Departures—A Jena Tradition." 2002–2004. uni-jena.de/History-lang-en.html.

George Eastman House. "George Eastman House Catalog." 2005. east manhouse.org.

Knudsen, Lewis F., Jr. "History of the Fifth South Carolina Cavalry." N.d. geocities.com/sccavalrycsa/5thCavSC_History.html.

Lane, Harriet Cobb. "For My Children." N.d. ftp.rootsweb.com/pub/ usgenweb/nc/wayne/history/hcobb01.txt.

Library of Congress. "Biographical Directory of the United States Congress, 1774–Present." N.d. bioguide.congress.gov/biosearch/bio search.asp.

Library of Congress. "Library of Congress Online Catalog." 2006. cata log.loc.gov.

Martin, James M. "The Civil War Message Board Portal." 2003. history-sites.com.

MyFamily.com Inc. "Ancestry.com." 1998–2007. ancestry.com.

MyFamily.com Inc. "Genforum." 2005. genforum.genealogy.com.

National Park Service. "Petersburg National Battlefield Pictionary." N.d. nps.gov/pete/mahan/pictionary.html.

National Park Service. "The Revolution Day By Day." 2003. nps.gov/ revwar/about_the_revolution/revolution_day_by_day.html.

Owens, Anne-Leslie. "The Tennessee Encyclopedia of History and Culture: John Calvin Brown, 1827-1889." 1998, 2002. tennesseeency clopedia.net/imagegallery.php?EntryID=B097.

Owens, Anne-Leslie. "The Tennessee Encyclopedia of History and Culture: Neill Smith Brown, 1810–1886." 1998, 2002. tennesseeency clopedia.net/imagegallery.php?EntryID=B100.

Phillips Academy Andover. "About Andover." 1999. andover.edu/about_ andover/overview.htm.

Princeton University. "Princeton's History." 2007. princeton.edu/main/ about/history.

Sayers, Alethea D. "Wounded at Gettysburg: A Diary Excerpt of Lieutenant J. R. Boyle, 12th South Carolina Volunteers." 2000. ehistory .osu.edu/uscw/features/articles/0006/boyle.cfm.

Stanton Hall and Longwood. "Stanton Hall." 2003. stantonhall.com.

Studnicki, Jim. "'Perry's Brigade:' The Forgotten Floridians at Gettysburg." 1998. nps.gov/gett/getttour/sidebar/perry.htm.

Texas State Historical Association. "The Handbook of Texas Online." 2005. tsha.utexas.edu/handbook/online.

University of Glasgow. "The Correspondence of James McNeill Whistler." 2004. whistler.arts.gla.ac.uk/correspondence/index.htm.

University of Richmond. "History of the University." 1995–2007. rich mond.edu/about/history.htm.

U.S. Navy Naval Historical Center. "Dictionary of American Naval Fighting Ships: *Glasgow*." N.d. history.navy.mil/danfs/g5/glasgow .htm.

Virginia Military Institute, "Virginia Military Institute Archives." 2006. vmi.edu/archives.

Walden, Geoff, and Laura Cook. "The First Kentucky Brigade, CSA: The 'Orphan Brigade.'" 1996–2006. rootsweb.com/~orphanhm.

Washington and Lee University. "Washington and Lee: A History." 2006. www2.wlu.edu/web/page/normal/174.html.

Wright, George. "Confederate Prisoners Held at Fort Warren in Boston." 2004. geocities.com/coh41/FtWarren.html.

Acknowledgments

Reporting that I spent hours typing on the computer, tucked away in libraries, and traipsing across battlefields suggests that this journey was a lonely trek along a solitary path. Quite the opposite is true. Along the way, I was joined by thoughtful individuals who generously shared their time, experience, and research; and throughout the journey the support of family and friends kept me on track.

My wife, Anne, encouraged me at every step. She is my cheerleader and my best friend. I am grateful for her love and support. This volume would not have happened without her understanding and generous spirit. My mother, Carol, followed my progress with enthusiasm, and walked the research trail herself: I will always remember her excited telephone call announcing that she had located the gravesite of Charles de Choiseul, who is buried in a cemetery not far from her Columbus, North Carolina, home. Louise Elsie Seiler Bodnar inspired me with her inner strength and independent nature. I wish she could be here to see her grandson's second book.

The majority of photographs reproduced here come from the collections of four people. I am forever in their debt for contributing to this project. I have come to know and admire each for his commitment to preserving a unique chapter in the visual history of our country, his knowledge of the Civil War, and his generosity and friendship. Bill Turner and I talked photography and Civil War for many enjoyable hours. I am pleased to include a selection of his *cartes de visite,* including a group of his beloved Virginians. David Vaughan opened his home to me, and graciously shared his impressive collection. I am honored to feature a selection of his images, particularly his Georgians. John Sickles and I swapped stories while poring over his collection one spring evening at his home. He profiled several of the subjects featured here in *Military Images* magazine. Larry Jones, author of *Civil War and Revolution on the Rio Grande Frontier: A Narrative and Photographic History,* and publisher of the long-running Confederate Calendar series, allowed me to select images from his wonderful collection.

Other images came from library and museum collections. Three in-

dividuals helped me to access their holdings and commented on the manuscript: Randy Hackenburg of the U.S. Army Military History Institute, Heather W. Milne of the Museum of the Confederacy, and Beth Bilderback of the South Caroliniana Library.

I benefited greatly from information provided by soldiers' descendants, genealogists, historians, and others. All contributed significant facts, anecdotes, and other details. Ross Brooks provided period newspaper articles and other source material; his efforts went far and above the call of duty, and I salute him for his fine work. Jim Power's transcription of the Thomas B. Webber diary and collection of information about that Kentucky cavalryman proved invaluable. Vicki Betts's transcriptions of articles referencing George Washington Chilton were most helpful. Starke Miller sent me copies of Chaplain Thomas Dwight Witherspoon's letters, and Wayne Sparkman provided additional details about the Mississippi minister. Jeff Giambrone sent a transcription of a journal entry describing the mortal wound of Abram Beach Reading. Joel Ramsey's biography of David Wardlaw Ramsey was much appreciated, as was Margaret Cline Harmon's research on the Watkins family and Bill LaBach's Gibson genealogy. Dr. Todd Allain contributed a copy of Alexander Pierre Allain's journal. Stacey Jones and Richard F. Barnes provided key details about the life and military service of Bryan Cobb. Joseph E. Major sent a transcript of a fascinating letter about Nimrod Kelley Sullivan. Jerry Hunt made available a letter about the genealogy of the George W. Fullerton family. Martin Callahan provided biographical information and a scan of the *carte* of John Wesley Harris, a copy of which I found in the files of the U.S. Army Military History Institute. Many others also provided materials, and I am deeply appreciative for the help of each and every one.

At the Arlington, Virginia, Public Library, Lynn Kristianson arranged numerous interlibrary loans, and Bonnie Baldwin of the Virginia Room was always helpful. I am thankful for their assistance.

Several individuals reviewed a draft of the manuscript. Among them were Ed Bearss, chief historian emeritus of the National Park Service; Ross Kelbaugh, author of *Introduction to Civil War Photography* and other books; and Bob Zeller, author of *The Civil War in Depth* and other books and president of the Center for Civil War Photography. I am grateful for their feedback and words of encouragement.

Robert J. Brugger and Anne M. Whitmore of the Johns Hopkins University Press offered direction, support, and encouragement during the development of both this book and its predecessor, *Faces of the Civil War: An Album of Union Soldiers and Their Stories.* I thank them for their efforts and appreciate their many kindnesses.

Chuck Myers and Jess Zielinski offered valuable insights and observations. I thank them for their thoughtfulness and friendship.

The pugs that followed Charlie also helped: Missy, my alarm clock; Bella, my battlefield travel companion; Lucy, who came along for the ride; and Brutus, who left too soon.

Index

Page numbers in italic refer to photographs.

Island, 74–75, 97–98, 114; Libby, 87, 89, 156, 197, 217; Ohio State Penitentiary, 123; Old Capitol, 163, 176; Western Penitentiary, 119

Quantrill, William C., 182

Ramsay, Andrew H., *146*, 147
Ramsey, David Wardlaw, *72*, 73–75
Ramsey, Rob, 74
Rawle, John, *78*, 79–80
Rawle, William, 79
Rayburn, Howell A., 13, *14*, 15
Rayburn, Milton V., 13–14
Raysor, George David, *102*, 103–104
Reading, Abram Beach, 33, *34*, 35
Red River Campaign, 38
"Red Shirts," 176
Reid, Legh Wilber, 189, *190*, 191
Resaca, Battle of, 18, 81
Richards, Adolphus "Dolly," 197–198
Richardson, Henry Hobson, 150
Richardson, Joseph Priestly, 150
Richardson, William Priestley, *148*, 149–150
Richmond, Virginia, 3, 11, 19, 35, 45, 47, 50, 66, 77, 107, 117, 130, 145, 147, 151, 155–156, 157, 177, 207, 211, 215–216; fall of, 123–124, 176, 191, 207, 210, 217, 219
Ripley, Roswell S., 137
Roddey, Philip, 141
Rodes, Robert E., 157
Russell, Charles, 162
Rust, Youel Gilbert, *10*, 11–12

Sanders, George N., 66
Sanders, Reid, *64*, 65–67
Santa Mesa, Battle of, 153
Santa Rosa Island, Battle of, 123
Savage's Station, Battle of, 33
Savannah, Georgia, 59, 77, 116, 173, 203
Schneck, Benjamin, 169
Scott, John Winfield, *22*, 23–24
Seddon, James A., 77
Seven Days Battles, 12
Seven Pines, Battle of, 45, 70
Shelby, Jo, 119

Shenandoah Valley, 29, 171, 189, 194
Sherman, William T., xix, 23, 60, 77, 173, 185, 201, 203–204, 207, 233–234
Shiloh, Battle of, 19, 23, 61, 80, 97, 135, 167, 183
Shriver, Daniel McElheran, *160*, 162
Shriver, Samuel Sprigg, *160*, 161–162
Smarr, John T., 183, *184*, 185
Smith, Baxter, 39
Smith, E. Kirby, 124
Smith, Frederick Waugh, 169, *170*, 171
Smith, George, 153
Smith, Oscar Vincent, *214*, 215–216
Smith, William Crawford, 151, *152*, 153
Smith, William "Extra Billy," 171
South Carolina Military Academy, 137, 203
South Carolina troops: First Artillery, 137; Fifth Cavalry, 187; Sixth Battalion Cavalry, 187; First Infantry (Orr's Rifles), 43, 101, 113, 147, 155–156, 157; Fourteenth Infantry, 175; Nineteenth Infantry, 43
South Mountain, Battle of, 45, 47, 151
Spanish–American War, 74, 153
Spotsylvania, Battle of, 155–156, 157, 159, 205, 210
St. Louis, Missouri, 27, 71, 91–92, 165, 193
Steedman, Isaiah, 74–75
Stewart, A. P., 135
Stone's River, Battle of, 80, 129, 135, 167, 183, 221
Stonewall Brigade, 29
Sturdivant, Nathaniel A., 143, *144*, 145
Sullivan, Nimrod Kelley, *112*, 113–114

Taylor, Kirkbride, 105, *106*, 107
Taylor, Richard, 21, 53, 221
Tennessee troops: First Heavy Artillery, 81; Sixth Cavalry, 57, 59; First Infantry, 153; Twenty-third Infantry, 135
Texas troops (Confederate): Third Cavalry, 231; Twelfth Cavalry, 14;